EAST EUROPEAN MODERNISM

ARCHITECTURE IN CZECHOSLOVAKIA HUNGARY & POLAND BETWEEN THE WARS 1919-1939

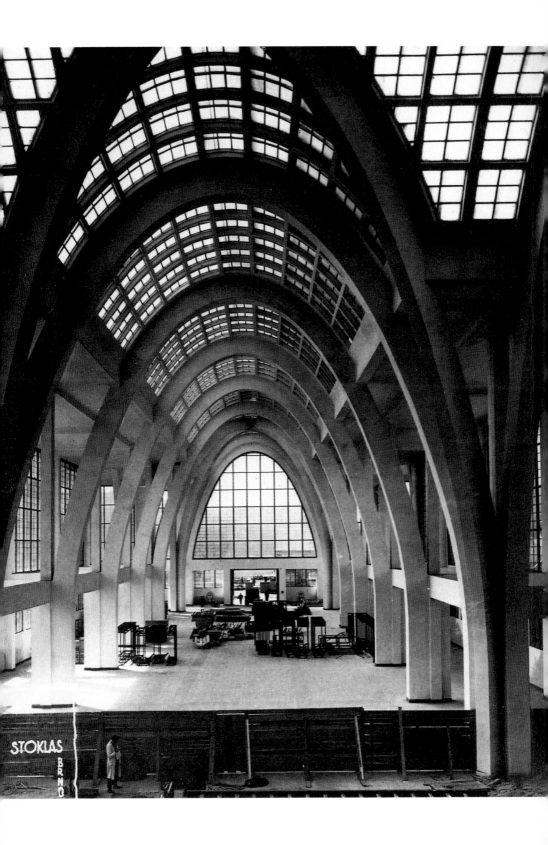

EAST EUROPEAN MODERNISM

ARCHITECTURE IN CZECHOSLOVAKIA HUNGARY & POLAND BETWEEN THE WARS 1919-1939

Edited with Introduction and Essays by
WOJCIECH LEŚNIKOWSKI

Essays by
VLADIMÍR ŠLAPETA, JOHN MACSAI,
JÁNOS BONTA AND OLGIERD CZERNER

RIZZOLI
NEW YORK

FIRST PUBLISHED IN THE UNITED STATES OF AMERICA IN 1996 BY
RIZZOLI INTERNATIONAL PUBLICATIONS, INC.
300 PARK AVENUE SOUTH, NEW YORK NY 10010

Library of Congress Cataloging-in-Publication Data

East European modernism : architecture in Czechoslovakia, Hungary, and
 Poland between the wars / edited with introduction and essays by
 Wojciech Lesnikowski ; essays by Vladimir Slapeta ... [et al.].
 p. cm.
 Includes bibliographical references and index.
 ISBN 0–8478–1893–4 (hardcover)
 1. Functionalism (Architecture)—Europe, Central.
 2. Architecture, Modern—20th century—Europe, Central.
 I. Lesnikowski, Wojciech G. II. Šlapeta, Vladimír.
 NA958.5.F85E28 1996
 720'.943'09041—dc20 96–10949
 CIP

FRONT JACKET ILLUSTRATION: *Farkas Molnár. Red Cube House. Project, 1922.*
BACK JACKET ILLUSTRATION: *Bohdan Lachert and Józef Szanajca. Centro-*
 Cement Pavilion. National exhibition, Poznań, Poland, 1929.
FRONTISPIECE: *Josef Kalous. Palace of Trade and Industry.*
 Exhibition of Contemporary Culture. Brno, Czechoslovakia,
 1926–28.

PRINTED AND BOUND IN HONG KONG

To the memory of Rebecca James-Leśnikowska,
 professor of architecture at the University of Kansas in Lawrence,
 who died in Poland on 22 July 1995.

ILLUSTRATION CREDITS

Courtesy of Architectural Museum of the National Bureau of Monuments, Budapest (duplicated and enlarged by Gábor Barka): Front jacket illustration; figs. 4.1–4.6, 4.8, 4.9, 5.2–5.6, 5.17, 5.31, 5.32, 5.34–5.36, 5.39, 5.41–5.43, 5.45–5.47, 5.49–5.51, 5.54–5.65.

János Bonta: Fig. 5.52.

© Hammond Incorporated, Maplewood, NJ, license no. 12,288: pp. 34–35, 56–57, 110–11, 122–23.

Wojciech Leśnikowski: Back jacket illustration; figs. 7.10, 7.14, 7.19, 7.20, 7.36–7.38, 7.40, 7.41, 7.44–7.47, 7.49, 7.51, 7.53–7.58, 7.65, 7.66.

István Merle, Polytechnical University of Budapest: Figs. 5.10, 5.11, 5.13, 5.22, 5.23, 5.25, 5.26, 5.40, 5.44, 5.48.

Courtesy of Museum of Modern Architecture, Wrocław: Figs. 6.1–6.17, 7.1–7.9, 7.15–7.18, 7.21–7.35, 7.39, 7.42, 7.43, 7.48, 7.50, 7.52, 7.59–7.64.

Courtesy of National Museum of Technology, Prague: Frontispiece; figs. 2.1–3.65, except figs. 3.8, 3.38 (reprinted by permission from Vladimír Šlapeta, *Brnon Funktionalistit: The Brno Functionalists* [Helsinki, 1983], pp. 25, 31); and figs. 3.29, 3.31 (reprinted from Alena Vondrová et al., *Architektura Cesky Funkcionalismus 1920–1940* [Prague, 1978], figs. 19, 22).

© 1937 by Rand McNally, R.L. 96–S–91: pp. 12–13, 178–79, 200–201, 286–87.

Courtesy of Edith Sipos, Budapest: Figs. 4.7, 5.1, 5.7–5.9, 5.12, 5.14–5.16, 5.18–5.21, 5.24, 5.27–5.30, 5.33, 5.37, 5.38.

Courtesy of the Winkler Family: Fig. 5.53.

ACKNOWLEDGMENTS

The authors of this book wish to express their deep gratitude to the National Endowment for Humanities in Washington D.C. for its generous support of this research. Professor Leśnikowski expresses his gratitude to Mr. Marek Kawczyński, the director of LOT Polish Airlines in Chicago, for a grant supporting his research. Professor Leśnikowski also wishes to thank Andrew Dębicki, Distinguished Professor of Spanish and Portuguese at the University of Kansas, for helping prepare the outline of this research, and Janet Crow, the executive director of the Hall Center for Humanities at the University of Kansas, for her assistance during the preparation of this research and during the course of writing this book. In addition, Professor Leśnikowski expresses his gratitude to Professor Agnieszka Pęckowska from the School of Architecture of the Polytechnic Institute of Kraków, to architect Krystyna Nyklińska of Kraków, to Professor Ewa Chojecka of the University of Silesia in Katowice, and to Weronika Naengast, editor at the Silesian Museum of Katowice, for their generous help in gathering factual material connected with Polish functionalism. All of Professor Macsai's research in Hungary for chapers five and six was made possible through the generosity of the Graham Foundation for the Advanced Studies in the Fine Arts, and Professor Macsai wishes to express his most sincere thanks to the Foundation.

CONTENTS

PREFACE

Wojciech Leśnikowski

Despite the collapse of communism and the dramatic change in the political and sociocultural nature of former Central European countries,[1] information on the twentieth-century modernist architecture of Czechoslovakia, Hungary, and Poland available in the West has been imprecise and fragmented. Forty years of communist domination of this part of the world eliminated any rational and objective historical analysis of the modernist heritage. Most studies on the subject had to be officially approved. Only during the waning days of communism did more objective information illuminating the accomplishments of this period appear. There was, of course, a rationale according to which the communist authorities held modernism in contempt. They viewed modernism as antihistorical and antihumanist and, therefore, alien to the Leninist vision of culture. Modern architecture was based on futuristic models of society and advanced technologies and adopted correspondingly dynamic and radical formal criteria. These were to replace the historically derived, monumental, static, centralized, and hierarchical principles of society and of architecture and city planning to which the Stalinist communist cultural ideologues were so attached. Communists rejected even the modernist ideal of a new society to be formed on the debris of traditional Western civilization on the ground that historical continuity was

to be maintained at all costs. Ironically, the communists frequently saw themselves as defenders and guardians of the Western historical heritage. They felt menaced by the assault of cosmopolitan and asocial modernism. They declared modern architecture artificial, detached, speculative, unnatural, and at worst bourgeois in origins. Consequently, modernist practice was forbidden in the Soviet Empire. Nikolaus Pevsner's *Penguin Dictionary of Architecture* (1966) contains virtually nothing on modern architecture in Czechoslovakia, Hungary, and Poland, giving the impression that nothing architecturally interesting had been accomplished there. (Recently new monographs dealing with the period 1919–1939 have appeared in all three countries, providing valuable information for this book.)

Knowledge of this period among the general public and architects inside these three countries has been no greater. Most architects who graduated from communist architecture schools have acquired only sketchy information about modernism. Yet Czechoslovakia, Hungary, and Poland developed a very sophisticated and comprehensive concept of modern architecture revealed in hundreds of often remarkable constructions. Fortunately most of these structures survived the destructions of the Second World War, primarily because of their locations. Housing developments, villas, sanatoriums,

and sports facilities usually stood outside urban centers. Today they present a unique opportunity to examine their concepts and to enjoy their designs. They reveal a stimulating originality and richness, produced in countries that historically formed a cultural bridge between Western and Eastern Europe.

Examination of the birth and development of architectural functionalism within the three countries reveals the extent to which external and internal sociopolitical events influenced architecture. Each country experienced a short-lived, incredibly intense and turbulent rebirth as an independent state even if their politics followed different paths. Avant-garde functionalism survived longest in Europe in these three countries, developing into a strong movement that lasted until the outbreak of the Second World War.

Functionalism was perceived by the cultural and architectural elite of all three countries as the voice of democracy, inspired by Holland, Weimar Germany, France, and Great Britain. Functionalism was also seen as an art of opposition to the growing threat of totalitarian cultures represented by Fascist Italy, National Socialist Germany, and the Stalinist Soviet Union. Despite political shifts, often conservative, in all three countries, cultural forces associated with the left maintained their intellectual identification with progressive European peers. Architects and artists developed extensive international connections, leading them to conceive on their own soil a functional architecture that was truly "socially engaged." This broad architectural culture assisted each society's efforts to become truly modern. As a result, functionalism continued to thrive here while it experienced grave difficulties in other European countries. The functionalism that blossomed in the late 1920s and thrived throughout the 1930s represents one of the highest achievements of modern architecture in Europe.

This book, a collaborative effort of five architectural writers from Czechoslovakia, Hungary, and Poland, presents the achievements of modern architecture from 1919 to 1939. It is devoted to the memory of a brilliant generation that met a tragic destiny at the hands of exceptionally brutal, ruthless, and reactionary Western and Eastern European forces.

NOTES

1. The term "Eastern European" traditionally referred to all Eastern Bloc countries, but that term has generally been replaced now by "Central European." The two terms are used interchangeably in this book, the latter to designate geographical division rather than ideological orientation.—ED.

Czersk

Khoinitse

Kamien

Svietse

A

Neustrelitz

Stettin

Wysoka

Wieebrok

Mrocza

Schneidemühl

Naklo

Wist

Czarnków

Chodziez

Znin

Bidgoshch

Nies

Wielen

Wagrowiec

Rogów

Tho

BERLIN

Oder

Miedzycho

Szamotuy

Warta

Oborniki

Mogilno

Strze

Gniezno

Frankfurt

Zbaszyn

Opalenica

Póznań

Kostiryn

Witkówo

Grodzisk

Sroda

Wrzesnia

River

Konin

Kostsian

Srem

River

Yarotsin

Kottbus

Leszno

Gostin

P

Koźmin

Pleszew

Tu

Kali

Krotoshin

Ostrów

Elbe

Oder

Kepno

Lututo

Görlitz

Breslau

Rychtai

Wielu

R.

Dresden

Dzi

witz

SNÉ MTS

KRKONOŠE MTS.

Chesto

ERZ GEBIRGE

Podmok

Rumburg

RIESEN GEBIRGE

Oppeln

Usti

Déčin

Liberets

Teplice

Ces. Lipa

Yablonets

Most

Litoměrice

Turnov

Truthov

Chomutov

Mělník

Yichin

Dvur Kralove

Neisse

Karlovy Vary

Zhatets

Lysá

Mladá Boleslav

Josefov

(Carlsbad)

Kladno

Nymburk

Hradets Kralove

Bečov

Chyse

Rakovnik

Labe R.

Rokytnice

Marianské-

Beroun

PRAHA

Kolin

Pardubitse

Zamberk

Hutakrole

Lázné

(PRAGUE)

Ratibor

Plzen

C

Dobriš

Kutná Hora

Khrudim

Usti

Sumberk

Opava

Bor

Dobrany

Pribram

Caslav

Svitavy

Rymarov

Mor. Ostrava

Boliuma

Domažlice

Rozmital

Z

Benesov

Jeníkov

Lvetla

Sternberk

Mistek

Test

Klatovi

Tábor

E

Něm. Brod

Policka

Olomouts

Frýdek

UMAVA

Strakonice

Pisek

Bechyne

Hunpolets

dar

Bystrice

Boskovice

Prerov

Novi Yichin

imperk

Týn

Sobeslav

Yihlava

Prostejov

Kromerizh

Buděyovitsa

Jindrichuv Hradec

H

Brno

Slavkov

Tur. S

(Budweis)

Trebon

Telč

(Brün)

Uh. Brod

Kremft

Kremže

Gmünd

Znoim

C

ČESKOSLOVENSKA

Trencin

Damube

Krumlov

Dyje

R.

Hodonin

Breclava

Passau

Piestany

Malacky

Ban. Stia.nica

Linz

River

Krems

Trnava

Hlohovec

Nitra

VIENNA

Galanda

Kremže

Lyck
Allenstein
Grajewo
Grodno
D. Eylau
Suchowola
Lubawa
Kuznica
Lasin
Kurzelnik
Szczuczyn
Osowiec
Sokólka
Wolpa
Grudzia, lz
Brodnica
Janow
Kolno
Radzilow
Tykocin
Wasilkow
Wolkowysk
Wabrzezno
Lidzbark
Dzialdowo
Myszyniec
Lomza
Bialystok
Narew
Nowy Dwor
Golub
Rlpin
Mlawa
Przasnysz
Ostroleka
orun
Ciechanow
Maków
Mazowieck
Ostrowia
Suraz
Lipno
Sierpc
Bielsk
Hajnówka
Wloclawek
Pultusk
Brok
Bransk
ica
Plonsk
Bug
Kleszczele
Pruzana
R.
Sokolów
eczo
Gostynin
Plotsk
Modlin
Radzym
Drohiczyn
Mielnik
Kamieniec Lit.
olno
Gabin
WARSZAWA
Praga
szyn
River
Czerniawczyce
Kutno
(WARSAW)
Mir
Siedlce
Janów
Kobryn
olo
Leczyca
Sochaczew
Biala
Brześć Litewski
Lowicz
Grodzisk
Miedzyrzec
Koden
Mokrany
Ozorkow
Zgierz
Skiernievits
Luków
Horodyszcze
Orzechowa
Ratne
Lodz
Groyets
Garwolin
Domaczewo
arta
Rawa
Zelechów
Radzyń
Parczew
Wlodawa
Lask
Warka
Pabjanice
Odrzywol
Deblin
Ostrów
Lubartow
Wyzwa
Kowel
Zdunska Wola
Opochno
Radom
Pulawy
Piotrków
Szydtowiec
River
Lublin
Chem
Turzy
Przedbórz
Konskiye
Itza
Wlodzim
Radomsk
Radoszyce
Solec
Józefów
Krasnostaw
Janow
Wloszczowa
Kieltse
Opatów
Krasnik
Hrubieszów
Lokacze
ova
Zarki
Chmielnik
Sandomierz
Janow
Komarow
Sokal Sw
ubliniec
Jedrzejow
Staszów
Bilgoraj
Laszczów
Pilica
Miechów
Pinczów
Majdan
Józefów
Tomaszów
Tarnowitse
Dziatoszyce
Mielec
Tarnogród
Belz
Ra
Bedzin
Korczyn
Leżajsk
Rawa ruska
ice
Proszowice
Radomysl
Rzeszów
Przeworsk
Kamionka S
owice
Chrzanow
Debica
Lancut
Jaroslaw
Zolkiew
Busk
Krakuy
Tarnów
Ropczyce
Jaworow
(Cracow)
Wieliczka
Tuchów
Dynow
Lwów
Bielsko
Maków
Limanova
Jasla
Krosno
Przemysl
(Lemberg)
Sw
eszyn
Zhivets
Nowy Sacz
Gorlice
Rymanuw
Sanok
Sambor
Grodek
Komarno
Bobrka
Nowy Targ
Dobromil
Mikolajów
Rohatyn
Trsténa
Starosól
Zakopane
Bardijov
Drohobycz
Stryj
Lipt. Sv. Mikulas
Kežmarok
Sabinov
Boryslaw
Kalusz
izomberok
Spiš N. Ves
Leroca
Bolechów
Dolina
Brezno
Dobsina
Humenné
Michalovce
Nadworna
Ban. Bystrica
Košice
Užhorod
Volovec
EPUBLIKA)
Róznava
Trebišov
Munkácevo
Hajniky
Rim. Sobota
Beregasy
Horincovo Jasene
arnovica
Lučenec

FUNCTIONALISM IN CZECHOSLOVAKIAN, HUNGARIAN, AND POLISH ARCHITECTURE FROM THE EUROPEAN PERSPECTIVE

WOJCIECH LEŚNIKOWSKI

We refuse, therefore, to allow any aesthetic considerations to predetermine construction, because they hamper the progress of architecture. New architecture must be hygienic. The achievements of medical science should determine layout, construction methods, and town-planning principles. This is all [of] the utmost importance for the health of mankind.

—Karel Teige
Stavba (Building), 1924

The architecture of industrial manufacturing and commercial facilities, exhibition halls, and bridges had a great deal to do with the creation of functionalist architecture. Many spectacular achievements of late nineteenth- and early twentieth-century industrial architecture, such as long-span constructions, and factors such as structural lightness, planning flexibility, and honest use of new building materials led modern architects to reevaluate their approach. In addition, the requirements of modern hygiene associated with combating rampant diseases such as tuberculosis introduced spaciousness, good ventilation, sanitary facilities, clean surfaces, and easy access to sunlight and greenery. New types of buildings emerged from health concerns, empowering functionally oriented architecture. Glass architecture, which originated at the beginning of this century, derived from this phenomenon, as well as from the desire to cultivate a spirit of openness.

Modernism sought to eliminate eclecticism by simplifying architectural language. This was dictated, on one hand, by the gradual disappearance of traditional crafts and, on the other, by intellectual and aesthetic comparisons between the modern machine (clean, efficient, and rational) and forward-looking architecture that opposed the popular nineteenth-century romanticism. Functionalist architecture drew on existing ideas. Early twentieth-century English town planning concepts associated with the garden city had a particularly profound impact on the formation of modernism. The other major influence was the myth of the United States: the country of the modern lifestyle, comforts, and advanced construction methods. American functional zoning, car-oriented transportation, and the use of vast green spaces appealed to many illustrious European modernists.

Functional architecture also related to the intense interest that many modernists expressed in town planning. For them, the very reason for inventing modern architecture was the need to radically restructure decaying European cities whose increasingly chaotic conditions reflected the laissez-faire practices of the nineteenth-century liberal capitalism. Combining modern technology and a functionalist approach to planning was seen as the best solution to the need for affordable housing and an improved urban environment.

Central European modern architecture owes much to modernist principles developed abroad, particularly in Germany. The experiments carried out by the German Werkbund organization attracted Czech, Hungarian, and Polish attention. The Deutscher Werkbund was established in 1907 by Hermann Muthesius, who conceived it in the spirit of the English Arts and Crafts movement. The Werkbund propagated industrial architecture, stressing the beauty and utility of machines and the discipline and rationality of industrial standardization. The Werkbund influenced most of Europe. Similar organizations were set up in Sweden in 1907, Austria in 1910, Switzerland in 1913, and England in 1915. The Werkbund's most direct influence is seen in the famous German and European housing exhibitions, such as those of Stuttgart (1927), Breslau (1929), Stockholm (1930), Zurich (1930), and Vienna (1932). Czechs participated in 1914 in the Deutscher Werkbund exhibition in Cologne, with a pavilion designed by Otakar Novotný. Housing exhibitions in Czechoslovakia (Brno, 1928; Prague, 1932) and Hungary (Budapest, 1933), as well as Polish housing settlements of the early 1930s, were all influenced by the Werkbund. The creation of the Bauhaus in Weimar in 1919, with its emphasis on design standardization, industrial production of mass economical housing, and close relationships between advanced means of production, new materials, and form making, also influenced Central European modernism. Several architects from Hungary and Czechoslovakia participated in Bauhaus educational efforts, and many studied there. Poland had no specific ties with the Bauhaus, but Bauhaus ideas were well-known and appreciated by Polish architects.

Modern functionalism did not develop without violent opposition. It was attacked for being a subversive agent of international communism. It was maligned for being of Semitic origins and, therefore, alien to Western cultural traditions. It is true that the architects of European functionalism were connected with the international socialist movement, and many were of Jewish origin. They did campaign for a new European order, a new social consciousness, and a new type of man and civilization. The major political and cultural tendencies of the time were internationalism, socialism, and communism, all in sympathy with functionalist ideology. All progressive forces emerging after the First World War dreamed of transforming Europe into a unified and modified political and social community. Most modern architects

were involved in left-wing politics: Gropius, Taut, Meyer, May, Berlage, Duker, van Doesburg, van Eesteren, Aalto, Lurçat, Terragni, Stam, Wagner, Oud, Pagano, Norwerth, Brukalski, Lachert, Syrkus, Gočár, Krajcar, Kroha, Molnár, Forbát, Fischer, Hilberseimer, Sert, Bourgeois, and many others participated in the activities of democratic, socialist, and communist forces. Functionalism and constructivism served as powerful international architectonic symbols of such sociopolitical beliefs. It is no wonder that, in reaction to opposition from conservative sociopolitical and artistic circles, specific associations of architects formed to shelter and defend individuals who shared similar concerns, goals, and convictions. These groups promoted domestic and international contacts, exchange of ideas, exhibitions, conferences, publications, and correspondence for the purpose of creating an international forum to debate and propagate the issues connected with modern architecture.

The Congrès Internationaux d'Architecture Moderne (CIAM), founded in 1928 in La Sarraz, Switzerland, grew out of the international housing exhibition in Stuttgart-Weissenhof of 1927. The CIAM sought to unify various national experiments in one international body of understanding. The term *International Style,* coined by Henry-Russell Hitchcock and Philip Johnson in 1932 in the United States, was ultimately associated with this event. Architects from Czechoslovakia, Hungary, and Poland were deeply involved in the organizational and the conceptual work of the congress. Each country sent delegates who presented projects. In turn, the CIAM disseminated the latest information to those three countries. Thanks to the CIAM and other national organizations, modernists had an opportunity to travel widely throughout Europe and to share their own thoughts and accomplishments with their colleagues. For example, El Lissitzky traveled between the Soviet Union, Germany, and Switzerland. Konstantin Melnikov was active in Paris. Le Corbusier built in Moscow and Stuttgart, and Erich Mendelsohn worked both in Leningrad and Czechoslovakia. Walter Gropius and Marcel Breuer participated in Soviet competitions. J. J. P. Oud, Victor Bourgeois and Josef Hoffmann built in Stuttgart, while André Lurçat and Peter Behrens built in Vienna. Ludwig Mies van der Rohe and Adolf Rading built in Czechoslovakia, Alfréd Forbát in Berlin; while Adolf Loos worked in Switzerland, Paris, and Czechoslovakia. While Gerrit Rietveld was building in Vienna, Willem M. Dudok, Jaromír Krejcar, and Theo van Doesburg designed in Paris. This extensive and feverish activity spread information about modernism throughout Europe.

Unfortunately, in the 1930s European functionalism was dealt a powerful blow with Adolf Hitler's rise to chancellor of Germany, as well as Josef Stalin's absolute rule of the Soviet Union. In both countries the development of modern architecture came to an abrupt halt. Elsewhere in Europe, modernists were put on the defensive, as the political pendulum swung from the left to the right. In France, Belgium,

Holland, Austria, Italy, and Scandinavia, functionalists found themselves under severe attack and retreated. Le Corbusier, after erecting a series of remarkable buildings in the 1920s, was practically jobless in the 1930s. The exception was the territory of Czechoslovakia, Hungary, and Poland, where modernism continued to exist in a strong and vigorous manner practically until 1939.

CZECHOSLOVAKIA

The dual state of Czecho-Slovakia was a product of the disintegration of the Austro-Hungarian Empire at the end of the First World War. In 1915 Tomáš Masaryk organized a Czech Committee in Paris, which was recognized by the Western Allies. In 1918 in Prague the committee proclaimed the birth of the Czech Republic. Two years later, this entity absorbed the territory of Slovakia, which was taken away from Hungary as a result of the Treaty of Versailles. Masaryk became the first social-democrat prime minister and later president of the Czechoslovak Republic. Masaryk's vision was built on the foundations of democratic philosophy, particularly that of England and the United States. He strongly believed in the humanist mission.

Czechoslovakia consisted of four provinces: Bohemia, Moravia, Slovakia, and Ruthenia. Slovakia was the largest, Ruthenia the smallest. In the early 1930s, the country's population of 13,613,000 reflected its complex political reality: the Czechs constituted the minority, representing only 47 percent of the population. The Slovaks counted for 28 percent; Germans, Hungarians and Poles along with a sizable Jewish minority centered mainly in Prague represented the rest. The Czechs were located mainly in Bohemia and Moravia, and the Germans in the Sudeten Mountains. Slovaks occupied the territories to the east of Moravia, and Hungarians were close to the Hungarian border. So formed, Czechoslovakia had Germany, Austria, Poland, Hungary, and Rumania as neighbors.

Czechoslovakia's demographic and geographic composition represented uneven development. Bohemia and Moravia were the most developed, industrialized, and educated, owing to the advanced culture of the Czech and German populations. The wealthiest cities and towns were located here. Prague, the famous European cultural center, counted 676,657 residents. Another intellectual and industrial center, Brno, the capital of Moravia, had 221,758 residents. Within Bohemia and Moravia, other important industrial towns were Plzeň, Hradec Králové, Pardurbice, Liberec, and Ostrava. In addition, health spas famous throughout nineteenth-century Europe, such as Karlovy Vary and Marianské Lázně, were located here. While Prague represented the European dimension in Czechoslovakian culture, Brno, once considered a suburb of Vienna, was a regional and industrial center. Yet Brno became a leading modernist architectural center due to its industrial power and important international connections. Not far from Brno the new industrial town of Zlín, created by industrialist

Tomáš Baťa, quickly became the world's center for shoe production.

In contrast to the more developed western and central Czechoslovakian regions, the beautiful region of Slovakia was underdeveloped and rural; its people poor and insufficiently educated. Its largest city was the provincial capital of Bratislava, with a population of 93,189, center of the region's educational, cultural, and industrial facilities. Other important towns were Prešov and Košice.

The complex demographic mix of the Czechoslovakian state, consisting of conflicting cultural and economic interests and traditions, caused serious and continual political tensions in the country. The Social Democrats, under President Masaryk, and the Agrarian party attempted to find a mutually acceptable solution to prevent the tensions from exploding. The situation worsened after Masaryk's death in 1935 because of increasing external pressure on Czechoslovakia from Nazi Germany. Hitler wished to incorporate the German minority living in the Sudeten Mountains into the greater Reich. The tragic 1938 Munich agreement, which represented the Western betrayal of Czechoslovakia, allowed Hitler to annex the Sudeten region, thus absorbing roughly 25 percent of the population and leaving the country practically defenseless. In March 1939 the Slovaks declared themselves independent, yet Hitler proceeded with the original annexation. In the same month he marched into the remainder of Czechoslovakia, occupying Bohemia and Moravia, which became Third Reich protec-

torates. Slovakia under Father Andreas Hlinka and later Josef Tiso became an independent German client state, with racist and pro-fascist policies. At the time of the final dismembering of Czechoslovakia, Poland invaded the border region around the town of Cieszyn, claiming the territory, which was largely occupied by the Polish minority, for herself. Thus, Czechoslovakia disappeared from the map of Europe until its resurgence in 1945 as a democratic state. In 1948 the communists removed its democratic government, and its president, Edvard Beneš, committed suicide.

Despite this tragic history, Czechoslovakia from 1919 to 1938 produced brilliant intellectual and economic achievements unique in Central Europe. Unlike Hungary and Poland, Czechoslovakia remained, despite the political turbulence within and outside its borders, staunchly democratic. Its middle class was strong, and its cultural and intellectual traditions enlightened. The Czech industrial base, a result of strong historical ties to Austria and Germany, was sophisticated and one of the best in Europe. The Czech manufacturing sector produced armaments, cars, trains, airplanes, glass, steel, and consumer goods of the highest quality. Such industrial complexes as Škoda and Baťa were among the most modern in Europe.

The wide public acceptance and development of functionalism in Czechoslovakia represents a unique and extraordinary achievement in the history of European modernism. In Germany, modernism found most of its support

in cities governed by Social Democrats. In Czechoslovakia, modernism received broad support from the middle class, which felt sympathy for its socialistic principles and which saw modernism as a voice of democracy in Europe. The development of sophisticated modernism in Czechoslovakia was also facilitated by a strong industrial base.

The creation of the independent Czechoslovakian state shifted the former Czech intellectual orientation away from Vienna toward Berlin, Paris, and Moscow. As early as 1920, Karel Teige and his friends, who were poets, writers, and painters, founded the Devětsil group, which took an antiacademic stand. The group maintained close relationships with similar groups abroad. Its ultimate goal was the elimination of formal arts from architecture in favor of constructivism. Teige, who between 1922 and 1938 edited the avant-garde Czech architectural review *Stavba* (Building) helped to develop extensive relations between Czech modernists and the international community. He met Le Corbusier in 1922 in Paris and in 1923 established close contacts with avant-garde German critic Adolf Behne from Berlin. Teige became a good friend of Hannes Meyer and was appointed external lecturer at the Bauhaus. Teige's intellectual attitude mirrored that of the Czech avant-garde, which could be described as a Marxist alliance of philosophy and technology. According to him this alliance was to produce a socialist landscape. Teige represented the popular intellectual struggle

between the conservative bourgeoisie and progressive communists. He also organized the Czech participation in the first Bauhaus exhibition in Weimar in 1922. In 1925 Teige traveled with a group of left-wing intellectuals to Moscow and Leningrad to learn about the Russian constructivist avant-garde. After his return, he disseminated his findings in Czechoslovakia. He eventually developed strong connections with the Russians, particularly with the brothers Leonid and Viktor Vesnin and Moisei Ginzburg. Teige participated in the first official congress of Soviet architects in Moscow in 1937 and felt shocked by the proclamation that Stalinist socialist realism was to be the official style of communism. He praised Le Corbusier's purism for its scientific, engineering emphasis. However, in 1928 Teige attacked Le Corbusier's proposal for the Mundaneum in Geneva, Switzerland, as being conservative and monumental, resulting in a famous debate between the two.

Czech participation in the CIAM was also intense, thanks to the energetic efforts of František Kalivoda of Brno. Kalivoda was instrumental in setting up the East European branch of the CIAM, which included Poland, Hungary, Czechoslovakia, Rumania, Yugoslavia, and Greece. Three CIAM conferences were held with delegates from those countries: in Budapest in 1937, where Swiss historian Siegfried Giedion participated, and later in 1938 in Zlín and Brno. Simultaneously, several Czech architects studied and worked abroad. Among them was Antonín

Urban, who worked for Hannes Meyer and later went to the Soviet Union as a part of Meyer's Red Brigade to build industrial towns. He taught at the Moscow Academy of Architecture and until 1942, the year he died, was the chief architect of the new town of Stalinsk. Lubomír Šlapeta worked for Adolf Rading and Hans Scharoun. Oldřich Udatný worked for Peter Behrens, and Jindřich Kriese for Heinrich Tessenow. In 1930 prominent Brno functionalist Jiří Kroha visited the Soviet Union to familiarize himself with the works of Russian constructivism. Subsequently, he lectured about his experience at home and helped to organize a 1932 exhibition on the Soviet avant-garde in Brno. Jaromír Krejcar spent eighteen months working with Moisei Ginzburg on various spa projects in Moscow, and František Sammer collaborated with Le Corbusier's Russian partner Nikolai Kelli on the construction of the Centrosoyous building in Moscow. Paris was the third center, after Berlin and Moscow, to attract Czech functionalists. Bedřich Feuerstein worked for Auguste Perret while Karel Stráník worked for Le Corbusier. Feuerstein and Sammer also worked in the office of their countryman Antonín Raymond in Japan. Six Czech students attended Bauhaus between 1929 and 1932.

In turn, several prominent foreign avant-garde architects were invited to lecture and build in Czechoslovakia. Henry van der Velde, Walter Gropius, and Hans Schmidt came from Germany to lecture in Prague while Hannes Meyer gave a series of lectures in Brno in 1931. H. P. Berlage visited Prague from Holland and gave a highly influential lecture. From Paris four prominent modern architects —Le Corbusier, André Lurçat, Marcel Lods, and Albert Laprade—visited Prague and Brno and lectured; in 1929 Victor Bourgeois came to Prague to speak about Belgian architecture. In 1935 Mart Stam visited Brno, the center of Czechoslovakian functionalism, and lectured on town planning in the Soviet Union. He also contributed to the design of the Baba housing development of Prague. In 1930 Mies van der Rohe built his famous Tugendhat House in Brno. Erich Mendelsohn built the Bahner department store in Ostrava in 1932. In the same year Thilo Schoder designed Villa Stross in Jablonec, and Moravian native Adolf Loos built the well-known Müller House in Prague in 1930. Some Bauhaus students, such as Lotte Stam-Beese and Zdeněk Rossmann, worked in Bohuslav Fuchs's atelier in Brno.

Thus, through extensive international contacts, middle-class support, and a sophisticated industrial base, the Czechs quickly developed their own powerful version of functionalism. In and around Prague and Brno, two metropolitan centers that became known for functionalist architecture, pioneering Czech architects erected a formidable series of buildings. These ranged from individual houses sponsored by the prosperous middle class to public housing, schools, commercial buildings, hospitals, sanatoriums, and industrial buildings.

Near Brno, a new industrial area was created, the famous Baťa industrial empire. This consisted of

a shoe manufacturing facility that became known as the industrial town of Zlín. This town represented one of the highest achievements in industrial organization, planning, and architecture in Europe. In 1904 the town's founder, Tomáš Baťa, studied American industrial organization and production and introduced American methods into his enterprises. Zlín was originally planned by Jan Kotěra in the spirit of Ebenezer Howard's garden city. In fact, the Czechs exhibited an early interest in English garden city planning. In 1910 Hermann Muthesius lectured on this subject in Prague; Henry Chapman, the secretary of the International Garden City and Town Planning Federation, lectured there in 1922. He was followed in 1923 by the famous English planner, Raymond Unwin, who lectured on his work.

In 1927, Zlín's second architect, František Lydie Gahura, adapted the Chicago-style skeletal frame for use throughout Zlín's industrial and administrative buildings. The city's third architect, Vladimír Karfík, worked from 1927 to 1929 in the office of Holabird & Root in Chicago and also worked for Frank Lloyd Wright. Baťa recalled Karfík from the United States; by 1930 he was the chief architect of Baťa's one-hundred-thousand-worker industrial empire. In 1935 Baťa held an international competition to explore various forms of social housing. Le Corbusier entered and was asked to consult on several Baťa projects. Among them were the Zlín-Bator agglomeration and Baťa's proposed industrial complex in France, called Hellocourt. Le Corbusier's efforts to obtain a commission from Jan Baťa, Tomáš's successor, came to nothing because the designer appeared to be too individualistic.

Meanwhile, architects such as Bohuslav Fuchs, Jiří Kroha, Hugo Foltýn, Josef Gočár, Jaromír Krejcar, Evžen Linhart, Oldřich Starý, and Ladislav Žák experimented with architecture that blended various international influences ranging from Adolf Loos to the Bauhaus and Le Corbusier, to produce a unique and sophisticated regional language. In the footsteps of German Werkbund innovations in social housing, the Czechs built two of their own experimental housing developments: the Nový Dům ("New House") in Brno (1928) and Baba Hill in Prague (1932), both among the best European achievements in this domain.

The growth and development of Czechoslovakian functionalism continued without much interruption until tragic political events led in 1938 to the dissolution of the Czech Republic. Jaromír Krejcar's famous Czechoslovak Pavilion at the Paris International Exposition of 1937, built as a sophisticated all-metal structure, demonstrated for the last time the unique and enlightened partnership of Czechoslovakian political authorities, industry, and architects brought together to advance modern architecture. These achievements were without parallel in Europe, given the short existence of the free Czechoslovakian state.

HUNGARY

On November 11, 1918 Emperor Charles abdicated his Austrian

throne, and two days later he relinquished the Hungarian throne. After four years of senseless European war initiated by Austria-Hungary, the dual monarchy ceased to exist. On November 18, the Hungarian People's Republic was proclaimed with Count Károlyi as prime minister and his Social Democratic party in charge. Hungary emerged from the defeat of the First World War a devastated and vastly diminished country. When the Hungarian peace treaty was signed on June 4, 1920 in the Grand Trianon of Versailles, Hungary lost 71 percent of its former territories, 60 percent of its population, and 56 percent of its industrial plants. Rumania received Hungary's Transylvania; Czechoslovakia, Slovakia and Ruthenia; Yugoslavia acquired most of the south; and Austria received part of Western Hungary.

At the time of the treaty, Hungary occupied 35,000 square miles, with a population of 7,614,000. The losses were proportionally far greater than those inflicted on Germany. While Poland painfully reconstituted her former pre-partition territories, and Czechoslovakia emerged as a fairly large state, Hungary stood despoiled and politically isolated. She had defenseless borders and no natural resources and inherited significant developmental differences between the cosmopolitan, metropolitan, European urban centers such as Budapest, where approximately one-seventh of the Hungarian population lived, and the provinces. Budapest's educated middle class strongly contrasted with the population of the rest of the country, which was provincial, uneducated, and poor. Most institutions of higher learning were located in Budapest along with what was left of Hungarian industry, such as the famous Csepel factories. Other Hungarian cities, such as Pécs, Szeged, and Debrecen, were small and provincial by comparison. Hungary had several neighbors: Rumania, Yugoslavia, Czechoslovakia, Austria, and Poland. Hungary's turbulent history between the two world wars can be easily understood in the light of such a historical catastrophe and the resulting bitterness that the nation must have felt. Hungary entered its difficult independence as a retarded, mostly peasant country still ruled by a land-owning aristocracy. Hungary's first, socialist prime minister and president, Károlyi, belonged to this aristocracy. The educated middle class, which owned most of Hungary's enterprises, was partially Jewish, and this eventually led to considerable anti-Semitism.

Adding to the country's early difficulties, before the Versailles treaty legitimized the Hungarian state, the Rumanian army occupied a portion of Hungary. This led to the short-lived communist regime of Béla Kun, who took power for two months in March and April 1919. Kun attempted to form Hungary on a Soviet model and to free the country from Rumanian interference. This had disastrous consequences: the Rumanian occupation of Budapest, followed by the right-wing, White counterrevolution and "White Terror." This culminated in the authoritarian rule of Nagybányai Horthy Miklós, former admiral in the Austro-Hungarian navy. In reaction to this national humiliation,

Horthy introduced pronounced nationalism and punishment for nonconformity. Thus, Hungarian fascism preceded Italian and German fascism. With Horthy in power, the old aristocrats returned to rule the nation, and scores of extremist national organizations, including anti-Semitic associations, appeared. Hungary, guided by Prime Minister Count István Bethlen, began the painful work of national revival. Eventually this led to national literacy and considerably revived industry, despite the 1929 economic collapse in the Western world.

The next dramatic evolution of the Hungarian nation occurred under Gyula Gömbös, an ardent admirer of Benito Mussolini and Adolf Hitler. Gombos's policies brought more tragedy to this battered nation. Hungary joined the Axis nations in hopes of recovering her lost territories in the event that another European war should bring German-Italian victory.

It is fascinating to contemplate the development of Hungarian functionalist architecture given its radical leftist political and conceptual nature. The conservative, nationalistic sociopolitical tendencies of Hungary's leaders and growing anti-Semitism had direct consequences for this movement. The Jewish industrial and cultural elite in Hungary patronized modern architecture, which the elite associated with democratic progress and free societies. It is surprising, therefore, the degree to which architectural functionalism established itself despite the adverse social, political, and cultural climate of Hungary's twenty years of inde-

pendence. Horthy's regime was more interested in neoclassical, monumental design or in architecture based upon patriotic, national motives than in architecture widely interpreted as cosmopolitan, rootless, subversive, and communist. That the Jews were able to continue their economic activities in Hungary, and therefore sponsor functionalist architecture, was certainly a result of Horthy's own surprising contribution. He refused to persecute the Jewish minority in deference to some of his countrymen, a commendable spirit comparable to that of another strong man in power in central Europe, Marshal Józef Piłsudski of Poland. This is perhaps why the Nuremberg tribunal did not find Horthy guilty of any atrocities (he was allowed to end his life in Spain as a free man). Thus, despite conservative government policies and a largely conservative public, Hungary produced a series of remarkable modern buildings, and her progressively minded talent was well represented on the international scene.

Two Hungarians were chiefly responsible for spreading information about the revolutionary qualities of Russian constructivism, which was founded in Moscow in 1922 by Alexander Rodchenko and Aleksej Gan. Alfréd Kemény, who at the time lived in Moscow, provided the first information on this subject in an article written in 1922 for the Viennese journal Egység (Unity). László Moholy-Nagy in the same year wrote the "Dynamische-Konstruktivitische Kraftsystem" (Dynamic Constructivist Energy System) manifesto, conceived in

the constructivist spirit, for the avant-garde Berlin review *Der Sturm* (The Storm). From 1919 to 1939 the Hungarian modernists established close relationships with the German Bauhaus, the CIAM, and the Russian constructivists. As in Prague, in Budapest former close and privileged relationships with Vienna gave way to more open international interests and contacts.

Despite the overall unfavorable public climate, a pioneering, modern, experimental individual house exhibition was organized and built in Budapest in 1933 in the spirit of the earlier German, Austrian, and Czechoslovakian Werkbund housing exhibitions. Many remarkable designers participated, among them modernists such as Farkas Molnár and József Fischer, designers of many excellent modern houses mostly located in Budapest's lovely Buda Hills residential district. Molnár studied at the Bauhaus from 1921 to 1925. After returning to Hungary in 1927, Molnár represented Hungary at the CIAM sessions and maintained close relationships with the international, (particularly German) avant-garde. Alfréd Forbát acquired considerable functionalist experience by working for Walter Gropius from 1920 to 1922. Forbát also worked for Hannes Meyer and went with him to the Soviet Union as a part of the Bauhaus "Red Brigade." Forbát designed a residential block in Berlin's famous Siemenstadt housing development. He returned from the Soviet Union in 1933 to set up an architectural practice in Pest, where he built several interesting buildings. The Bauhaus also attracted many Hungarian teachers, among them Marcel Breuer. Breuer studied at the Bauhaus between 1920 and 1925, and in 1925 was put in charge of the furniture design studio. He eventually became one of the century's most acclaimed furniture designers. In 1923, in the midst of ideological crises at the Bauhaus, Gropius asked László Moholy-Nagy to teach at the school. He replaced Johannes Itten and had a decisive influence on the future development of Bauhaus curriculum and its products. Breuer and Moholy-Nagy continued their remarkable careers in the United States, where they became successful and widely respected. Another Hungarian at the Bauhaus was Otti Berger, who began her studies there in 1927 and was put in charge of the textile design atelier in 1931. Hannes Meyer put Ernő Kállai in charge of the Bauhaus school review in 1928. Kállai later wrote about the legacy of the Meyer era and criticized Gropius's established "Bauhaus Style." Hungarian painter Vilmos Huszár was active in the Dutch De Stijl movement and wrote violent denunciations of the early "romantic" direction that the Bauhaus had followed under Itten. Given the small Hungarian architectural community, the international activities and accomplishments of Hungarian modernists were impressive, as were the products that they were able to achieve under often difficult conditions.

POLAND

One-and-a-half centuries after being partitioned among Russia, Prussia, and Austria-Hungary, Poland was

recreated by the 1919 Versailles treaty as a fairly large, independent state of diverse ethnic composition. Once again Poland became what was historically known as the kingdom (republic) of nations. Her population reached 33,823,000 in 1936: 69 percent Poles, 14 percent Jews, 14 percent other Slavs, and 3 percent Germans. Poland occupied 388,600 square kilometers and was the sixth largest European state. Its frontiers resulted from often politically motivated Versailles treaty decisions, producing such political anomalies as the infamous Pomeranian corridor, which gave Poland a narrow access to the Baltic Sea. At the same time it cut off East Prussia from Germany, resulting in the 1939 conflict between Germany and Poland and consequently in the Second World War. The Polish situation was further complicated by Polish military actions aimed at correcting Versailes treaty decisions. The annexation of a portion of Lithuania, the 1922 war against the Soviet Union that resulted in the absorption of a portion of former Polish Ukraine, and the armed uprising in Upper Silesia, which forced Western authorities to award Poland this particular territory, all created an unfavorable diplomatic climate for Poland in Europe. As a result of her actions Poland ended up having frontiers with the Soviet Union, East Prussia, Czechoslovakia, Lithuania, Latvia, Rumania, Germany, Hungary, and the free city of Danzig.

The twenty years of independent Poland's internal politics were also turbulent and often dramatic. The first seven years were democratic, with several elected, politically moderate governments succeeding one another. The democracy was replaced in 1927 via a coup d'etat by Marshall Józef Piłsudski's government, which introduced a centralized and moderately dictatorial leadership. The marshall believed that under democratic rule Poland had become ungovernable. Poland, he felt, needed political and economic stability and military strength to survive. In his opinion, only a strong centralized government could meet such demands. Piłsudski's death in 1935 was followed by governments of his closest associates, some of whom were former army colonels. They enforced conservative policies that dominated Poland until the eruption of the 1939 Polish-German armed conflict. Poland emerged from 150 years of foreign domination and the First World War ruined by foreign economic exploitation and military invasions. A nation with a small, educated middle class and an extremely weak infrastructure and industry, Poland was also badly ridden with poverty and catastrophic health problems. The First World War, fought mostly on French and Polish territories, resulted in hundreds of thousands of Polish casualties and destroyed cities, towns, and the national infrastructure. In addition, ethnic tensions partially inherited from the occupying powers were acute.

As a result of forced partitions, Poland had at the moment of her 1919 independence three drastically

different economic and cultural zones. The former Russian zone, which included such cities as Warsaw, Łódź, Radom, Lublin, and Wilno, was backward, provincial, conservative, and poverty-ridden. This zone had almost no industry, with the notable exception of Łódź (the "Polish Manchester"), a world-renowned wool center of 639,000 inhabitants. The middle class of this province was weak; the ethnic composition complex and full of potential conflicts. As in Hungary and Czechoslovakia, the Jewish minority controlled much of the commerce and industry in Poland. Jews also dominated such professions as medicine and law. The Jewish professional middle class was particularly active and influential in Warsaw, Łódź, Lublin, Lwów, Wilno, and Bielsko. Along with Vienna, Warsaw represented the largest urban concentration of Jews in Europe. Given the professional and financial weakness of the Polish middle class, this led to frequent outbursts of anti-Semitism that eventually generated special laws restricting Jewish access to higher education. Many elite architects concerned with the development of architectural functionalism and modern art were Jewish, and many clients responsible for building modern villas and apartment buildings were also Jewish. Warsaw, the capital of Poland that eventually encompassed 1,125,000 people, was far removed from Moscow, Berlin, Vienna, and Paris. Nonetheless, the city developed cosmopolitan, diverse interests and connections and became the center of the Polish avant-garde in architecture and the arts.

The former western Prussian occupation zone, with the city of Poznań as its metropolitan center, counted 260,000 inhabitants and was untouched by the First World War. It was relatively prosperous and educated; subsequently it became known as the province of high organizational skills and rationality.

The southern provinces, which once belonged to Austria-Hungary, had two beautiful, historic cities, Kraków and Lwów, as centers. The first counted 238,000 and the second 316,000 inhabitants. The southern regions developed strong cultural and economic ties with Vienna, the capital of the Austro-Hungarian Empire, which strongly influenced Kraków and Lwów. Warsaw, because of its geographic isolation and inherent opposition to Russian interference, developed multiple international interests ranging from cubism to functionalism to constructivism to neoclassicism as well as a national vernacular, whereas Kraków and Lwów's intellectual interests were more conservative and regional. The southern region was also particularly rich in colorful vernacular architecture and art, which led architects and artists to pay more attention to the national heritage than to the international arena. Silesia, which was awarded to Poland in 1922 as a result of a military coup, was the country's most industrialized province. Joining Poland, Silesia was abruptly cut off from its organic partner

and Western neighbor, Lower Silesia. Silesia thus became partially economically crippled. Much of the skilled German labor departed, and the Polish population, which lacked sophisticated professional skills, found itself without skilled management. In addition, the major towns of this region, such as Katowice, Bytom, and Bielsko, had no important educational facilities. Thus the Polish central authorities were forced to organize the province's administrative, economic, and social structure and were often compelled to improvise.

It is thus not surprising that Polish modern architecture showed broad interests and ambitions primarily associated with replanning old cities, planning new communities with various forms of large-scale affordable housing, and addressing other public needs. Given the urgent social problems, Polish architectural modernism took public interest to heart from the very beginning. Polish modernists often addressed public health via hygienic architecture. Yet lacking the vigorous nineteenth-century industrial traditions that in other advanced European countries contributed to the emergence of modern architecture, Polish architects and planners were forced to rely on foreign experience in an effort to update design and construction techniques. In town planning, the Poles turned to English garden cities and suburbs. The Warsaw Hygienic Society became the center of activities for the propagation of hygienic awareness. Dr. Władysław Dobrzyński, at one time Ebenezer Howard's collaborator

and co-organizer of the International Association of Garden Cities, was the pivotal figure in this society and pioneered the idea of housing cooperatives in Poland based on English-German models. The German experience in this domain was known in Poland, particularly Hermann Muthesius's contributions to the spread of the English-inspired garden city to continental Europe. The first fruit of this influence, the Hellerau workers' colony in Dresden of 1905, had a significant impact on the early Polish planned settlements. In 1922 architect Henryk Stifelman partially realized the workers' and employees' housing for the Starachowice industrial complex in a similar spirit. The Polish Manor Style, which he applied to this development, corresponded to the English and German cottage style of Hellerau. Tadeusz Tołowinski's 1923 competition entry for the Ząbki garden city east of Warsaw represents a similar approach; a large garden-city suburb of Kraków, built in the 1920s for the Officer's Cooperative, was also carried out in the national style. The architects responsible for the 1920s portion of this settlement—Alfred Kamarski, Kazimierz Kulczyński, and Józef Karwat—preferred a romantic language reminiscent of German and English projects.

French ideas about hygienic architecture, championed by Henri Sauvage, and the French garden-city planning of the 1920s were also followed with interest in Poland. Holland, the mother country of functionalism, attracted keen Polish attention from the very

beginning. The Poles were aware that as early as 1901 the Dutch parliament ordered that all building construction be under state control. This unified Dutch efforts in planning and in large-scale building. The massive Amsterdam and Rotterdam housing developments could not have been built without government sponsorship. The evolution from eclecticism to modernism was achieved here faster than in any other European country, and Dutch modernism influenced Europe. In consequence, many early Polish planning propositions included a mixture of English, German, Dutch, and French influences. The 1928 housing development for the district of Bielany in Warsaw by C. Rudnicki and F. Klein combines Beaux-Arts formalism and a large functionalist block system. Stanisław Filipkowski and Stefan Siennicki's regulatory plan for the city of Radom of 1925, where the attempt to reinforce urban density is mixed with modernist large-block mentality, is another good example of such complex influences, as is M. Ochnio's 1936 regulatory plan for the town of Ciechanów, northeast of Warsaw. The 1920s generated many regulatory development plans for major Polish towns, which culminated in the great modernist undertaking: the Warsaw Plan of 1932.

However, gradually and unavoidably the Polish approach to urbanism moved away from the English and German picturesque and French formality toward Dutch and German functionalism. Among many examples of this new approach, the garden suburb of Kraków, called Cichy Kącik, built during the late 1930s for the Saving Institution of Kraków, is particularly accomplished. Planned and designed by architect Wacław Nowakowski, it demonstrates how far the integration of functionalist planning and functionalist architectonic ideas progressed in Poland.

The importation of foreign planning and architectural ideas to Poland had been greatly facilitated by the fact that because there were no schools to study architecture in partitioned Poland, Poland's future architects and planners had to undertake their studies abroad, mainly in Russia, Austria, Germany, Italy, and France. The most prominent Polish planner, Tadeusz Tołowinski, studied in Karlsruhe, Germany, while prominent members of the Polish functionalist avant-garde such as Stanisław Brukalski, Bohdan Lachert, Szymon Syrkus, Romuald Gutt, Bohdan Pniewski, and Edgar Norwerth studied in Darmstadt, Milan, Vienna, Graz, Winterhur, St. Petersburg, Moscow, and Paris. These individuals transplanted the latest ideas in planning and architecture to a generally fertile ground. This was particularly so throughout the 1930s, when architecture was seen as an important agent of the ambitious state-controlled public developments.

Polish participation in the CIAM and other international organizations and competitions also ensured a steady flow of up-to-date information to Poland. The Bauhaus became so known and respected in Poland that it attracted several Poles. Among them was Max Krajewski, who studied metalworking. He was eventually responsible

for the construction of Gropius's Törten estates in Dessau and of the new suburb of Dammerstock in Karlsruhe. Sharon Arieh studied with Hannes Meyer, and Jan Weinfeld distinguished himself in the field of experimental theater and public exhibits at the Bauhaus.

Polish architects, because of their considerable travels, were able to transfer much information from abroad. Piotr Łubinski described the evolution of Dutch architecture in the Polish architectural magazine *Architektura i Budownictwo* (Architecture and Construction), which helped to popularize Dutch ideas in Poland. Young modernists Stanisław and Barbara Brukalski visited Holland, where they were so impressed with Gerrit Rietveld's design for the Schröder House in Utrecht that they designed their own house in Warsaw in the spirit of the Dutch master. The Dutch influence was particularly associated with the housing built by J. J. P. Oud, which was often echoed in the buildings sponsored by the Warsaw Housing Cooperative. The architecture of Willem Dudok, especially his town hall in Hilversum, also influenced Poland.

Weimar Germany had powerful and aggressive industrial traditions and strongly developed social policies. Its dynamic building activities attracted the attention of Polish architects and planners. Bauhaus educational goals and German planning techniques and accomplishments in constructing economic housing were carefully studied in Poland. The German Werkbund housing experiments, carried out in 1927 in Stuttgart, in 1929 in Frankfurt and Breslau, and in 1930 in Berlin, were visited and described by such architectural writers and architects as Alfred Lauterbach, Teodor Toeplitz, and Edgar Norwerth. The 1927 Greater Warsaw Zoning Plan was often compared to a similar plan carried out for Berlin in 1925. The German desire to abandon the nineteenth-century dense block configuration because of growing congestion found a following among Warsaw planners. The works of Otto Haesler, Bruno Taut, and Walter Gropius (whom the leading Polish modernist, Szymon Syrkus, described in glowing terms) were critically evaluated in Poland. This quickly led to the adaptation of characteristic German "finger plan" schemes, large open-block systems (which allowed large amounts of greenery and light), single and optimal orientation of buildings, separation of vehicular from pedestrian traffic, modular structural coordination, and maximum economy in apartment layouts. Polish planners, architects, and building specialists visited the German *Siedlungs* in Magdeburg, Berlin, Leipzig, Dresden, Breslau, and Frankfurt and reported on their findings.

American experiments carried out by such planners as Clarence Perry in the domain of "neighborhood units" also influenced the development of Polish modern architecture. Austrian architecture was mainly known thanks to the writings and works of Adolf Loos. Two distinguished Polish modernists, Władysław Szwarncenberg-Czerny and Romuald Gutt, studied with Loos in Vienna and helped to

popularize his ideas in their native professional milieu. The Viennese expressionism popular in 1920s and demonstrated in the architecture of the "Red Vienna" monumental housing constructions also influenced Polish architecture, particularly in cities such as Kraków.

In part, the French influence reflected Beaux-Arts and neoclassical architecture. Major government commissions for ministries, banks, museums, and churches carried out by architect-academicians such as Adolf Szyszko-Bohusz in Kraków, and Marian Lalewicz in Warsaw show such lineage. Many stripped-down neoclassical buildings dating from the second half of the 1930s, which correspond to Italian fascism, can be also traced to French designs such as the Museum of Modern Art in Paris and the Palais Chaillot complex. The architecture of Auguste Perret was also carefully studied in Poland, particularly because it revealed a challenging combination of modern building materials and classical design. The modernist French influence centered on the writings and works of Le Corbusier, whom many Polish architects adored and considered, as did Szymon Syrkus, a genius. The influence of Le Corbusier on Polish architecture was such that even after 1934, when modern architecture was under attack all over Europe and Le Corbusier was often singled out as the chief villain, the Polish modernists did not change their extremely favorable view of him. Le Corbusier was seen by the Polish avant-garde as the revolu-

tionary and anti-bourgeois fighter, a view that corresponded well to the Poles' leftist politics. The work of two other leading French modernists, Robert Mallet-Stevens and André Lurçat, was also known and respected in Poland.

The Polish connection to Soviet architecture was more complex than its relationship with Western Europe. Political relationships with the Soviet Union, considered a major threat to Polish independence, were strained. Moreover, Polish architects who studied in Russia represented three clashing orientations: one, the search for national expression stimulated by vernacular traditions of Russia and Poland as represented, for instance, by Stanisław Noakowski, who studied in St. Petersburg; two, the Beaux-Arts influence, represented by academicians such as Adolf Szyszko-Bohusz and Marian Lalewicz, who studied at St. Petersburg's Academy of Fine Arts; and three, modernism favored by architects such as Edgar Norwerth, who studied at the Institute of Civil Engineers in St. Petersburg and practiced architecture in Moscow. Norwerth, after his return to Poland, wrote about Russian industrial architecture and warned against simplistic interpretations of modernist architecture in Russia as sole representatives of political Bolshevism. He pointed out that modern architecture was practiced all over Europe, although he recognized that in the Soviet Union constructivism took its ideals to typically Russian, extremist points of view. Norwerth was impressed with Russian industrial buildings, some of which

he helped to build during his stay in Moscow. He mentioned a proposal in Moscow to call the graduates of the Department of Architecture "artists-engineers." He condemned, however, any attempt to create a romantic cult around factory constructions, which he accused many contemporary functionalists of doing.

The influence of the Russian constructivist avant-garde was very strong in Poland. The abstract painter Władysław Strzemiński, who was Kasimir Malevich's assistant in Moscow, influenced many of his architect friends, including Bohdan Lachert, Stanisław Brukalski, and Szymon Syrkus, after his return from Russia. Malevich, Polish by birth, returning from his lecture trip to Germany, stopped in Warsaw, where he met the members of the avant-garde organization Praesens. He also published an article entitled "l'Univers conçu sans objet" ("The universe created without object") in the group's magazine. The theoretical disputes conducted by the Russian constructivists were well-known in Poland. Information about Russian developments in architecture was also provided by such well-informed writers as Leonard Tomaszewski. Tomaszewski visited the Soviet Union in 1937 and wrote about the Soviet attempts to redistribute the population around new industrial centers, as well as about the conceptual ideas associated with planning new towns. He described the antiurban attitudes of architects such as Moisei Ginzburg, who saw no need to bring one hundred million peasants to Russian cities.

Tomaszewski interpreted antiurban attitudes on the part of some Russian constructivists as a fear that a massive movement of peasants to the cities would weaken the urban middle class. He also cited the literary and often unrealistic quality of Russian constructivism and understood why the Russian authorities called on German specialists such as Bruno Taut and Ernst May for help. Another modernist, Romuald Miller, who studied at the Institute of Civil Engineers in St. Petersburg, became the editor of *Architektura i Budownictwo.* Miller wrote several essays on modern architecture including the Russian perspective. In his 1933 article "Do Źródeł Plastyki i Architektury" ("Sources of Plastic Arts and Architecture") he argued that the progress achieved in modern technology was sufficient reason for modern architecture to exist. Architects could translate the machine with its own logic into a new and powerful aesthetic. At the time of the collapse of Russian modernism in 1933, he thundered against eclectics, imitators, and traditionalists.

In summary, during their approximately twenty years of national independence following the First World War, Czechoslovakia and, in particular, Hungary and Poland emerged from positions of considerable political and socioeconomic disadvantage to rebuilt their shattered economies, infrastructures, schools, and national institutions. Despite tempestuous, often violent and painful beginnings, there is little doubt that these countries generated the most sophisticated modern archi-

tectural culture in Europe after the collapse of modern architecture in Germany. Fortunately, most functionalist architecture survived the destruction of the Second World War, and although many functionalist buildings are not in ideal condition after four decades of neglect under communism, they remind us of an epoch rich in design talent and accomplishments.

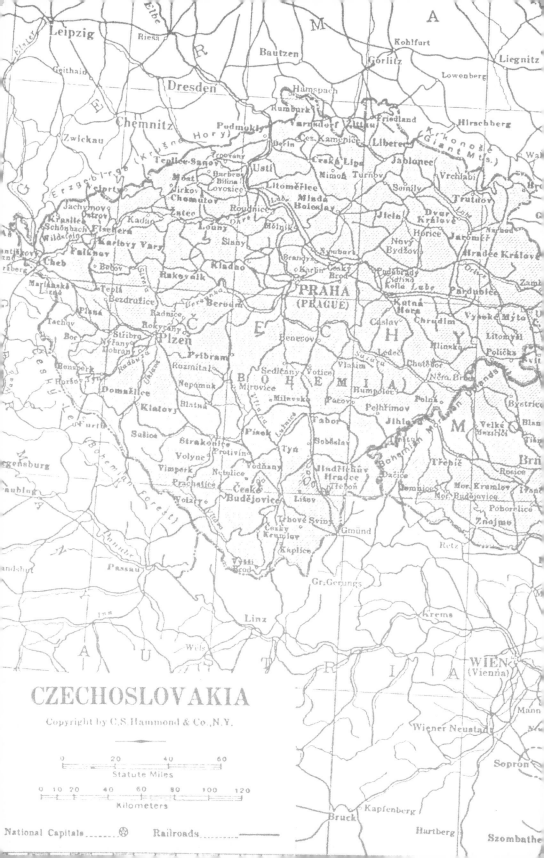

CZECHOSLOVAKIA

Statute Miles

Kilometers

National Capitals ⊕ Railroads

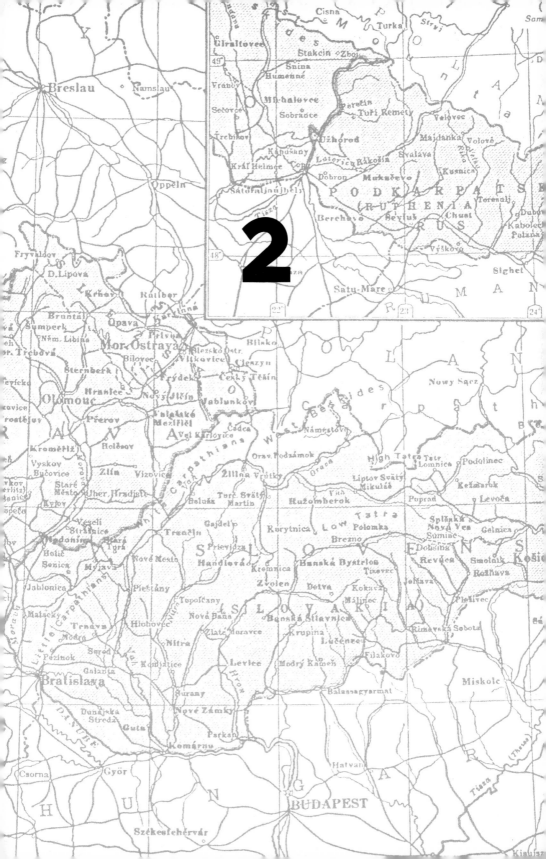

COMPETING IDEAS IN CZECHOSLOVAKIAN ARCHITECTURE

VLADIMÍR ŠLAPETA

Although the most important trend in Czechoslovakia's architecture between the two world wars was functionalism, buildings and urban units of traditional conservative character were also constructed at that time, particularly in the 1920s. Among other things, the new state needed an image of strength, representing the nation through its public buildings and complexes. Moreover, mature architects who had studied in Vienna and had much experience during the prewar era and sought inspiration in the legacy of the past were charged with such tasks. The style of important government buildings from the early 1920s differs from that of the buildings designed in the late 1920s when the younger generation of functionalist architects and clients, who identified with the spirit of the international style, prevailed.

The 1880s saw the birth of cubist architects such as Josef Gočár, Pavel Janák, and Otakar Novotný, who tried to develop in the early 1920s what was called rondocubism to symbolize the new Czechoslovak state. They amalgamated the legacy of cubist plasticity and Slav traditions. In this style Gočár designed the Czechoslovak Legion Bank (Prague, 1921–23), whose street facade was abundantly decorated with quadratic, circular, and cylindrical elements, with sculptures by outstanding Czech sculptors, a frieze representing marching legionnaires by Otto Gutfreund, and caryatids representing heads of soldiers by Jan Štursa (figs. 2.1, 2.2). Janák, in cooperation with Josef Zasche, a German architect living in Prague, in the Riunione Adriatica di Sicurta (1922–24) applied architectural and sculptural decoration more inspired by early Italian Renaissance than by local cubist and Slav traditions. The "National Style," alias rondocubism, was applied in Prague also in the reconstruction of Brno Bank in the New Town of Prague with a dynamically accented corner by Gočár, in the apartment house in Letná Square by Novotný (1921), in Rudolf Stockar's department store (1920), and in the municipal blocks with small flats in Holešovice and Dejvice districts. The orientation toward the social task of architecture, particularly housing and town planning as postulated by Janák in his theoretical works of the early 1920s, can best be seen in the plan of Hradec Králové, East Bohemia. After Jan Kotěra's death Gočár

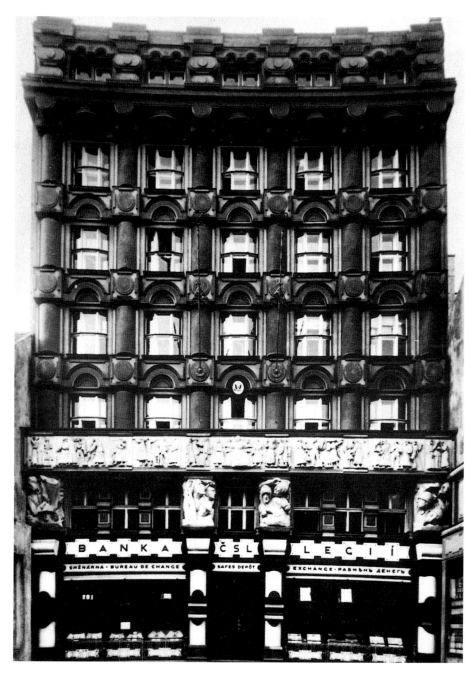

2.1. Josef Gočár. Czechoslovak Legion Bank. Prague, 1921–23.

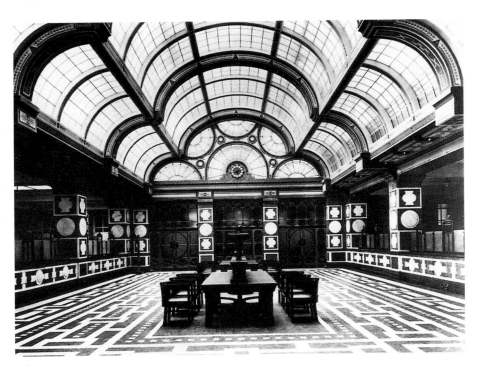

2.2. Josef Gočár. Czechoslovak Legion Bank. Prague, 1921–23.

took over as adviser to the mayor, František Ulrych, and with his work gave new, modern shapes to the town (figs. 2.3, 2.4). After winning the 1922 master-plan competition Gočár proposed to expand Hradec Králové to the other side of the Labe (Elbe) River, with a new administration center, a school complex, and a housing estate conceived in the National Style spirit or—later on—in the spirit of Dutch brick-based architecture and functionalism (fig. 2.5). Gočár's Anglo-Czechoslovak banks in Pardubice and Ostrava were also designed in the National Style. Janák, on the other hand, closed the development of rondocubism with his monumental, Slav-inspired crematorium in Pardubice (1923) (fig. 2.6). Soon after that, particularly after the visit and lectures of the Dutch architect H. P. Berlage and the Belgian architect Henry Van de Velde in Prague, Janák, Gočár, Novotný, and others concentrated on brick-based architecture and only after 1925 embraced white functionalism.

Also influential in the early 1920s was the English garden-city style, which had penetrated the Czech lands shortly after 1910 through the traveling exhibition of "Karlsruher Gartenstadtgesellschaft" (Karlsruhe Garden City Society), the sojourn of several Czech architects (Jaroslav Stockar, Vilém Dvořák) in England in the early 1920s, and the lectures of Hans Kampffmeyer and Raymond Unwin, as well as the 1924 Czech edition of Ebenezer Howard's *Garden Cities of Tomorrow.* However, most of the garden cities built in Czechoslovakia at that time featured single-family houses for middle and upper clerical classes, as in Ořechovka, a garden city in Prague built to the master plan by Jaroslav Vondrák.

From the beginning of the Czech Republic the designs for the new government ministries and agencies in the capital were

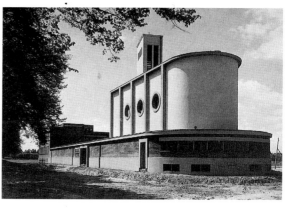

2.3. *Josef Gočár. Ambrosius Choir. Hradec Králové, 1926–27.*

sought through competitions such as that for the development of Petrská District. In the late 1920s monumental ministry buildings designed by Otto Wagner's pupils were constructed on the Vltava River embankment, namely the Ministry of Transport by Antonín Engel and the Ministry of Agriculture by František Roith. Another large complex of ministries was designed and built by Bohumil Hypsman, also Otto Wagner's pupil, on a site under the Emmaus Monastery, where the architect with an articulated symmetrical composition created an elegant pedestal for the Gothic towers of the monastery. Another important

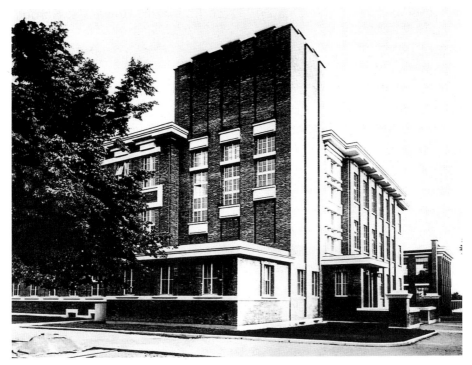

2.4. Josef Gočár. High School. Hradec Králové, 1924.

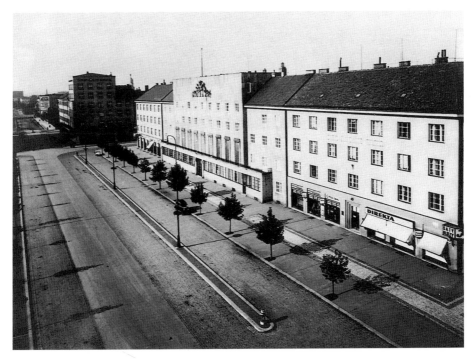

2.5. Josef Gočár. Ulrych Square. Hradec Králové. 1924–30.

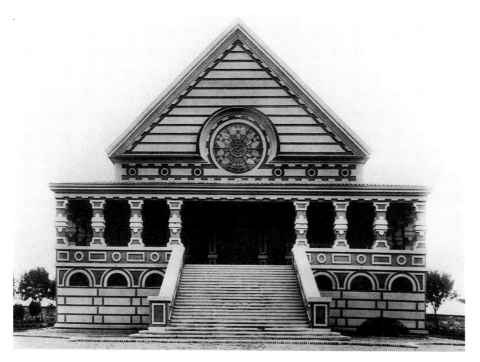

2.6. *Pavel Janák. Crematorium. Pardubice, 1921–23.*

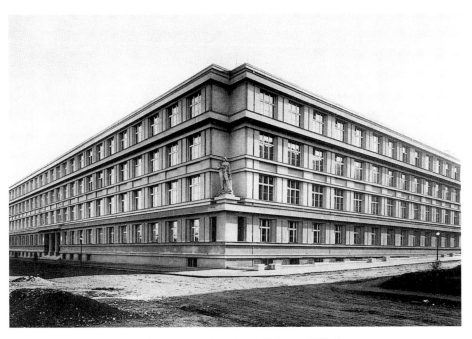

2.7. Bedřich Feuerstein. Military Geographic Institute. Prague-Bubenec. 1921–22.

administrative building, the Workers' Accident Insurance Company (now the Ministry of Economy) was built in 1924–29 to the winning design by Friedrich Ohmann's pupil Jaroslav Rössler.

Two other significant buildings should be mentioned: the Military Geographic Institute, built in Prague-Bubenec in 1921–22 by Bedřich Fuerstein (fig. 2.7), and the Czechoslovak Pavilion at the Exposition Internationale des Arts Décoratifs et Industriels Modernes in Paris of 1925, by Josef Gočár (fig. 2.8). The first represented a heavily modernized and simplified version of monumental classicism that was applied to many government buildings in Central Europe, while the other was an attempt to use the modern language of architecture, a language unfortunately compromised by too many references to romantic and picturesque sources.

Two new buildings for Charles University in the Old Town of Prague were also designed in the academic style. The Faculty of Law was based on Jan Kotěra's original project; however, after his death in 1923 it was reworked and simplified by his old colleague Ladislav Machoň. According to Kotěra's master plan, a symmetrical composition of two opposite buildings, the Faculty of Law and the Theological Faculty, was planned in the area of Čech Bridge. For the Faculty of Law, Machoň created a top-lit, full-height monumental central hall. The Theological Faculty project was never realized, while the Faculty of Philosophy, next to the Rudolfinum Concert Hall, was designed in 1925–29 by Josef Sakař in the conservative academic neo-Renaissance style.

Wagner's pupil František Roith constructed three additional, important monumental buildings next to the Ministry of Agriculture. After winning the 1924 competition he designed the Czech Savings Bank building in Wenceslas Square with a refined granite facade and beau-

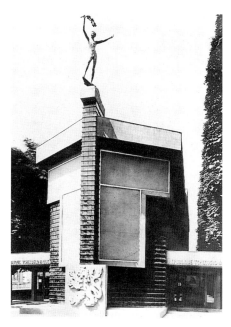

2.8. Josef Gočár. Czechoslovak Pavilion. Exposition Internationale des Arts Décoratifs et Industriels Modernes, Paris, 1925.

tiful details in the art deco spirit. In 1925–30, after winning another competition, he designed for Mariánské Square in the Old Town, next to the Klementinum Jesuit College and the baroque Clam-Gallas Palace by Johann Bernhard Fischer von Erlach, the symmetrical Municipal Library, inspired by Italian models and harmonically completing the historic context (fig. 2.9). The third was a winning competition project for Živnostenská

Banka on Na Příkopě street at the Powder Tower, where Roith gave an imaginative modern interpretation of the details of Wagner's Postal Savings Bank in Vienna, successfully integrating monumentalism and modernism.

The most important urban development between the two world wars was the construction of Dejvice District in Prague's West End. The master plan was by Antonín Engel, Wagner's pupil and later rector of the Czech Technical University in Prague. His 1921 concept of

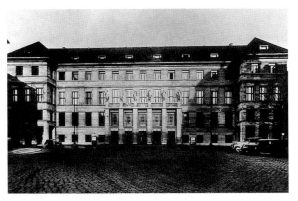

2.9. František Roith. Municipal Library. Prague, 1925–30.

development for the Dejvice basin contains a central U-shaped Victory Square with a circular junction of three radial wide roads. The facades of the square as well as that of the nearby university campus, designed in the academic style by Engel, were built in the early 1930s.

In a similar spirit Engel conceived the Municipal Waterworks in Prague-Podolí built in 1923–27 (fig. 2.10). The colossal row of columns in front of the facade hides a bold concrete structure and an impressive interior whose modern concept is reminiscent of Auguste Perret's work. The last important monumental building in Prague is the Stock Exchange next to the National Museum, designed by Jaroslav Rössler and winner of a 1935 competition.

Outside Prague, the unfinished fragment of Academy Square in Brno started construction in 1925 to the winning master plan by Friedrich Ohmann's Prague pupil Alois Dryák for the monumental Faculty of Law building. Some of Arnošt Wiesner's works, reminiscent of ancient architecture, such as the city crematorium in Brno of 1925 conceived in the form of Mesopotamian ziggurat (figs. 2.11, 2.12), are equally monumental and traditional.

Architect Emil Belluš proved capable of combining modernism and traditionalism in Slovakia, both in his early work such as National House, Banská Bystrica, of 1925 and in his fully developed style at the turn of the 1930s and 1940s which culminated in the monumental National Bank in Bratislava. Another architect whose work demonstrates similar complex influences was Dušan Jurkovič. Jurkovič was known at the beginning of the century as an architect of a very original Jugendstil style, mixing experience with the British Arts and Crafts movement and Vienna's Jugendstil with inspiration from Moravian and Slovak folk architecture (the Pustevny and Mamenka dormitories in Pustevny, Beskydy Mountains, 1899; the spa building in Hacovice; the Cottage

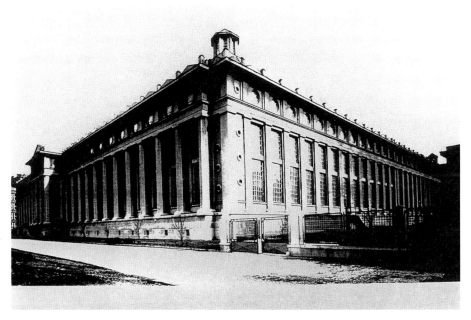

2.10. Antonín Engel. Municipal Waterworks. Prague-Podolí 1923–27.

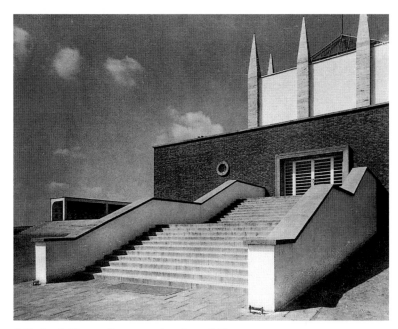

2.11. Arnošt Wiesner. City crematorium. Brno, 1925.

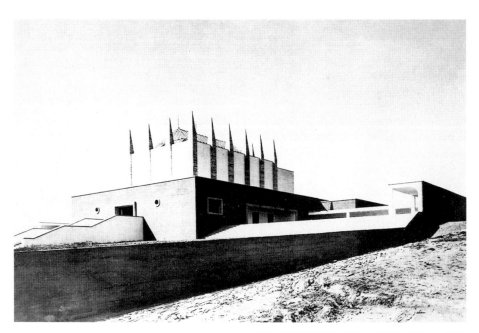

2.12. Arnošt Wiesner. City crematorium. Brno, 1925.

House at Rezek; the Cultural House at Skalica; his own house in Brno; and Villa Nahlovcky in Prague). During World War I, in his design of the romantic Soldier's Cemeteries in Gallizien, Jurkovič had an opportunity to develop monumental architecture. His General Štefánik memorial on Bradlo Hill (1928) is a poetic transcription of the ziggurat principle in the romantic Carpathian countryside for the Slovak hero of World War I and the Slovak liberation.

However, the most important architect to apply monumental and classical concepts in Prague was Wagner's pupil Josef Plečnik of Slovenia. Plečnik came to Prague in 1911 when Franz Ferdinand d'Este, successor to the throne of Austria-Hungary, prevented him from taking over Wagner's position at the Academy of Fine Arts in Vienna. Jan Kotěra, Plečnik's schoolmate and friend in Wagner's school, called him to Prague in order to establish a school of architecture at the Academy of Fine Arts. Thus, another important architect appeared in the city: besides Kotěra, a modern master, rational and cosmopolitan, there was now Plečnik, a deeply religious, ascetic, and ludicrous man. "It is clear to everybody that the new professor places all his life in the school and sacrifices his happiness," remembered Josef Štěpánek. "The atmosphere of religion, the deep Catholic passion for dark chapels and niches, the submission to mysticism and to the topographic beauty of the Latin language—this was the mental bath of his students." Kotěra was liberal in his educational work and tolerated different ways of searching, while Plečnik's teaching was rigid, even doctrinaire. Profane motifs were put aside in favor of monumental, sacral, and funeral themes, which were treated in the classical spirit. Kotěra's pupil and biographer Otakar Novotný later wrote:

> Plečnik helps his students with direct interventions in their work; as a result, they grow lazy in their ideas. Therefore this teaching method does not leave permanent traces, and as the time goes his students abandon even the little of Plečnik's greatness that they were able to understand and rather follow Kotěra's way than that of their immediate teacher who, in spite of that, gave them good foundations of conceptual generosity, cultivated their sense of detail and their taste in expressing their ideas. However, because all this was separated from the contemporary taste and failed to have a right, living content, we can only say that the great artist [Plečnik] was but an episodist in the history of Czech architecture.

Despite such criticism many of Plečnik's pupils made good careers. Otto Rothmayer helped his teacher and later followed him in his reconstruction work on the Prague Castle; Alois Mezera designed the city crematorium in Prague (1925–29) (figs. 2.13, 2.14) and the Czechoslovak embassies in Berlin, Belgrade, Warsaw, and Ankara; Hubert Aust designed the monumental Czechoslovak Church and the Memorial of Yugoslav Partisans in Olomouc; Alois Metelák specialized in glass design; Karel Štipl was a professor of decorative sculpture, and finally Josef Fuchs,

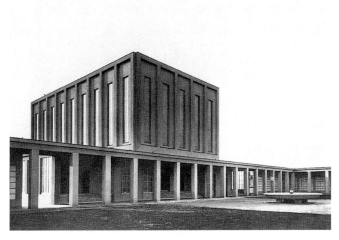

2.13. Alois Mezera. City crematorium. Prague, 1925–29.

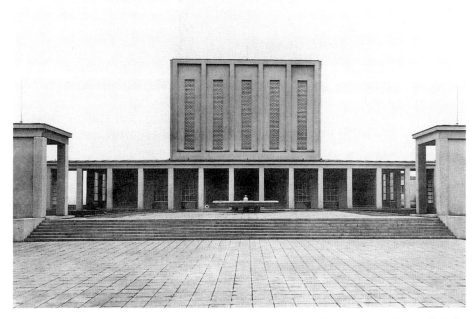

2.14. Alois Mezera. City crematorium. Prague, 1925–29.

Ludvík Hilgert, Karel Řepa, Josef Štěpánek, and Jindřich Merganc were top representatives of functional architecture.

However, Plečnik's greatest chance in Prague came after the emergence of the Czech Republic when, on Jan Kotěra's initiative, President Tomáš Garrigue Masaryk invited him to reconstruct the Prague Castle as a presidential seat. Plečnik interpreted in a new and quite individual way the genius loci of this historic architectural complex (figs. 2.15, 2.16, 2.17, 2.18, 2.19). He rebuilt the courtyards, terraces, gardens, and secluded spots by giving them order, monumentality, and, on the other hand, an atmosphere of intimacy and contemplation in the Mediterranean sense of the word: an architecture of memory. The classical ancient order, corresponding to Masaryk's concept of modern democratic society, is amalgamated here with an original Slav warmth.

Plečnik's last work in Prague was the Church of Jesus' Sacred Heart in Vinohrady District (fig. 2.20). During the 1919 competition for the church most of the outstanding Czech architects signed a petition asking the jury to charge Plečnik with the job, in recognition of his educational merits. After some hesitation Plečnik accepted and, from 1928 to 1933, built the church. The monumental structure, with a large nave covered with a coffered ceiling and a belfry stele with a clock reminiscent of a big monstrance dominating the whole composition, went beyond the trends of the period and stands in full contradiction to the two modern functionalist churches built at the same time

nearby: the Catholic church by Josef Gočár consecrated to St. Wenceslas and the Protestant (Czechoslovak) church by Pavel Janák.

Janák was aware of the contradiction between what Plečnik had made in the Prague Castle and in Vinohrady and what the Czech architects were striving for. He wrote in 1928:

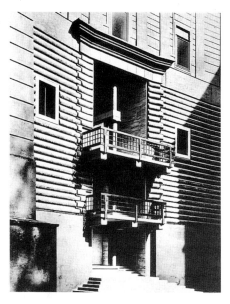

2.15. Josef Plečnik. Staircase from the third castle courtyard to the Rampart Garden. Prague Castle. Prague, 1929–31.

Down in the town it is a fight for how to think and how to build, how to find a unique and universal opinion which can be pushed through and supported against any other possibility, to make it not only generally accepted but also unquestionable. Up here [i.e., in the Castle] he is an artist who only builds seemingly without any doubt. The work here totally differs from the work down in the town: it follows a different, and also a personal line. Down in the

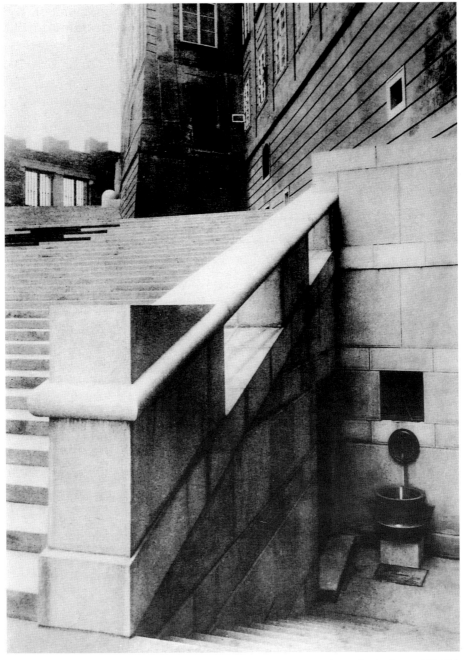

2.16. *Josef Plečnik. Staircase at Paradise Garden. Prague Castle. Prague, 1922–25.*

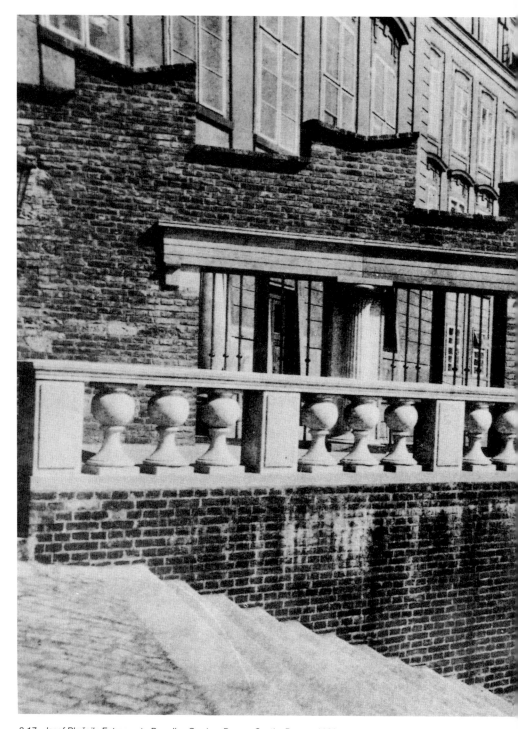

2.17. Josef Plečnik. Entrance to Paradise Garden. Prague Castle. Prague, 1922.

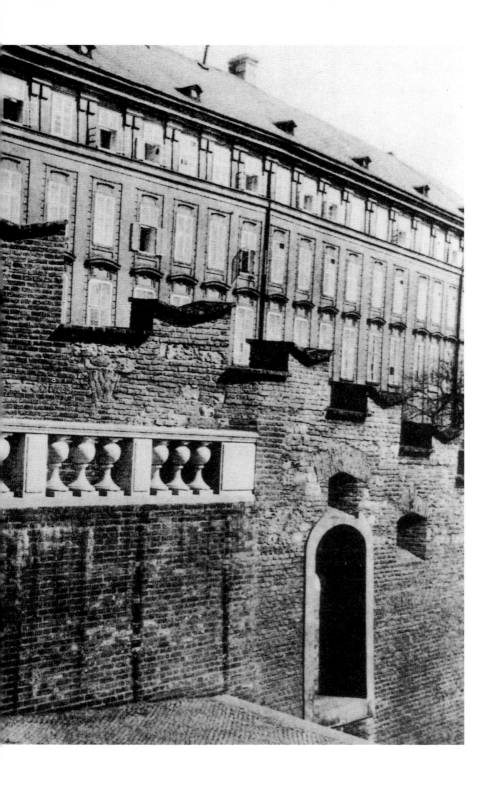

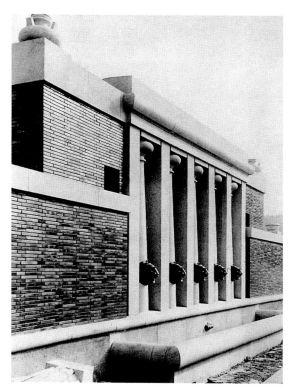

2.18. Josef Plečnik. Fountain at the park wall. Lany (Prague),
1929–30.

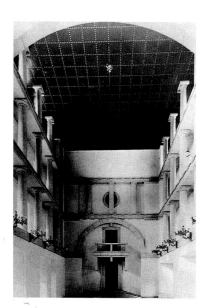

2.19. Josef Plečnik. "Plečnik Hall." Prague
Castle. Prague, 1928–30.

town he tries to find the most rational, the most favorable way of construction whereas here he seems to be a man who does not know the price of material and who specifically praises its rarity, as he uses the most expensive and the most refined building materials. Down in the town only the reasons of necessity are sought. This artist thinks of, and is fully preoccupied with, the size of columns. Down in the town we only hear: calculation, activity, organization, usefulness, profitability. Here it is a type of art which only displays humbleness, pure exultation.

Jaroslav Frágner, the team of František Čermák and Gustav Paul, and the Brno team of Jan Vísek, Jaroslav Grunt, and Vilém Zavřel. In turn Czech theorists and architectural historians redis-covered Plečnik in the 1980s in connection with a revision of modernism and with the Plečnik exhibition at the Centre Pompidou in Paris. Soon after, in December 1989, new president of the reborn republic Václav Havel entered the rooms reshaped by Plečnik. Havel committed himself to the demo-cratic traditions of his prewar predecessor, Tomáš Masaryk, who had in-vited Plečnik to recon-struct Prague Castle.

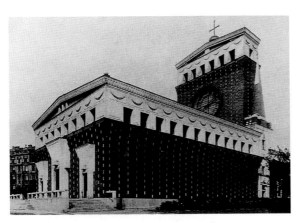

2.20. Josef Plečnik. Church of Jesus' Sacred Heart. Prague-Vinohrady, 1928–33.

In the 1930s the modern, func-tionalist trend was generally ac-cepted in Czech architecture, and Plečnik was for some time assigned a role of "episodist," as Otakar Novotný put it. In the late 1940s, however, in a competition for the Parliament building in Prague's Letná Square, all three winning proj-ects showed a surprising departure from functionalism of which Plečnik would have approved: monumen-tal, classical inspiration by former distinguished modernists such as

Dresden
Hamspach
Chemnitz
Rumburk
Podmokly
Varnsdorf Zittau Friedl
Krušné Hory
Verin Čes. Kamenice Liberec
Teplice-Šanov
Trnovany Česká Lípa Ja
Ústí
Most Duchcov Mimoň Turnov
Bílina
Jirkov Lovosice Litoměřice
Chomutov
Mladá
Žatec Roudnice Boleslav
Jičín
Ohře
Kadaň
Louny Mělník
chera
Slaný
arlovy Vary No
Byd
Kladno Nymburk
Brandýs
Rakovník Karlín Český
tov Brod Čudob
Bezdružice Beroun Č
Berounka
Radnice PRAHA Čáslav
Rokycany (PRAGUE) H
Stříbro Č
fany Plzeň E C Leded
obran
Příbram Benešov Sázava
Radbuza Vlašim
Úslava Rožmitál
Úhlava Votice
mmžlice Nepomuk B O H E M I A
Mirovice Humpolec
Milevsko Pacov
Klatovy Blatná
Pelhřima
Otava Tábor Jih
Sušice Písek Lužnice
Strakonice Soběslav
Protivín Týn
Volyně
Vimperk Vodňany Hluboká
Netolice Bol
Prachatice Třeboň Dačí
mian Vltava České Lišov
Wolary Budějovice
Forest Trhové Sviny
Český Gmünd
Krumlov

FUNCTIONALISM IN CZECHOSLOVAKIAN ARCHITECTURE

VLADIMÍR ŠLAPETA AND WOJCIECH LEŚNIKOWSKI

Czechoslovakian architecture held a special position in Europe between the two world wars. Czech and Slovak architects neither initiated avant-garde movements nor developed extreme theories like the Russian constructivists or the representatives of organic architecture in Germany. Yet the level of the Czech work, with many nuances in style, is remarkably high.

The high quality of the arts and architecture achieved during the brief two decades of what is now known as the First Republic cannot be explained by the mobilization of national forces and enthusiasm in the new-born state alone. Its roots go back before World War I and lie in the absorption of ideas coming from both the West and the East.

The history of modern architecture in Czechoslovakia dates from the turn of the century. In 1898 Jan Kotěra returned to Prague from his studies with Otto Wagner at Vienna's Academy of Fine Arts to become a professor at the School of Arts and Crafts, the chairman of the Mánes artists' group, and the editor in chief of the review *Volné Směry* (Free Directions). A leader of the young generation, Kotěra proclaimed the slogans "Open the windows toward Europe" and "Catch and overtake Europe" and changed the orientation of the Czech arts from Vienna toward more western centers of culture.

While inspiration for the fine arts came from Auguste Rodin and the Norwegian painter Edward Munch, who was exhibited in Czechoslovakia in 1902, for architecture it came from the top European architects and Frank Lloyd Wright, whose works were published in *Volné Směry*. Also of great importance were Kotěra's trips to the Netherlands and to England, which helped him develop his architecture from the Vienna Secession and the English Arts and Crafts to a rational architecture based on unplastered brickwork. This is exemplified in his City Museum of Hradec Králové (1906–12) with a free, asymmetrical ground plan, probably the first structure in Europe to apply Wright's ideas. Kotěra educated two generations of architects: first the cubist generation at the School of Arts and Crafts and later, from 1911 until his death in 1923, the functionalist generation at the Academy of Fine Arts, where a school of architecture was established.

About 1910 the members of a new generation of architects, including Pavel Janák, Josef Gočár, Josef Chochol, Vlastislav Hofman, and Otakar Novotný, were dissatisfied with the exaggerated rationalism of recent architecture and proclaimed a cubist program. In the spirit of Janák's critical review of Otto Wagner's rationalism, titled "From Modern Architecture to Architecture," they proposed to spiritualize architecture by means of sculptural surfaces expressively dramatizing the facade. They also attempted to convert Picasso's and Braque's two-dimensional painting into the three-dimensional vocabulary of architecture. Czech architecture successfully entered the international arena through exhibitions and articles published in the Berlin review *Der Sturm* (The Storm) and the gallery of the same name headed by Herwarth Walden and through participating in the 1914 Werkbund exhibition in Cologne. These contacts were interrupted by the outbreak of World War I.

After the revolution of October 28, 1918, which brought forth an independent Czechoslovakia, the international contacts intensified. Czechoslovakian architecture and arts were now drawn toward France (Auguste Perret and Le Corbusier), the Netherlands (Amsterdam and Rotterdam), and Germany (the Bauhaus) and toward the new ideas of Russian constructivism. All of these trends were largely publicized and discussed in the architectural reviews *Stavba* (Building), *Stavitel* (Builder), *Styl* (Style), and *Architekt SIA*.

The early 1920s saw three parallel currents of evolution toward an international style in Czech architecture. The first was represented by a group of architects, Jaromír Krejcar and "the Four Purists" (Jaroslav Frágner, Karel Honzík, Evžen Linhart, and Vít Obrtel), and members of the artists' association Devětsil headed by Karel Teige, who arranged international contacts. Owing to the connection with the critic Adolf Behne in Berlin, the group was represented at the First International Exhibition of New Architecture held at the Bauhaus in Weimar in 1923. Ex-cubists Josef Chochol and Bedřich Feuerstein, who had designed the Nymburk Crematorium, were regarded as doyens of the group.

The second group, mostly consisting of the second generation of Kotěra's pupils (including Bohuslav Fuchs, Josef Štěpánek, Kamil Roškot, and Adolf Benš), gathered around the review *Stavitel.* First they confronted the influence of rondocubism, then they joined the new architecture movement inspired by the Dutch tradition of unplastered brickwork masonry.

The third group, whose members graduated from the School of Architecture at the Czech Technical University in Prague (Oldřich Tyl, Oldřich Starý, Ludvík Kysela, František Albert Libra, etc.), formed the Club of Architects and published the review *Stavba*. These architects arrived at the International Style mainly through the constructive and technological aspects of architecture. The club organized a lecture series called "For New

Architecture" in the winter of 1924–25 in Prague and Brno featuring top architects like J. J. P. Oud, Walter Gropius, Amédée Ozenfant, Le Corbusier, and Adolf Loos. This event contributed to the triumph of the new style in Czechoslovakia.

Soon the first structures designed in the spirit of international

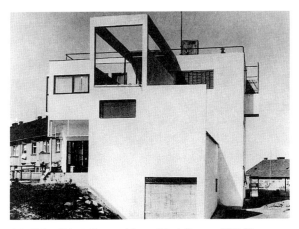

3.1. Evžen Linhart. House of the architect. Prague, 1927–29.

functionalism appeared. Jaromír Krejcar's Olympic department store, built in 1924–26 in Prague, represented one of the first reinforced-concrete skeletal structures in Czechoslovakia; together with Ludvík Kysela's Lindt department store of 1925 it was the first modern department store in downtown Prague. In 1927–29 Evžen Linhart built the first villa in the capital inspired by Le Corbusier—his own house (figs. 3.1). The architecture of this remarkable house was unusually advanced compared to the general state of architecture in the country at that time: it had an L-shaped plan, a reinforced-concrete skeleton, two major roof terraces, and a ramp connecting two levels of the living room. These structures signaled that the

young Czech intelligentsia and the young bourgeoisie had started to identify with the spirit of the new style of life and architecture, moving away from Austro-Hungarian inspiration toward France and the West.

Whereas in Germany new architecture appeared mostly in the new neighborhoods of Berlin, Frankfurt, Karlsruhe, Hamburg and other regions strongly influenced by Social Democrats, and in France Le Corbusier and Robert Mallet-Stevens were constructing houses for members of the cultural nobility such as Madame Stein and Dr. Blanche, the clients of Czechoslovak modern architects were members of the young middle class. For creative inspiration these Czechoslovak clients often looked to renowned foreign architects who were then invited to design and build new houses and commercial buildings. Among them was Adolf Loos, who in 1928–30 built the Müller House in Prague (fig. 3.2), and Ludwig Mies van der Rohe, who built the world-famous Tugendhat House in Brno in 1929–30 (fig. 3.3). Due to these foreign influences and the talent of the Czechoslovak architects, the new architecture gradually became an image of the new state, and by the late 1920s many young architects had realized large public buildings, including the Trade Fair Palace (1924–28) in Prague by Oldřich Tyl and Josef

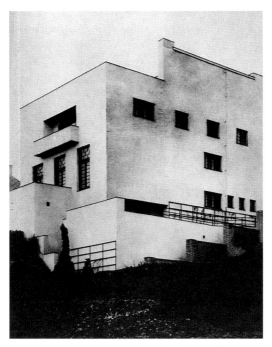

3.2 Adolf Loos. Müller House. Prague, 1928–30.

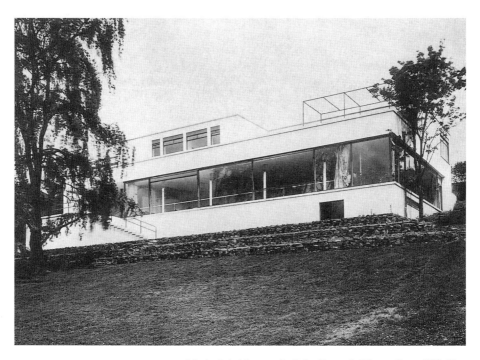

3.3. Ludwig Mies van der Rohe. Tugendhat House. Brno, 1929–30.

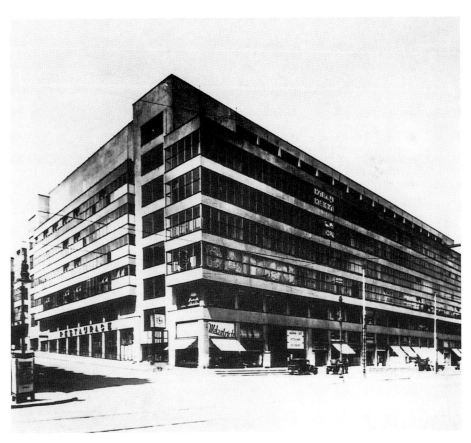

3.4. Oldřich Tyl and Josef Fuchs. Trade Fair Palace. Prague, 1924–28.

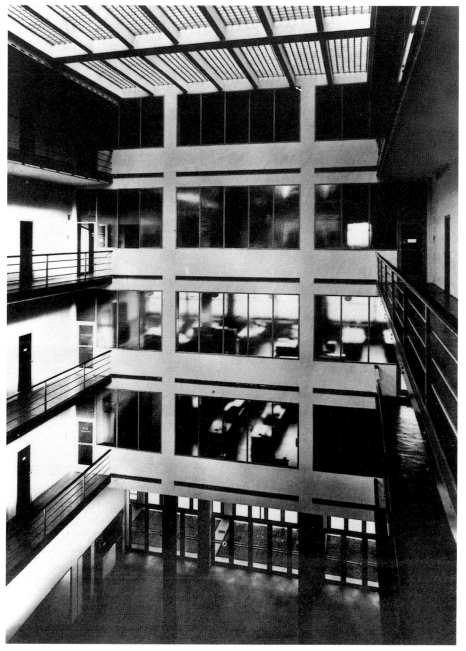

3.5. Adolf Benš and Josef Křiž. Electric Works. Prague-Holešovice, 1926–35.

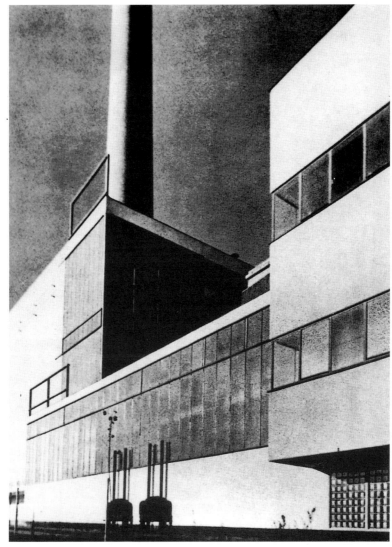

3.6. Jaroslav Frágner. ESSO power plant. Kolín. 1929–31.

Fuchs (fig. 3.4), the office building of the Electric Works in Prague (1926–35) by Adolf Benš and Josef Kříž (fig. 3.5), and the General Pensions Institute (1932–34), also in Prague, by Josef Havlíček and Karel Honzík. All three buildings had the reinforced-concrete skeletal structure that was by then widespread and allowed a flexible, open plan.

Modern architecture expanded from the capital to the provinces, as evidenced by Jaroslav Frágner's works in the small town of Kolín. His ESSO power plant (1929–31) in its marvelous purity foreshadowed Mies van der Rohe's post-World War II power station at the Illinois Institute of Technology in Chicago and earned Frágner the nickname "the Czech Gropius" (fig. 3.6). The 1932 department store and apartment house for the automobile manufacturer Tatra featured a skeletal structure that allowed Frágner to create an extraordinarily airy and lightweight building that became famous for its cantilevered sculptural external access stairs and balconies.

During the 1920s another important center of Czechoslovakian architecture developed in Brno, the capital of Moravia. Although in the nineteenth century the city had been called "an Austrian Manchester" or "a suburb of Vienna," it now became, owing to President Masaryk's initiative, a major economic and cultural center. The city's most important architect was Bohuslav Fuchs, who arrived in 1923 and until the early 1930s executed a number of public and private works of remarkable quality: the cemetery chapel (1925),

which still shows the influence of Dutch brickwork-based architecture, and the Avion Hotel (1927–28) (fig. 3.7). The hotel, probably Fuchs's most important work, was sited on a very narrow, deep lot in an undeveloped area in the historic center

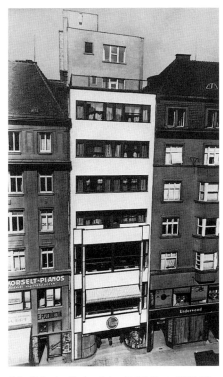

3.7. Bohuslav Fuchs. Avion Hotel. Brno, 1927–28.

of town. Fuchs solved this problem by using a complex system of stairs and by cleverly distributing the public rooms, multiplying the illusion of space with upper and lateral lighting fixtures and mirrored walls. He thus created a continuous space with a number of surprising interrelations and views (fig. 3.8).

In the late 1920s Jiří Kroha, a new professor at the School of Architecture in Brno, brought local architects together with his first

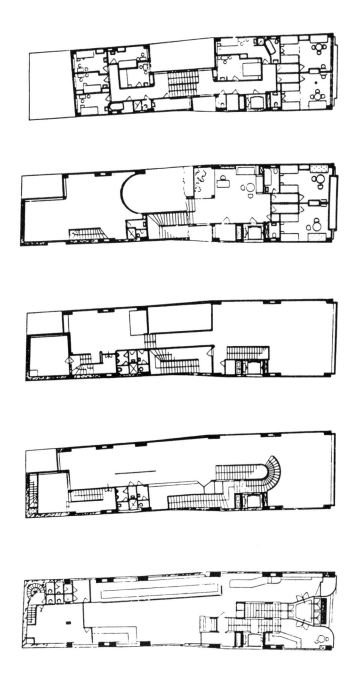

3.8. Bohuslav Fuchs. Ground floor, cafe levels, hotel room level plans
(bottom to top), Avion Hotel. Brno, 1927–28.

pupils. One student, Josef Kranz, made his debut with the Era Café (1927–29) in the Černé Pole district (fig. 3.9), which was appreciated by Philip Johnson and Henry-Russell Hitchcock in their book *The International Style*. The building demonstrated the considerable influence of the Dutch architect J .J. P. Oud on the Czechoslovak functionalists. The street facade featured a masterful composition of large windows and tiny ventilation louvers, while remarkable lighting effects were achieved through a transverse illumination system of large windows along the front wall and a glass-brick wall in the rear.

The first housing exhibition of the Czechoslovak Werkbund, called "New House," was organized in the autumn of 1928 in Brno in connection with the Exhibition of Contemporary Culture. It echoed the similar "Die Wohnung" (The Apartment House) exhibition organized by the Deutscher Werkbund in Stuttgart-Weissenhof in 1927, but without financial support from local authorities. The initiative and financing came from the construction company Uherka and Ruller, which built sixteen detached houses but went bankrupt soon after, since almost no houses sold. This poor economic result had an impact on the strategy of another exhibition organized by the Werkbund on Baba Hill in Prague four years later. Nevertheless, this first exhibition had a capital impact on the development of modern Czechoslovak architecture. The conceptual and formal quality presented was very high, and the houses that were built reveal the mature func-

tionalist characteristics of machine age, hygienic architecture in the crisp geometry of their facades and in their roof terraces, balconies, and horizontal ribbon windows. Among the buildings constructed for the exhibition was the Double House designed by Hugo Foltýn and Miroslav Putna (figs. 3.10, 3.11), an individual house by Jiří Kroha (fig. 3.12), and the Triple House by Bohuslav Fuchs and Josef Štěpánek (fig. 3.13). Each of these houses showed remarkable stylistic consistency and a deep understanding of the principles of functionalist architecture, yet it is not surprising that their abstract white architecture provoked a negative reaction from the general public, which was accustomed to living in a more traditional manner. This impressive complex has survived in poor condition due to the lack of interest in modern architecture on the part of the communist authorities.

In the late 1920s the Left Front, a group of avant-garde artists affiliated with the CIAM, was established in Prague, chaired by Karel Teige and actively supported by Josef Chochol. Soon afterward a very active architecture culture emerged in Prague and in Brno, responding to the deep economic depression and the grave housing problem of the lower classes. Teige, following Marxist philosophy, sought a solution in the work of the Soviet constructivists. He agreed with Le Corbusier's opinion that architecture is both an art and a branch of science. The avant-garde architects supported Teige's ideas in important journals that he either edited or influenced, such as

3.9. *Josef Kranz. Era Café. Brno, 1927–29.*

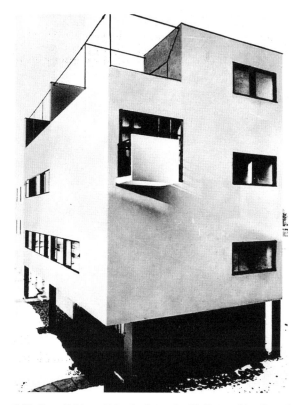

3.10. Hugo Foltýn and Miroslav Putna. Double House. "New House" housing exhibition of the Czechoslovak Werkbund. Brno, 1928.

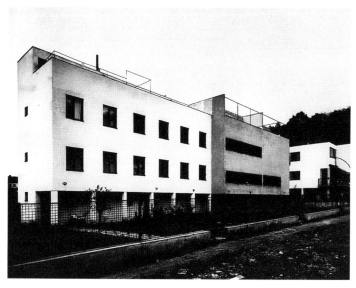

3.11. Hugo Foltýn and Miroslav Putna. Double House. "New House" housing exhibition of the Czechoslovak Werkbund. Brno, 1928.

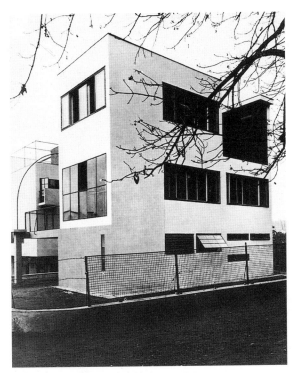

3.12. Jiří Kroha. Individual house. "New House" housing
exhibition of the Czechoslovak Werkbund. Brno, 1928.

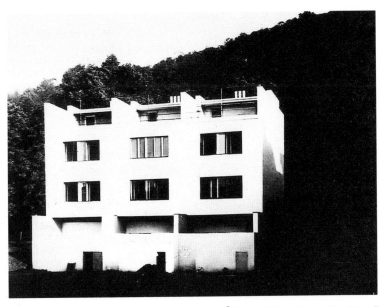

3.13. Bohuslav Fuchs and Josef Štěpánek. Triple House. "New House"
housing exhibition of the Czechoslovak Werkbund. Brno, 1928.

Stavba, Stavitel, and *Devĕtsil ReD,* where they could publicly confront and internationally debate the problems of new dwelling forms. Their vision of the new dwelling found its incarnation in the concept of collective houses. Teige outlined the idea in his 1932 article "The Smallest Flat":

> The smallest flat in the collective house is to be regarded as a dwelling cabin, as a room for the private life of each individual. These cabins will be grouped into large dwelling hives. The way of life of a class necessitates abolishing the traditional family household and socializing children's education. The existing forms of collective dwelling, such as flats, permanent-stay hotels, boarding houses, hostels, and family boarding houses, differ according to the classes they are intended for and according to the line separating the centralized household and the individual or family dwelling. In the collective houses this line will rigorously separate all the cultural and social processes—which will concentrate in public buildings—from the dwelling functions of individuals, which will concentrate in dwelling cabins. That is why the space of this dwelling unit can be reduced to a minimum, to what really is the minimum flat. From this unit everything is excluded that does not belong to the dwelling and private functions: there is no dining room, no salon, and no children's room. It is just a room for sleeping, relaxing, and studying, and for individual cultural work, for the intellectual and intimate life of each individual. No permanent living together of two persons in one unit is possible. This minimum flat for an individual, man or woman, is a dramatic reduction of the existing household, so it ceases to be the traditional flat. It means a change of quantity into quality. In progressing from the castle and palace through the nineteenth-century bourgeois apartment, from the luxurious flat to the minimum household, there are quantitative changes. And these quantitative changes, the reforms and restrictions that have taken place up to now and that have been brought about by architectural and technical progress (rationalization of the flat and revision of its dimensions), now arrive at a point where with the new social content quantity changes into quality, where the traditional—even the smallest—household (the small bourgeois flat) is overcome, where a radical section is made that separates the dwelling unit at the subsistence level, the flat without household, from the public centralized services and socialized education of children. The traditional flat, i.e. the household with rooms, finally disintegrates here into its functions and elements, which are organized centrally and collectively.

In spring 1930 Teige declared the architecture section of the Left Front to be the Czechoslovak Congrès Internationaux d'Architecture Moderne (CIAM) group, which then focused on collective houses. After his lecture at the Bauhaus on the "Sociology of Architecture," Teige organized a public discussion on dwelling problems in the review *Tvorba* (Creation). As a result, Josef Havlíček and Karel Honzík presented the first Koldom project, a system of two apartment

houses with dwelling cabins that could be entered from long corridors and were connected by means of vertical circulation systems. The architects submitted the project, which formally showed the influence of Le Corbusier, in a competition for small apartments for the Pankrác and Holešovice districts. Teige, however, criticized the centralization of all functions in the same building and preferred the project by the Comité Internationale pour la Résolution des Problèmes de l'Architecture Contemporaine (CIRPAC), prepared by Jan Gillar and Josef Špalek and presented in the same competition, where dwelling functions are decentralized in houses called "dwelling hives," with dwelling units conceived as "maisonnettes." Both projects, which deliberately ignored the conventional competition requirements, were then exhibited at the third CIAM in Brussels and published in the congress catalogue.

Teige attended the congress and spoke on the problem of housing and architecture in Czechoslovakia. He was asked to prepare and edit the general report, titled "Die Wohnung für das Existenzminimum," (Minimum-Existence Housing) based on the reports of various Czech groups. The top project materializing Teige's theoretical efforts was a collective housing estate in Prague's Pankrác District, known as the L Project, prepared by several members of the Left Front architecture section (Peer Bucking, Jan Gillar, Augusta Müllerová, Josef Špalek) and presented at the time of the Brussels congress in a competition for small apartments organized by the Central Social Insurance Com-

pany as a demonstration against its conditions. Teige characterized it as "the only large ideological work done in Czech modern architecture." The project detailed a housing development for five thousand inhabitants containing fifteen apartment blocks (each for three hundred inhabitants), a center for culture and relaxation, sixty-seven children's pavilions for five hundred preschool children, a medical clinic, a central kitchen, and a sports field. Teige regarded the project as "an architectural manifesto," its formal aspects close to the instrumental, scientific method of architecture as postulated by himself and Hannes Meyer.

Several remarkable collective dwelling projects were also presented in a third competition organized by the cooperative Včela (Bee). Teige's ideas appear in the projects prepared by Zdeněk Rossmann and Václav Zralý, Czech Bauhaus students, and in Ladislav Žák's project, which exhibits an excellent layout of dwelling cabins. An important contribution to the problem was the 1932 theoretical study by the PAS group (Janú, Štursa, Voženílek) for an industrial satellite district of Prague, which anticipated the principles of collective dwelling as well as Milyutin's concept of the linear town. The program of leftist architects also included analyses of the poor housing situation of the proletariat, as evidenced in Teige's writings "Sociology of Architecture" (1930) and "The Smallest Flat" (1932). An interesting pendant to them is the "Sociological Fragment of Dwelling" from Brno (1930–33). These works were complemented

by a number of studies on the housing situation in Bratislava and in Slovakia published by Zdeněk Rossmann and in the region of Ostrava by Josef Kittrich. The exhibition called "Proletarian Dwelling," organized in Prague in 1931 by Jan Gillar, František Jech, Josef Kittrich, Augusta Müllerová, and Nesim Nucis with German architects Hans Stolpe and Peer Bucking, first made such analyses known to the general public; the authorities closed down the exhibition after two days.

The ideology of the Left Front architecture section, with its uncompromising criticism of the social situation, reached the very limits of the law. Its views were reflected in the activity of the Czech CIAM group and its relations to the CIAM headquarters in Zurich. At the extraordinary CIAM congress held in Berlin in June 1931 the Czechoslovak group was represented by Nusim Necis, who confirmed that the group played "an important ideological role" there, particularly by showing irreconcilable class viewpoints that resulted in a split between the Czechoslovak group and the CIAM center. The mutual contacts were interrupted, apparently because of ideological differences, and although Teige officially continued to be the Czechoslovak delegate, the Czechoslovak group ceased to work until the mid-1930s.

The activity of the Left Front culminated in a congress of leftist architects held in Prague from October 29 to November 1, 1932 to analyze the architecture situation during the depression. As a result, the Union of Socialist Architects was established on February 10, 1933 and Jiří Kroha was elected chairman.

The utopian period of Czech architecture (1930–33), during

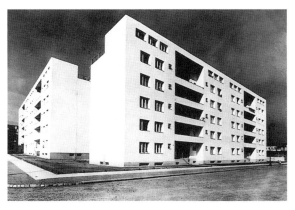

3.14. Josef Polásek. Municipal apartment block. Brno-Hušovice, 1930.

which the architects, having almost no construction orders, dealt with theoretical problems, was followed in the mid-1930s by a building phase spurred by economic revival. However, some works were made during the early 1930s in spite of the depression. They included groups of small-apartment blocks constructed according to the new State Support Act, which subsidized the construction of apartments of up to forty square meters. In Prague municipal apartment blocks with balconies were constructed in the Holešovice district, designed by František Albert Libra and Jiří Kán. In the Pankrác district, where the trend of separate blocks surrounded by gardens was quite apparent, a

housing development called the Green Fox, designed by Libra, Kán, Antonín Černý, and Bohumír and Ladislav Kozák, was built for the Central Social Insurance Company. In Brno municipal blocks of small apartments were mostly designed by Josef Polásek, first in Hušovice (fig. 3.14) and then in Královo Pole, where five-story terrace houses line the street, with

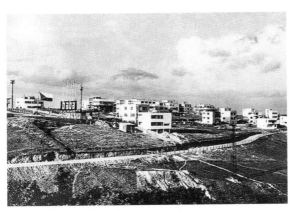

3.15. Baba Hill housing development. Second housing exhibition of the Czechoslovak Werkbund. Prague, 1932.

duplex apartments with shops on the ground floor and more apartments upstairs. The municipal councils of Prague and Brno thus responded to Teige and other architects; they decided to construct small apartments of the family type and reflected the concept of collective dwelling without family households as suggested by the Left Front.

In 1932 the second housing exhibition was organized on Baba Hill in Prague under the auspices of the Czechoslovak Werkbund. The event was inspired by the 1927 exhibition organized by the Deutscher Werkbund in Stuttgart-Weissenhof and by the 1928 "New House" exhibition in Brno; the houses were on a site similar to the southern slope of Weissenhof (fig. 3.15). Since the Prague exhibition was not subsidized by the city or any building company but financed by private clients, free-standing single-family houses for middle and upper classes were built there. The master plan, designed by the chairman of the Czechoslovak Werkbund, Pavel Janák, also included semidetached houses, but since no interest was shown in these, no such houses were built. As a result, at the time this was the only organized housing exhibition for which houses were built not as manifestos but as a result of the traditional dialogue between architect and client (others were organized in Brno [1928], Breslau [1929], Zurich-Neubuhl [1930–32], and Vienna [1932]). Janák's master plan was based on a chessboardlike distribution of houses that exploited the view of the Vltava River valley and of Prague Castle. The exhibition grounds were surrounded by uniform fencing, and harmonized gardens were designed for most houses by landscape architect Ottokar Fierlinger.

In spite of the harmonious master plan and the general functionalist style, each house shows a different architectural vocabulary. This reflected the age range of the architects, which spanned twenty-four years: the oldest was Josef Gočár, born in 1880; the youngest were Hana Kučerová-Záveská and

Zdeněk Blažek, both born in 1904. Gočár preferred solid forms and in some cases used a stone plinth; members of the youngest generation, particularly Ladislav Žák and Hana Kučerová-Záveská, preferred dematerialized, elegant forms based on Le Corbusier's villas. The Baba Hill site, where twenty houses under construction were presented to the public in September 1932 and twelve more one year later, with some interiors completed and accessible as exhibits, strongly influenced the housing ideas of the middle classes and made the single-family house a field of experiment for functionalist architects. Here we see all nuances of functionalism, from austere rationalism to the streamline style to organic architecture.

In most houses at the Baba development, the living room and bedrooms face south, with the service rooms on the north. Most contain two or three bedrooms; four houses contain two apartments; three houses with studios were intended for fine artists, and one was designed in 1932 for the architect Pavel Janák (fig. 3.16). The 1932 Sutner House designed by Oldřich Starý (figs. 3.17, 3.18) imitated very closely housing types shown at the Stuttgart-Weisenhoff housing exhibition. It is a simple, plain cubical volume supported by columns on the ground floor, with characteristic ribbon windows and a roof terrace protected by the thin metal railing typical of func-

tionalist designs. In the house for Dr. Mauk (fig. 3.19), architect Josef Gočár situated the living room upstairs and the bedrooms on the ground floor to offer an attractive view of the castle. Another house designed by Gočár for Dr. Julius Glücklich (fig. 3.20) was very similar to Dr. Mauk's house in plan and architectural style.

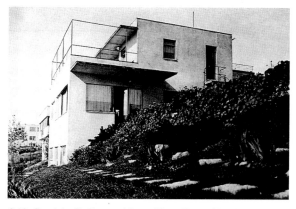

3.16. Pavel Janák. House of the architect. Second housing exhibition of the Czechoslovak Werkbund. Baba Hill, Prague, 1932.

Another outstanding house in the small- to medium-size category was the one designed by Hana Kučerová-Záveská for the contractor Suk (fig. 3.21). It shared its elegant and bold formal language with Le Corbusier's Villa Stein (1927) in Garches and Villa Savoye (1929–31) in Poissy, with which it can be compared in terms of lightness, flowing horizontal lines, and the spirit of openess it conveys. Another important house designed perhaps more in the spirit of the Bauhaus than of Le Corbusier was built in 1930–32 by the team of Evžen Linhart and Antonín Heythum (fig. 3.22).

The most important works of the Baba exhibition were probably

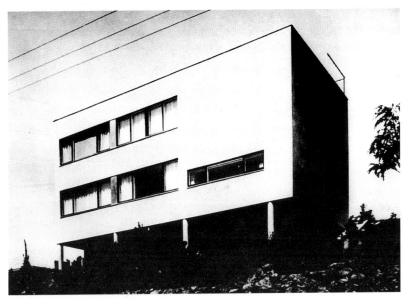

3.17. Oldřich Starý. Sutner House. Second housing exhibition of the Czechoslovak Werkbund. Baba Hill, Prague, 1932.

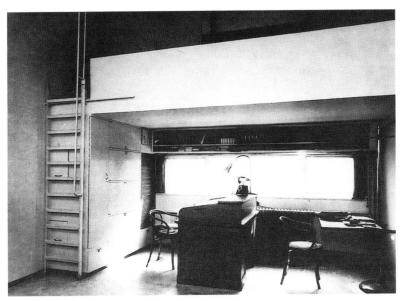

3.18. Oldřich Starý. Sutner House. Second housing exhibition of the Czechoslovak Werkbund. Baba Hill, Prague, 1932.

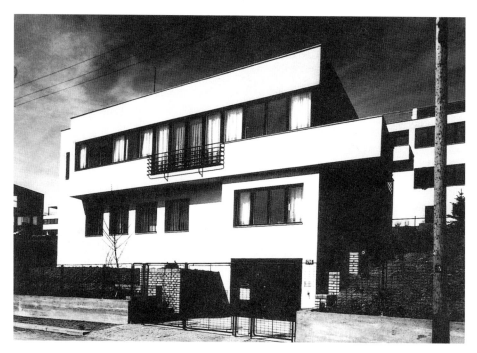

3.19. *Josef Gočár. House for Dr. Mauk. Second housing exhibition of the Czechoslovak Werkbund. Baba Hill, Prague, 1932.*

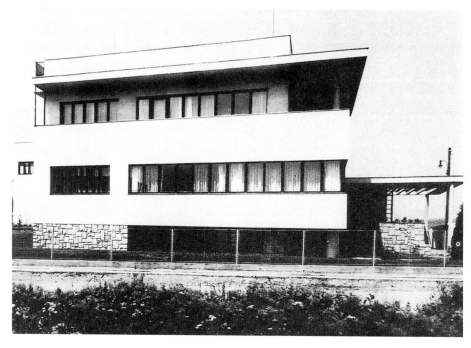

3.20. *Josef Gočár. House for Dr. Julius Glücklich. Second housing exhibition of the Czechoslovak Werkbund. Baba Hill, Prague, 1932.*

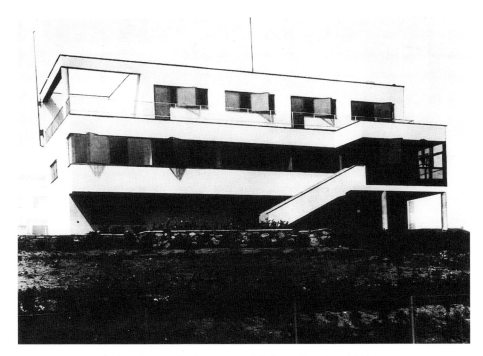

3.21. Hana Kučerová-Záveská. House for the contractor Suk. Second housing exhibition of the Czechoslovak Werkbund. Baba Hill, Prague, 1932.

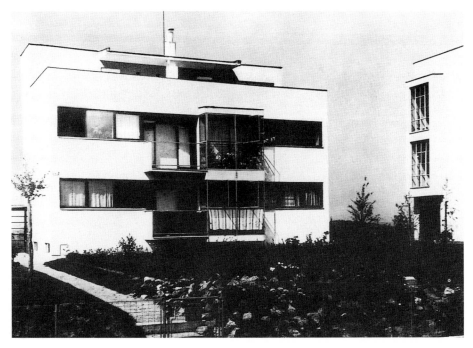

3.22. Evžen Linhard and Antonín Heythum. House for Dr. Lisy. Second housing exhibition of the Czechoslovak Werkbund. Baba Hill, Prague, 1932.

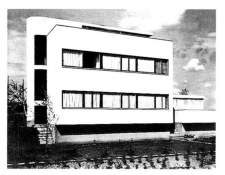

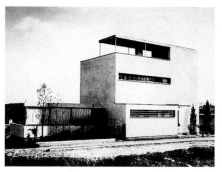

3.23. Ladislav Žák. House for Dr. Karel Herain. Second housing exhibition of the Czechoslovak Werkbund. Baba Hill, Prague, 1932.

3.24. Ladislav Žák. House for Dr. Karel Herain. Second housing exhibition of the Czechoslovak Werkbund. Baba Hill, Prague, 1932.

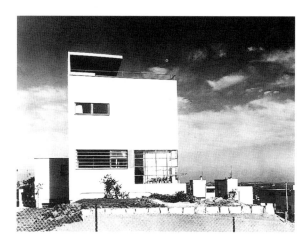

3.25. Ladislav Žák. House for Professor Čeněk. Second housing exhibition of the Czechoslovak Werkbund. Baba Hill, Prague, 1932.

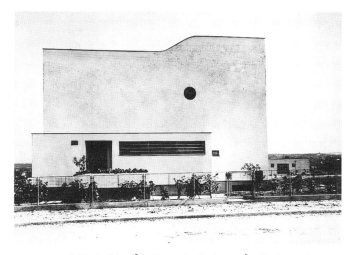

3.26. Ladislav Žák. House for Professor Čeněk. Second housing exhibition of the Czechoslovak Werkbund. Baba Hill, Prague, 1932.

the three single-family houses designed by Ladislav Žák, which were his first built works and ranked him among the most successful young Czechoslovak architects. The houses he designed for Dr. Karel Herain (figs. 3.23, 3.24), Professor Čeněk (figs. 3.25, 3.26), and Dr. Zaorálek (figs. 3.27, 3.28) are medium-sized units with a longitudinal living space on the ground floor and cabinlike bedrooms upstairs with terraces that could be adapted for the collective "hive-houses" that Karel Teige dreamed of (fig. 3.29). The architecture of all three houses demonstrates this architect's outstanding talent. Simple, delicate, thin, and supremely elegant, Žák's houses are a delight to visit even if they appear neglected today. Žák's success in the exhibition led to important commissions for houses, such as one for the aircraft designer Dr. Miroslav Hain in the Visočany district of Prague (figs. 3.30, 3.31, 3.32, 3.33, 3.34), built between 1932 and 1937. This large house exemplifies the romantic approach to functionalist, machine-oriented architecture. Many of its elements, such as strongly articulated terraces detached from the main volume of the building and the viewing platform high above the roof, refer to the spirit of immateriality and flight. The building is a total work of art, with its interiors and furnishings also intended to convey the spirit of a modern "living machine" working for its owner. Another superb house that Žák designed in 1934–35 was for film director Martin Frič and was located on a steep slope not far from the Baba development

(fig. 3.35). This building, with its white streamline volumes, rounded corners, round naval-style windows, and dynamic terraces open to gardens below and to views of Prague in the distance, represented the culmination of Žák's architectural work.

Although the Baba housing development is the best-known example of Czechoslovak functionalism in its design sophistication and the variety of architectural solutions proposed there, the individual houses designed in other Czechoslovak towns and localities also showed a very high level of creative accomplishment. In particular, in Brno, the true center of Czech modernism, were three outstanding houses: two that Jiří Kroha and Bohuslav Fuchs built for themselves in 1928–29 (fig. 3.36), and Jiří Kroha's so-called Villa Patočka of 1935 (fig. 3.37). Their abstract, elegant architecture was similar to the Baba development houses and other famous functionalist villas of Prague. In Fuchs's own cubical house, a double-height living room and a second-floor gallery that provides access to the bedrooms form an essential part of the overall spatial composition (figs. 3.38, 3.39). The design of its kitchen and bathrooms responded to the most refined notions of laboratory functions proposed at the time in Europe. Also in Brno, Josef Kranz, architect of the famous Era Café, built the elegant Villa Slavík (1930–31).

An attempt to develop the Baba experiment by lending a social aspect to the construction of single-family houses was made in

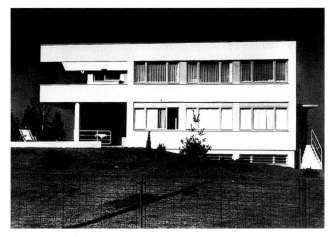

3.27. Ladislav Žák. House for Dr. Zaorálek. Second housing exhibition of the Czechoslovak Werkbund. Baba Hill, Prague, 1932.

3.28 Ladislav Žák. House for Dr. Zaorálek. Second housing exhibition of the Czechoslovak Werkbund. Baba Hill, Prague, 1932.

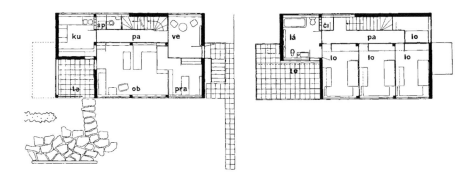

3.29. Ladislav Žák. Ground floor plan, house for Dr. Zaorálek. Second housing exhibition of the Czechoslovak Werkbund. Baba Hill, Prague, 1932.

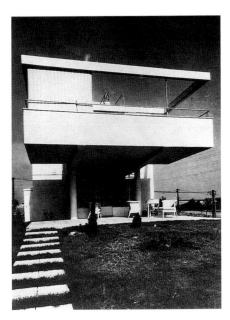

3.30. *Ladislav Žák. House for Dr. Miroslav Hain. Prague-Visočany, 1932–37.*

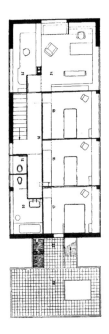

3.31. *Ladislav Žák. Second floor plan, house for Dr. Miroslav Hain. Prague-Visočany, 1932–37.*

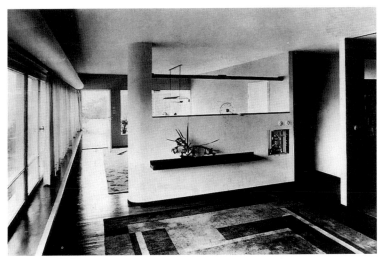

3.32. *Ladislav Žák. House for Dr. Miroslav Hain. Prague-Visočany, 1932–37.*

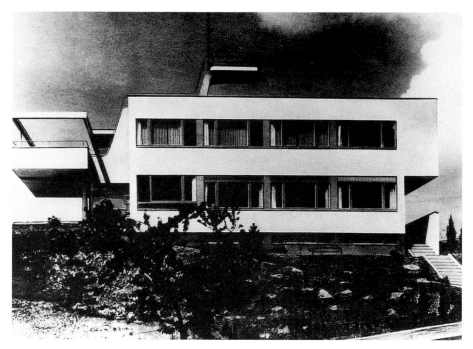

3.33. Ladislav Žák. House for Dr. Miroslav Hain. Prague-Visočany, 1932–37.

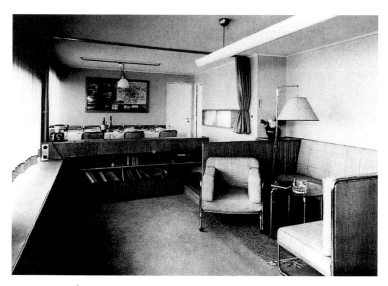

3.34. Ladislav Žák. House for Dr. Miroslav Hain. Prague-Visočany, 1932–37.

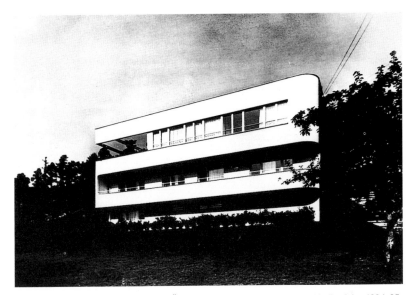

3.35. Ladislav Žák. House for Martin Frič. Prague-Hodkovicky, 1934–35.

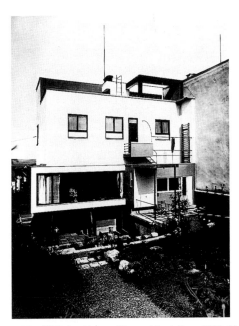

3.36. Jiří Kroha. House of the architect. Brno, 1928–29.

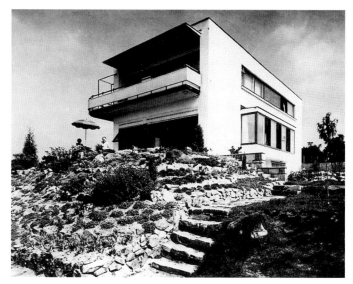

3.37. Jiří Kroha. Villa Patočka. Brno, 1935.

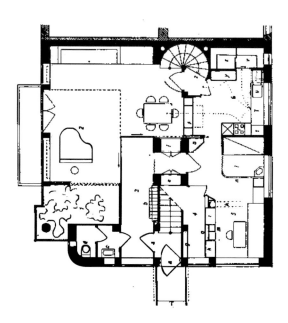

3.38. Bohuslav Fuchs. Ground floor plan, house of the architect. Brno, 1928–29.

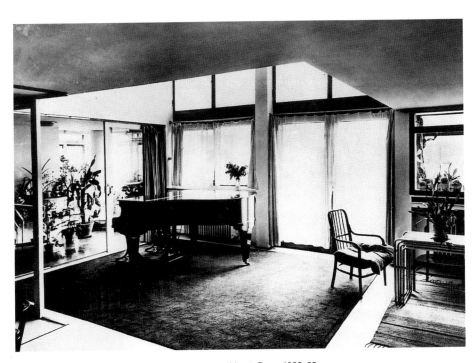

3.39. *Bohuslav Fuchs. Living room, house of the architect. Brno. 1928–29.*

Zlín, where a housing development with cooperative houses known as Podřevnická was built in 1932. Jaromír Krejcar's former colleague Miroslav Lorenc there built a group of small, standard houses with three to five rooms.

After the Baba exhibition housing development, the single-family house became a typological category in which all nuances of the functionalist style were applied, from the austere rationalist concept used by Oskar and Ella Oehler in Prague, Teplice nad Bečvou, and by Jaroslav Frágner in Kostelec nad Černými Lesy; to the aerodynamic steamshiplike villas in Brno-Pisárky designed by Bohuslav Fuchs, and those in Barrandov and Jevany by Vladimír Gregr; to the organic style preferred by the brothers Lubomír and Čestmír Šlapeta in northern Moravia. Their houses showed more expressionistic and organic features, without doubt derived from the architecture of German architects such as Hugo Häring and Hans Scharoun. Two significant houses designed by Lubomír Šlapeta were the one for Dr. Kremer in Hlučín (1933–34) (fig. 3.40), and one for Dr. Eduard Liška in Slezská Ostrava (1935–36) (fig. 3.41). They incorporated more curving walls, surfaces, and natural materials and were less abstract and detached from their contexts. Although very modern and functional, they nevertheless were less dogmatic than most

other Czechoslovak functionalist works.

Large houses were rarely built: in the house for the industrialist Sochor in Dvůr Králové, Josef Gočár created a symbiosis of modern Czech architecture and fine arts by placing in the interior works of art made by his friends, members of the artists' association Mánes. The house for the

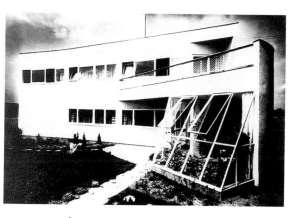

3.40. Lubomír Šlapeta. House for Dr. Kremer. Hlučín, 1933–34.

industrialist Volman in Čelákovice by Karel Janů and Jiří Štursa was conceived in the fashionable Corbusian spirit and completed, shortly before the outbreak of World War II, this series of individual creations witnessing the rich dialogue between the modern architects and their enlightened and cultivated clients.

This could also be seen in a number of summer houses in the countryside built in the late 1930s, for instance by Jaroslav Frágner in Nespekty, by Josef Štěpánek in Vodňany, by Karel Honzík in Zadní Třebáň and Dobřichovice, and by the Šlapeta brothers in the Beskydy Mountains. Natural materials, such as wood and stone, were used,

which proved a shift from white functionalism toward organicism. This derived from the return-to-nature movement and the lifestyle theories developed at the time by Karel Honzík and Ladislav Žák.The range of styles adopted by Czech architects includes fashionable streamline houses in Jablonec nad Nisou by the outstanding German architect Heinrich Lauterbach, from

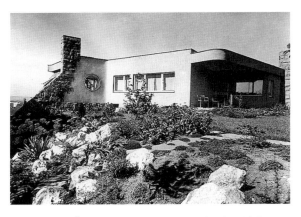

3.41. Lubomír Šlapeta. House for Dr. Eduard Liška. Slezská Ostrava, 1935–36.

Breslau (figs. 3.42, 3.43). Other houses were built by Viennese architects influenced by Adolf Loos and Josef Frank. Frank's pupils Rudolf Baumfeld and Norbert Schlesinger built the Loew-Beer House in Brno-Pisárky in 1935, whose shapes prove direct links with the house by their professor in Vienna-Hietzing. Loos's pupils Jacques Groag and Heinrich Kulka found political asylum for a short time in Czechoslovakia in 1938. Before emigrating, they had designed houses from Vienna for their Czech friends: Jacques Groag conceived an organic villa for Ing. Eisler in Ostravice and a number of houses in Olomouc; and Heinrich Kulka designed sev-

eral houses in Jablonec nad Nisou and in Hronov, as well as a house in Hradec Králové and a weekend house in Železná Ruda.

At the same time another type of single-family house was developed with a shop on the ground floor, which was very popular in the small towns and villages of Bohemia and Moravia. The clients, mostly medium- and small-level businessmen, identified with the spirit of modern architecture. The Tatra store in Kolín by Jaroslav Frágner, a two-story shop with glass walls and an apartment for the owner on the top floor, and the house with a consulting room for Dr. Martínek in Opava-Kateřinky designed by Lubomír Šlapeta, are fine examples of this category.

In the early 1930s the Czechoslovak government made a great effort to introduce a new social program, particularly in the field of health care. The Central Social Insurance Company and the Provincial Life Insurance Company organized a number of important competitions for sanatoriums all over the country in which a new type of such structures with a high standard of architecture, organization, and technology was developed. One excellent result was the Machnác Sanatorium in the beautiful spa of Trenčianské Teplice (1930–32) designed by Jaromír Krejcar (figs. 3.44, 3.45, 3.46), chosen from among sixty-one competition entries. Krejcar

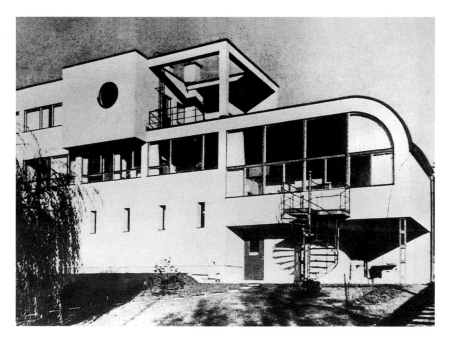

3.42. Heinrich Lauterbach. House for Dr. Schmelowsky. Jablonec
nad Nisou, 1931–32.

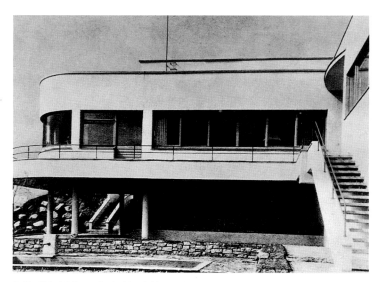

3.43. Heinrich Lauterbach. Hasek House. Jablonec nad Nisou,
1931–32.

conceived the building as a small prototype collective house with a T-shaped layout clearly separating the two main functions of the sanatorium: accommodation in a long, two-bay wing whose facade had balconies opening to the sun, and social life concentrated in the other part with a glass vestibule and an access ramp. This work, architecturally perfect down to the details, is

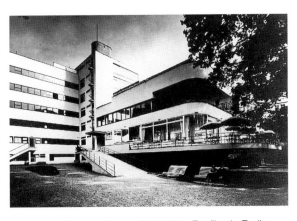

3.44. Jaromír Krajcar. Machnác Sanatorium. Trenčianske Teplice (Slovakia), 1930–32.

one of the best monuments of Czechoslovak functionalist architecture. Bohuslav Fuchs, a highly skilled architect living and working in Brno, was at the same time constructing the Morava Sanatorium (1930–31) in Tatranská Lomnica (fig. 3.47). The tapered partition walls between dwelling units and the social block connected to the sloping ground disclose the architect's early tendency toward organic architecture. Fuchs designed and built The Green Frog thermal bath (1936–37) in Trenčianské Teplice (fig. 3.48). He designed it in a back-to-nature spirit rather than according to the strict function-

alist, therefore abstract, formulas. This bath used organic materials and free geometrical forms and shapes. The TBC sanatorium in Jablunkov by Miloš Laml and the large complex of TBC sanatoriums in Vyšné Hágy in the High Tatra Mountains by František Albert Libra and Jiří Kán also exhibit a high standard of architecture.

In school buildings the most interesting structure of the early 1930s is the French School (1931–34) in Prague-Dejvice. In the second round of competition, with eight top architects submitting, Jan Gillar's project was selected for realization (fig. 3.49). Gillar conceived the school as a system of three pavilions containing a nursery and elementary school, a secondary school and school administration, and an assembly hall and gymnasium, connected by interior streets leading to a large vestibule with two glass walls. The architect was undoubtedly influenced by Hannes Meyer's school at Bernau near Berlin, built in 1928. With the simple articulation of mass and fashionable details Gillar created one of the most important school buildings of the 1930s, next to André Lurçat's school at Villejuif near Paris.

In the town of Mladá Boleslav, Jiří Kroha built the Technical High School (1922–24), in which he demonstrated an astonishingly inventive, self-assured handling of modern architecture given that

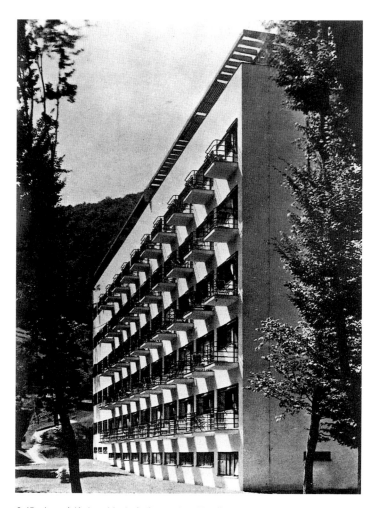

3.45. Jaromír Krajcar. Machnác Sanatorium. Trenčianske Teplice (Slovakia), 1930–32.

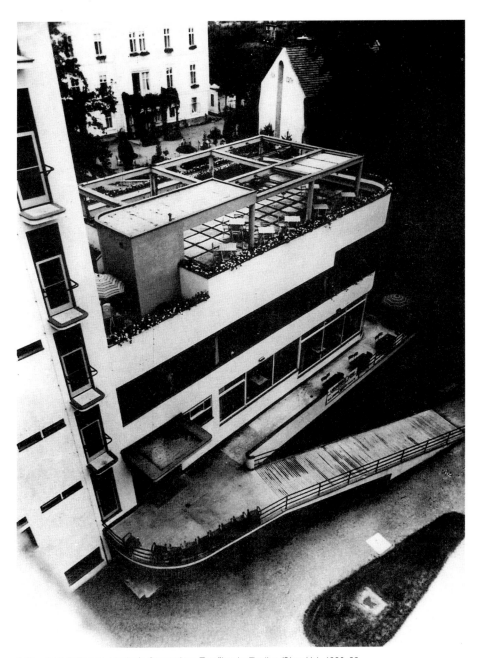

3.46. Jaromír Krajcar. Machnác Sanatorium. Trenčianske Teplice (Slovakia), 1930–32.

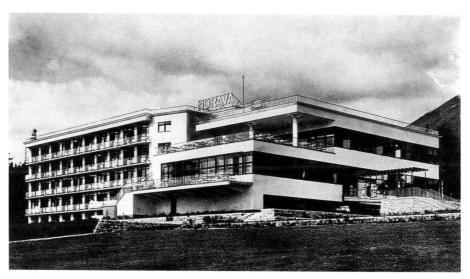

3.47. Bohuslav Fuchs. Morava Sanatorium. Tatranská Lomnica (Slovakia), 1930–31.

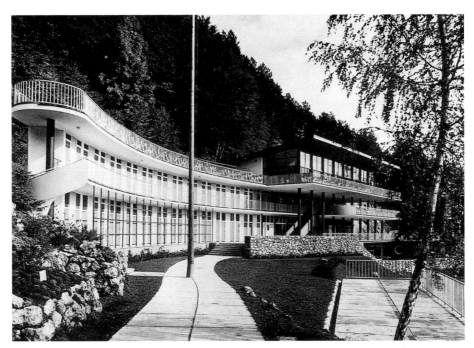

3.48. Bohuslav Fuchs. The Green Frog thermal bath. Trenčianske Teplice (Slovakia), 1936–37.

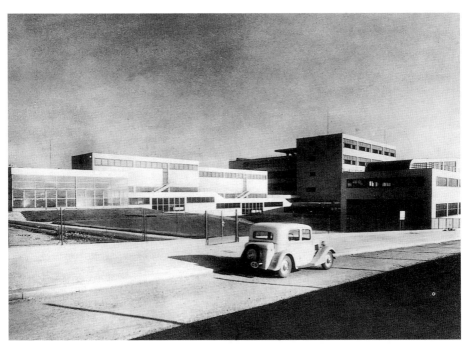

3.49. Jan Gillar. French School. Prague-Dejvice. 1931–34.

functionalism was still in its formative years (fig. 3.50). In Brno, Bohuslav Fuchs in collaboration with Josef Polásek executed the design for a large, pioneering educational complex, the Vesna Girls' School and the Eliška Machová Girls' Home in Pisarky (1929–30) (fig. 3.51), for which inspiration came from the pioneering works of Johannes Duiker of Holland. Fuchs and Polásek expressed the structural frame of both Vesna buildings on the exterior in the spirit of structural honesty that was dear to functionalist ideology. This school complex later inspired the Italian rationalist Giuseppe Terragni's famous Casa del Fascio in Como.

In spite of the depression, in the early 1930s a number of new commercial and administrative buildings appeared, such as the proud glass palaces of the Baťa shoe shops, built not only in the major towns of Prague, Brno, Bratislava, and Ostrava but also in Poland, France, Holland, and England; and two Baťa department stores by Ludvík Kysela built in Prague in 1929–30 (fig. 3.52) and 1929–35 (fig. 3.53). Kysela, an excellent architect of commercial buildings, designed another outstanding glass structure in 1929: the Arcade ALFA on Wenceslas Square in Prague. Vladimír Karfík, Chief Architect of the Baťa Company, designed and built in 1930 the Baťa department store in Brno. This was Karfík's first project after returning from the United States, where he had worked at the Holabird & Root architecture office in Chicago. The Baťa store in Brno was one of the first examples of the glass-and-steel curtain wall in Europe. Among these glass-and-metal palaces was also the Palace of the Czechoslovak Werkbund (1934–36) in Prague by Oldřich Starý and the Moravská Banka

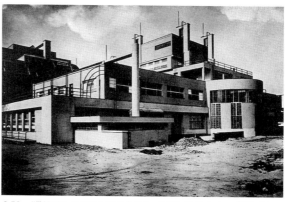

3.50. Jiří Kroha. Technical High School. Mladá Boleslav, 1922–24.

bank building by Bohuslav Fuchs (1930–31) in Brno (fig. 3.54). More than any other building type of this period, these lightweight, transparent structures, glowing day and night with a remarkably playful and joyful presence, represented the true nature of the modern age, even if they did sometimes destroy the scale and character of the surrounding historic context.

Similar commercial buildings with lightweight skeletal structures and completely glazed facades were built not only in Prague and Brno but in many other towns: Ostrava, Liberec, Bratislava, and Olomouc, for example. In 1931, Bohuslav Fuchs designed the municipal savings bank for Třebíč, built in a corner of the town square,

and shortly afterward, together with Jindřich Kumpošt, a savings bank for Tisnov creating harmony between modern architecture and the historic context. The German architect Erich Mendelsohn realized his last project in Czechoslovakia before emigrating to England and Palestine: the Bachner department store on Zámecká Street in Ostrava, with a round neon light

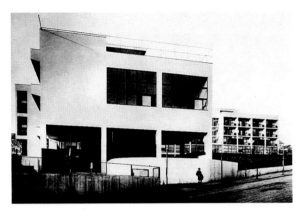

3.51. Bohuslav Fuchs and Josef Polásek. The Vesna Girls' School and Eliška Machova Girls' Home. Brno-Pisarky, 1929–30.

at the corner. In the early 1930s the center of Zlín developed its current face. The Social House, the country's best hotel at the time, designed by Miroslav Lorenc and redesigned by Vladimír Karfík, with a large cinema for twenty-two hundred spectators and a steel-frame structure by František Lydie Gahura, was constructed on the northern slope over the factory (fig. 3.55). The green axis of the northern slope, lined with hostels according to Gahura's master plan, closes with a *point de vue*—the Tomáš Baťa Memorial with glass walls and Baťa's airplane suspended inside (fig. 3.56).

In 1935 a new period of the Czechoslovak CIAM group started.

It was initiated by several architects in Brno who were more realistic and who were dissatisfied with the lack of international contacts. František Kalivoda, a graphic artist and architect, had participated in the fourth CIAM in 1933 aboard the cruise ship *Patris II* from Marseille to Athens. In 1934–35 in Amsterdam, La Sarraz, and Zurich, Kalivoda promised to reorganize or reestablish the Czechoslovak CIAM group. In December 1935 he published, together with Bohuslav Fuchs, a special issue of the journal *Index* devoted to the history and activity of the CIAM. The new CIAM working group announced in the issue included the following members: Adolf Benš, Jaroslav Frágner, Josef Havlíček, and Karel Honzík from Prague and Bohuslav Fuchs, Jaroslav Grunt, František Kalivoda, Jindřich Kumpost, Josef Polásek, Jan Vísek, and the German architect Henryk Blum from Brno. The group's administration was expected to move to Brno, with Kalivoda as secretary, whereas Karel Honzík was expected to be the secretary in Prague. This initiative, however, did not find much understanding in Prague and brought about a quarrel between Teige's group and the Brno group. The controversy had a negative impact on the international recognition of the Czechoslovak CIAM group. While Kalivoda in a letter to Siegfried Giedion declared the original Teige group nonexistent,

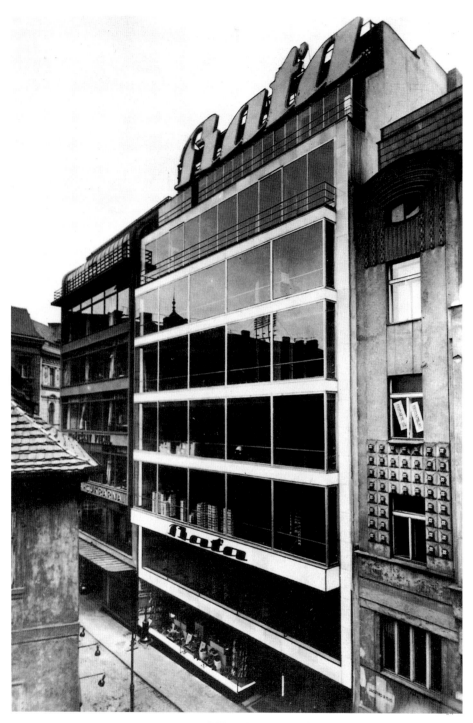

3.52. *Ludvik Kysela. Baťa department store. Prague, 1929–30.*

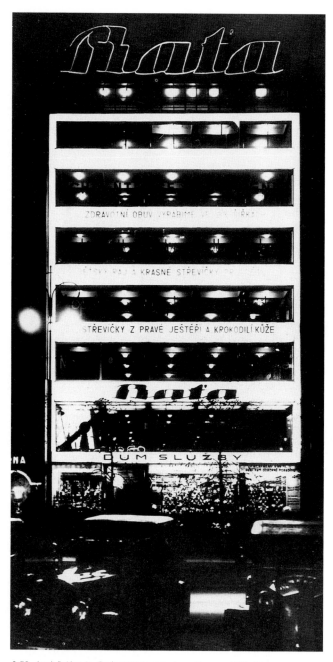

3.53. Ludvík Kysela. Baťa department store. Prague, 1929–35.

members of the CIAM group in Prague informed the CIAM in Zurich that they did not intend to join the new group. The letter caused many problems among the international contacts and for a long time complicated the official recognition of the Czechoslovak CIAM group.

Whereas the Prague group failed to work, Kalivoda was very active and together with Josef Polásek attended the Budapest meeting of the CIAM East national groups in February 1937 and organized a meeting of these groups in Zlín and Brno in late spring of the same year. The CIAM center in Zurich, however, did not officially recognize any Czechoslovak group because of the controversy between the Prague and the Brno groups.

Nevertheless, the controversy had no impact on building activity, which had been rapidly growing since the mid-1930s in connection with the booming national economy. Teige's view of architecture as a branch of science lost any support except perhaps within the PAS group, and discussion on this topic was closed in 1935 by Josef Havlíček and Karel Honzík, who wrote in Vít Obrtel's magazine *KVART* (QUART) that "depriving architecture of its sentimental aspects . . . means converting the living, biological organism of construction into a barrackslike utilitarian storage of people, and in urban planning it is the way to deadly boring towns."

In 1935 Le Corbusier came to Czechoslovakia on Jan Baťa's invitation to act as a jury member in the Zlín housing competition organized by the Baťa Company. The jury, whose other members were Pavel Janák, Bohuslav Fuchs, Jaroslav Syristé, and Professor Schoen from Zagreb, selected the single-family house designs sub-

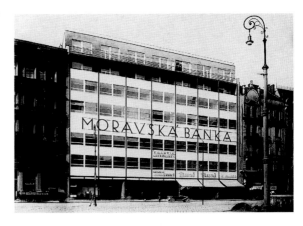

3.54. *Bohuslav Fuchs. Moravská Banka. Brno, 1930–31.*

mitted by the Swedish architect Erick Svedlund and by Vladimír Karfík of Zlín and the semidetached houses designed by Adolf Benš and František Jech of Prague and by Antonín Vítek of Zlín, which were then built by Jan Baťa in the exemplary housing development Nad Lomem. Baťa asked Le Corbusier to prepare a study concerning the regulation of the Dřevnice River valley between Zlín and Otrokovice, including what was known as the Southern Slopes, studies for standardized department stores in France, and a study of the Baťa Pavilion for the International Exposition in Paris. However, there was a misunderstanding between Le Corbusier

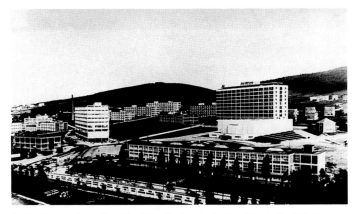

3.55. View of city center. Zlín, 1935. Master plan by František Lydie Gahura.

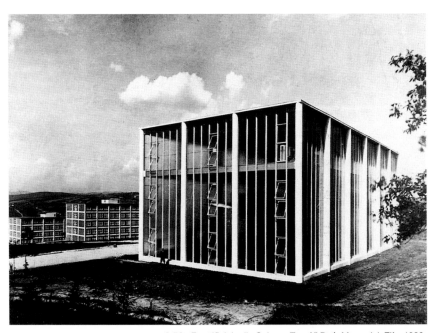

3.56. František Lydie Gahura. Tomáš Baťa Memorial. Zlín, 1932.

and Baťa. Whereas Baťa proclaimed the slogan "living separately, working together" and preferred single-family houses amid greenery, following the example of England, Le Corbusier suggested a group of tall collective blocks on the Southern Slopes. This was unacceptable for Baťa, and the only Corbusier idea that materialized was the facade of standardized department stores for France, which Jan Baťa and Vladimír Karfík also applied to the company store in Amsterdam.

Yet Le Corbusier dominated modern Czech architecture and his style found many individual modifications throughout the country. Le Corbusier's strip windows were widely applied, particularly in luxurious houses in Prague. They were used in houses filling the voids in apartment blocks in New Town, Vinohrady, Holešovice, Letná, and other districts dating from the turn of the century. A facade model generally followed was Le Corbusier's own house in Paris. However, the ground plans are quite different, with rather classical principles from the turn of the century: the hall in the middle of the apartment is connected by folding glass walls to living rooms on both sides, which produced more light and better ventilation across the depth of the apartment. This type was developed in Prague, in particular, by Eugen Rosenberg,

who after graduating from Gočár's school at the Academy of Fine Arts worked in Le Corbusier's studio and after his return to Prague built a number of such houses in the Letná, Holešovice, and New Town districts. In some cases, for instance in the house for Karel Janú on Milada Horáková Avenue, the blocks also contained apartments

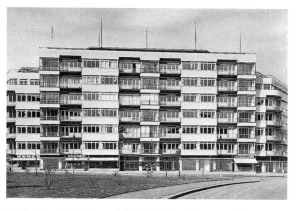

3.57. Richard F. Podzemný. Provincial Bank Apartment House. Liberty Square, Prague-Dejvice. 1936–38.

of the maisonnette type. Emanuel Hruška, Jaroslav Stockar, Josef Šolc, Hilar Pacanovský, Václav Kopecký, and other architects also designed and constructed such blocks.

This type of high-quality apartment house culminated in the Provincial Bank Apartment House on the corner of Liberty Square, Dejvice District, designed by Janák's pupil Richard F. Podzemný (fig. 3.57) In his winning 1936 competition project Podzemný united the five staircase sections in one unit, with a common entrance and a foyer in the square front and an interior street on the ground floor to which the vertical circulation (staircases and elevators) of indi-

vidual sections connects. The building exhibits high-standard equipment, with underground garages, a tennis court inside the block, and a solar terrace on the roof, and displays an excellent

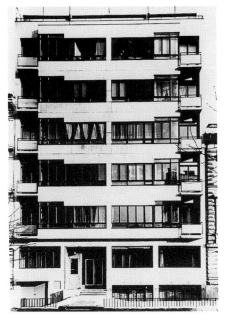

3.58. Václav Kopecký. Apartment house. Prague-New Town, 1938.

functional and architectural layout with direct lighting in all apartment rooms and a sculptural, ceramic-lined main facade combining strip windows, winter gardens, and loggias. Among other high-quality apartment houses built at the end of the 1930s, two in particular should be mentioned: one in Prague-Letná of 1938, designed by Josef Havlíček and another in Prague-New Town by Václav Kopecký, also of 1938 (fig. 3.58). Both were elegant examples of the urban, functionalist designs popular at this time in many European countries and featuring extensive horizontal

fenestration, characteristic corner windows, and a large number of balconies, terraces, and flat roof-terraces. Similar but more modest apartment houses can be found in other towns: in Brno, for instance, by the Kubú brothers, and in Přerov in the apartment house for the industrialist Zejda by Oskar and Ella Oehler.

In 1936 another series of competitions for municipal blocks with small apartments was organized in Prague and Brno. As a result, housing developments were built in Prague-Brevnov to the plans by Antonín Černý and a group of young architects including Václav Hilský, Rudolf Jasenský, František Jech, and Karel Kozelka; in Holešovice District by F. M. Černý and Kamil Ossendorf; in Libeň District by Josef Chochol and Richard Podzemný; in Brno by Bedřich Rozehnal and a group of Prague architects including Hilský, Jasenský, Jech, and Kozelka on Renneská Street; and elsewhere by Josef Polásek.

In the late 1930s new hospitals were conceived in the functionalist spirit, most designed by Bedřich Rozehnal, an architect from Brno who specialized in this particular field after the success of his pavilion-based Institute for Radiation Treatment on the Yello Hill. In the large-scale pavilion-based hospitals built in Nové Město na Moravě, Dačice, and Kyjov he developed a new type of medical facility corresponding to the technological and psychological changes in medical care. The in-patient pavilions with characteristic facades are primarily conceived as two-bay buildings on a 7.2-

meter module, with well-lit glass spaces for social contact instead of dark corridors. Rozehnal typically used large surfaces made of glass bricks on both the interior and exterior. Among the other top works in this field are the pavilion-based sanatorium in Vráž by Antonín Tenzer, František Čermák, and Gustav Paul and the dermato-venerological pavilion of Bulovka Hospital in Prague by Jan Rosůlek.

Among the new office buildings, a sixteen-story headquarter building for the Baťa Company was constructed in the center of Zlín in 1937–38 to plans by Vladimír Karfík (fig. 3.59). It was the tallest building in Europe at the time, with the skeletal reinforced-concrete frame planned on a 6.5-meter square module. Karfík borrowed the idea of skeletal planning from Chicago high-rise constructions, with which he became familiar during his four-year stay in that city. Of interest is the general manager's office placed in the fully air-conditioned elevator. Glass facades were no longer confined to Baťa shops; they were also used in the Brouk & Babka department stores (1938–39) built in Prague by Josef Kittrich and Josef Hrubý and in Kladno and Liberec by Jan Gillar.

Of the theaters built in the 1930s, the most important is that in Ustí nad Orlicí (1934–36) (fig. 3.60). Kamil Roškot connected the auditorium with the stage tower by long horizontal balconies and thus created a monumental composition using modern vocabulary. Jan Vísek won the two-round competition for the National Theater in Brno, yet his excellent and functionally well-conceived design could not be realized due to the outbreak of World War II.

The field of industrial, transportation, and exhibition buildings in Czechoslovakia also yielded several remarkable examples of design. Increasing air travel required a new airport in Prague. After a 1931 competition the airport was built with a ceramic-tiled passenger hall to plans by Adolf Benš.

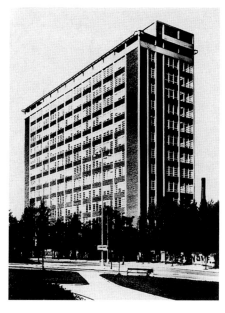

3.59. Vladimír Karfík. Baťa headquarters. Zlín, 1937–38.

The late 1920s was marked by a great building boom in Brno. Master plans, such as the Greater Brno Master Plan prepared by Bohuslav Fuchs, Josef Peňáz, and František Sklenář, offered a basis for further works in the town. The ideas of this project were further developed in another town planning competition, the Master Plan for the Brno Exhibition Area, won by Josef Kalous. The Exhibition Area opened its gates in 1928

when the Exhibition of Contemporary Culture was organized on the occasion of the tenth anniversary of the Czechoslovak Republic. Kalous won the commission for the main pavilion, the so-called Palace of Trade and Industry (fig. 3.62). By using reinforced-concrete parabolic arches, the designers succeeded in creating a monumental edifice that dominated the

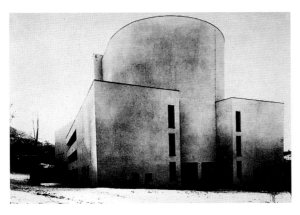

3.60. Kamil Roškot. Theater. Ustí nad Orlicí, 1934–36.

whole area. Among other pavilions designed for this exhibition were Josef Gočár's Pavilion of Fine Arts, Pavel Janák's Pavilion of the School of Industrial Arts, Bohuslav Fuchs's Pavilion of the City of Brno, and Jiří Kroha's Man and Mankind Pavilion.

The young Czech state was represented at international exhibitions and fairs abroad by national pavilions conceived exclusively in the functionalist style, to the design of Adolf Benš in Liege (1930), Kamil Roškot in Chicago (1933) (fig. 3.61), and Antonín Heythum in Brussels (1935). In the period of economic revival and boom before World War II, two important exhibitions were

organized: the "Building and Housing Exhibition" in Brno in the autumn of 1933 and the "VABU" exhibition (architecture, housing, and urban planning) in Prague in the summer of 1935. The 1933 Brno exhibition also produced theoretical works, particularly the *Sociological Fragment of Dwelling* by Jiří Kroha, and displayed examples of the latest architectural works, such as the excellent maternity hospital built in Brno by Jan Vísek. The VABU exhibition was organized on the occasion of a congress of the International Housing Union held in Prague to review the work of Czechoslovakian architects in the last decade, from small single-family houses to regional planning. The exhibition was visited by many foreign specialists, including Auguste Perret, who were surprised by the high quality of the architecture. Congress participants also visited Hradec Králové, Zlín, Brno, and Bratislava to see modern architecture. As a result, Czechoslovakian architecture was increasingly publicized in the top European architecture journals.

The second decade of Czechoslovak functionalism closed superbly with the construction of two exhibition pavilions—for the world expositions in Paris (1937) and New York (1939). The Paris pavilion, made to the winning design by Jaromír Krejcar, can be regarded as a manifesto anticipating the high-tech movement in architecture of the mid-1960s (figs. 3.63,

3.64, 3.65). The steel structure with four columns bears a cantileverlike glass jacket over the lookout terrace on the Seine embankment. The pavilion proved the high level of Czechoslovakian industry and technology on the eve of World War II. As opposed to the poetic rationalism and constructivist spirit of the Paris pavilion, the pavilion in New York, built to plans by Kamil Roškot, showed a trend toward monumentalism in modern architecture, with sharp contours of white masses, a play of light and shadow on large unbroken surfaces, and outstanding access roads and terraces. No wonder the French critic Michel Ragon called Roškot "a Czech Le Corbusier."

Paradoxically, the decade of evolution from the beginning of the 1930s to the outbreak of World War II began with the Left Front movement and with theoretical efforts within the Czechoslovak CIAM group aimed at a new formulation of the small apartment, yet it saw the realization of architecture that reflected middle- and upper-class culture, which identified with and sponsored functionalism. This particular feature of modern Czech architecture differs from the evolution of modernism in Germany and the Netherlands.

A symbolic end to the era was the exhibition "For New Architecture" organized at the Museum of Decorative Arts in Prague in 1940, when the country was already occupied by German Nazis. Czechoslovakia was to be separated for more than forty years from international architectural development.

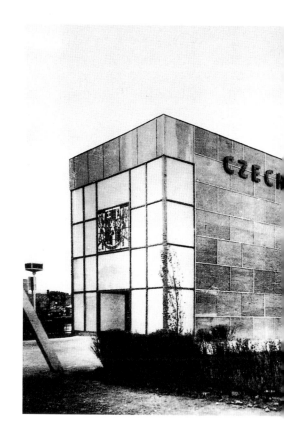

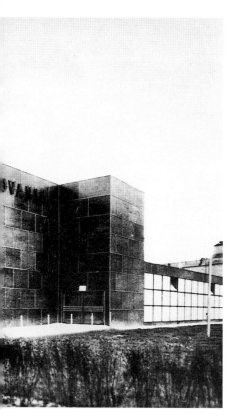

3.61. Kamil Roškot. Czechoslovak Pavilion. "Century of Progress" Chicago World's Fair, 1933.

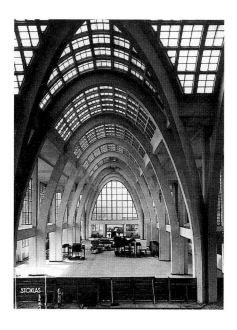

3.62. Josef Kalous. Palace of Trade and Industry. Exhibition of Contemporary Culture. Brno, 1926–28.

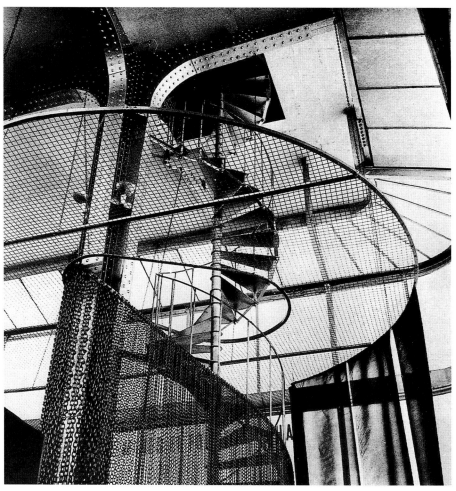

3.63. *Jaromír Krejcar. Czechoslovak Pavilion. Paris International Exposition, 1937.*

3.64. Jaromír Krejcar. Czechoslovak Pavilion. Paris International Exposition, 1937.

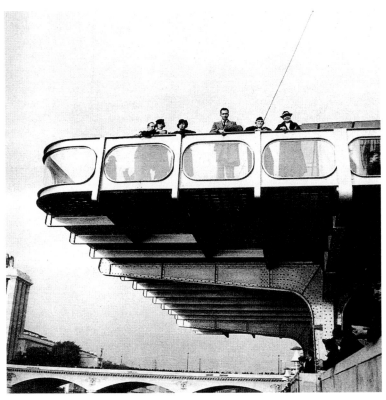

3.65. Jaromír Krejcar. Czechoslovak Pavilion. Paris International Exposition, 1937.

elbach

Handlova o

R I A

C

Z

F

C

H

O

Zvolen

WIEN
(Vienna)

Trnava

Vah

Nitra

Stiavnica

Krupina

Luč

Sa

Széczén

Leitha

Bratislava
(Pressburg)

Danube

Nové Zámky

Vác

Bala

P
Rom

Neusiedler

Magyaróvár

Moson

Komárno (Duna)

Esztergom
(Gran)

ener Neustadt

Lébény

Csorna

Győr

Komárom

Tata

Szentendre

Gödöllő

Rákospa

Lake

Bánhida

Ujpest

opron

toszentmiklos

Kapuvar

Győrszentmarton

Bicske

Zsámbek

BUD

eg

Mihályi

Varsány

Kisbér

Felscút

Budafok

Kispest

as

Csepreg

Raba

Mór

Erd

Csepel

illely

Sárvár

Papa

Zirc

Székesfehérvár

Vál

Soroksar

Monor

ger

Celldömölk

Ercs

Pil

Vasvár

Rum

Devecser

Varoslőd

Veszprém

Várpalota

Ráckeve

Dömsöd

Kormend

Balatonfüred

Adony

Kunszentmiklo

Zalaszentgrot

Sümeg

Lepsény

Kerekegyház

tgotthard

Tapolcza

Balaton

Sárbogárd

Kecske

lovo

Zala-

Keszthely

Lake

Siófok

Ozora

SÁRVIZ

Szabadszalla

egerszeg

Balaton

Dunaföldvar

Solt

Nova

Paksa

Karád

Tab

SIÓ

Paks

Kiskunfé

Söjtör

Balatonszentgyörgy

Tamási

Gyonk

CANAL

Dunapataj

Kisk

Lenti

Marczali

Kiskomárom

Tolna

Kalocsa

Kecel

Nagykanisza

Nagybájom

Dombóvar

Szekszárd

Kiskunhalas

Somogyszob

Kaposvár

Janoshalma

Zakány

Csurgo

Kadarkút

Komlo

Baja

Berzencze

Pécs
(Fünfkirchen)

Bátaszék

Bácsalma

Szigetvár

Mohács

Duna

Barcs

Dráva

Villany

Sombo

U

G

O

S

L

A

V

Siklos

Danube

Osijek
(Eszék)

SLOVAKIA

Rimavská
Sobota

Szendrő

Gonc

Sátoraljaújhely

Latorica

Edeleny

Sárospatak

Fórró

Tolcsvao

Kisvárda

(Uno) R.

Putnok

Sajószentpeter

Balsa

Dombrád

Bereh

Miskolc

Szerencs

Tokaj

Nyirmada

Fehergyarma

Nadasd

Diósgyőr

Felsőzsolca

Nyiregyháza

Mátészalk

Emőd

Nagykalló

Eger
(Erlau)

Mezőcsato

Bulgár

Hajdunánás

Nyirbátor

Gyöngyös

Mezőkövesd

Idudorog

Nyirbogát

Nyiradony

Kál

Hajdu...mény

Carei

Jászárokszallas

Heves

Balm..zujváros

Hajduhadház

Tiszafüred

Debrecen

Jászapáti

Hajduszoboszló

Valea-lui Mihai

Jászberény

Abádszalok

Nagykáta

Nádudvar

Nagyleta

Jászladány

Kunhegyes

Ujszász

Karcag

Püspökladány

Berettyóujfalu

Abony

Szolnok

Kisújszallás

Nagykőrös

Törökszentmiklós

Füzesgyarmat

Oradea

Mezőtur

Turkeve

Dévaványa

...josmizse

Szeghalom

Gyoma

Vésztő

Alpár

Endrod

Szarvas

Mezőberény

Salonta Mare

...áza

Kunszentmárton

Békés

Csongrád

Békéscsaba

Gyula

Sarkad

Szentes

Mindszent

Oroshaza

Ketegyhaza

Kistelek

Hódmező-
Vásárhely

...ndorozma

Mezőhegyes

Szeged

Makó

Battonya

Subotica
(Theresiopel)

Nádlac

U **Arad**

Timişoara

HUNGARY

Copyright by C.S. Hammond & Co., N.Y.

SCALE OF MILES

0 10 20 30 40 50

National Capitals

Railroads

Canals

COMPETING IDEAS IN HUNGARIAN ARCHITECTURE

JOHN MACSAI

To understand the significance of avant-garde modern architecture in Hungary between the world wars, one must realize that modern buildings constituted a relatively small part of the total construction output of the period. Compared with the feverish construction activity in turn-of-the-century Budapest, there were altogether few new buildings between 1919 and 1944. More importantly, modernism—as represented by Bauhaus-trained or influenced architects—was opposed from many sides.

In all but a few Budapest districts (Rózsadomb, Svábhegy, Újlipótváros) the number of modern buildings built between 1919 and 1944 was limited. This is even more visible in the smaller cities of Hungary. One obvious explanation is the state of the economy after World War I: even in victorious countries, it took years for the economy to recover. Hungary not only suffered war damage and terrible inflation but also lost her best agricultural land, as well as a majority of her forests, mines, and other sources of raw material, in the Treaty of Versailles. This brought the economy to a standstill. To exacerbate the problem, thousands of refugees poured in from the territo-

ries given in Versailles to Czechoslovakia, Rumania, and Yugoslavia, creating a housing shortage of nearly two hundred thousand units. Prior to 1914, approximately five hundred new apartments had been built annually in Budapest, but this number dropped to thirty in 1917, and the pre-1914 number was superseded only in 1927. And just as the economy showed signs of improvement, Hungary—like the rest of Europe—was hit by the 1931 depression, unemployment, and economic stagnation. Recovery did not occur until the mid-1930s, with added impetus provided by war production after 1939. As a result, most of the country's modern buildings were built during the early 1940s. By this time, there was an economic mini-boom, and rental apartment buildings seemed a better investment even than hard, foreign currency. Modern architecture, which had enjoyed only limited acceptance in the 1930s, was by now generally acceptable, though in a more mellow, more decorative form. Many architects who had first found it alien were willing to practice a tamer version during the 1940s.

Prior to 1940 the modern idiom was appreciated only by the well-educated, progressive sector of

the population. It took strong convictions, if not outright courage, to be different, to build a flat-roofed villa, a pure white cube with spiral stairs that resembled a ship more than a house among its conservative, high-gabled neighbors. Much of the progressive upper-middle class lived in Budapest. The nouveau riche manufacturers and merchants either truly appreciated avant-garde modernism or, even if they did not understand what it was all about, wanted it as a visible symbol of achievement. It was an expensive luxury to live in and properly furnish these Bauhaus buildings, which looked misleadingly simple with their unusual and, therefore, expensive details. With inventive sliding walls and windows, as well as lots of built-in cabinetry, these buildings required extra attention and highly skilled labor.

The upper class and the aristocracy, who could easily afford the modern, preferred safe, conservative architecture, continuing the eclectic traditions of the previous century: neoclassical, neo-Romanesque, neo-Gothic, neo-baroque, etc. These attitudes were mirrored throughout Europe where, after the turn-of-the-century art nouveau and the short-lived National Romantic episode, a strong conservative revival set in.

While the Hungarian economy showed signs of improvement by the late 1930s, after World War I only municipal and state governments could commission significant public buildings other than housing. The Hungarian government was generally conservative, and this conservatism was further reinforced by the right-wing Horthy regime, which was pushed further to the right as the Nazis gained strength and finally power in Germany. Hungary's friendliness toward the two major fascist governments in Europe, Germany and especially Italy, also affected the fate of Hungarian architecture.

The strongest, most indigenous architectural direction in Hungary, National Romanticism,

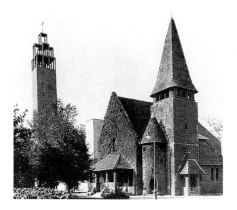

4.1. Aladár Árkay. Roman Catholic church, Városmajor district. Budapest, 1920.

flourished between 1890 and 1910 and had almost disappeared by the time the Bauhaus arrived. This movement, under the leadership of Ödön Lechner, set out to create a Hungarian national style. Its historical antecedent was the English Arts and Crafts movement, and it was fueled by the awakening interest in folk art and rural architecture, especially that of Transylvania. It was also influenced by the work of Finnish architects who pursued similar goals. The Hungarians worked to achieve an identity vis-à-vis Hapsburg Austria and its nationalities; the Finns wanted to express their national identity in opposition to Tsarist Russia. The work of Eliel

Saarinen, Hermann Gesellius, and the early work of Lars Sonck influenced the "young ones," the second generation of Hungarian National Romantics—leader Károly Kós, Dénes Györgyi, Dezső

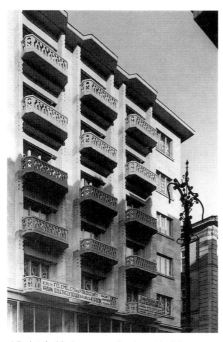

4.2. István Medgyasszay. Apartment building on József Attila Street. Budapest, 1927.

Zrumeczky, Béla Jánszki, Béla Lajta, and many others. By 1920 however, Lajta, whose style had already gravitated toward the modern, died, and Kós, who moved to Rumania to show solidarity with its Hungarian minority, withdrew from practice. While Aladár Árkay had never been a member of the group, his work after World War I followed principles similar to those of the "young ones" around the turn of the century (fig. 4.1). The only surviving and active member, István Medgyasszay, not only continued to build in the National Romantic

idiom but—more interestingly—used National Romantic detail on otherwise strictly modern apartment buildings throughout the 1920s and 1930s (fig. 4.2).

While National Romanticism declined after World War I, the other survivor from the previous century, eclectic conservatism, stayed much alive. Conservatives found the "modern" repugnant. Many members of the architectural avant-garde were active socialists or secret communists (the Communist Party was declared illegal during much of the period), but this was not the main reason that they received no commissions from the government or from the aristocracy. Officialdom and the aristocracy simply found the pristine, undecorated cubic forms of the Bauhaus ugly. They, like the conservative section of the upper-middle class, were more at home with the familiar, decorative styles of the past—Roman, Gothic, or Renaissance. The Hungarian historian, Gyula Szekfű, in his important book, *Három Nemzedék* (Three Generations), christened this entire class "neo-baroque." The name stuck, and neo-baroque stands today in Hungary for all eclectic styles of the period between the two world wars. The majority of these neo-baroque buildings were commissioned by the government or the Catholic Church, another conservative force.

In contrast to the modern, the neo-baroque was not limited predominantly to Budapest. Most of the small towns in Hungary, destroyed during the 150-year Ottoman occupation, were rebuilt during the eighteenth century in

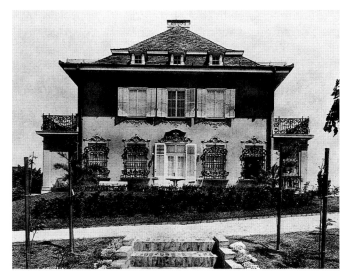

4.3. Gyula Wälder. House on Szemlőhegyi Avenue. Budapest, 1937.

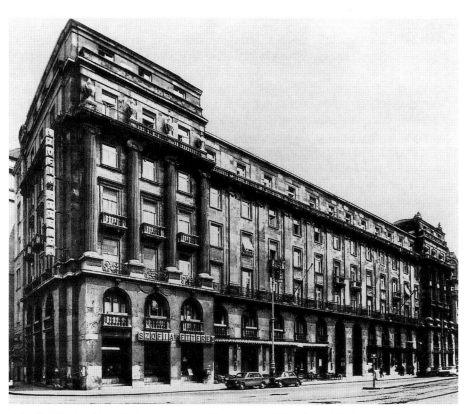

4.4. Béla Málnai and Gyula Haász. Apartment building on Kossuth Lajos Square. Budapest, 1929.

a true baroque style that dictated their scale and character. Consequently, the neo-baroque harmonized with the existing context of towns like Debrecen, Szeged, and Pécs. Gyula Wälder and Iván Kotsis were the most sought-after neo-baroque practitioners, followed in popularity by Flóris Korb, Dénes Györgyi, Béla Málnai, Lajos Kozma, and others (figs. 4.3, 4.4).

4.5. György Rácz. Agricultural College. Sárospatak, 1940.

Neo-baroque preceded modernism and continued from 1911 through 1944. Another direction that paralleled strict modernism was practiced by a group of architects that avant-gardist Farkas Molnár named "gables" in contrast to the modernists who preferred flat roofs. This group accepted modern functional planning principles but found flat-roofed buildings ill-fitted to the local fabric. Architects of this movement, like their National Romantic colleagues around the turn-of-the-century, advocated strong hipped or gabled roofs and "natural" materials such as fieldstone, wood, and rough stucco. They were also influenced by Giuseppe Pagano's 1936 book about Italian regionalism and especially by the German *Heimatstil* movement that advocated the continuation of folk tradition and nationalism in architecture. Outstanding practitioners of the "gables" were former modernists Pál Virágh and György Rácz and former neo-baroque designer Iván Kotsis. A more relaxed attitude toward tradition and the vernacular was perceptible almost everywhere in Europe at this time, even in the work of Le Corbusier, the apostle of modernism.

Populist interest in the folk tradition received a strong impetus at the Department of Architecture of the Polytechnical University in Budapest. Students were not only taught how to reconstruct historic buildings but were required to measure and document peasant architecture of the villages. At the same time, a group of writers and sociologists focused on the poverty, minimum hygiene, and unhealthy conditions in the typical Hungarian peasant house. It is no wonder that these architects who felt so strongly about folk tradition found Bauhaus architecture alien and ill-fitting in the Hungarian rural context. The architecture that Jenő Padányi-Gulyás, János Wanner, Gyula Rimanóczy, László Miskolczy, and others created continued local vernacular traditions while solving waterproofing, light, ventilation, and sanitation problems long neglected in the villages (fig. 4.5).

In addition to the contextual, tamed modernism of the "gables"

and the village revival of the populists, the modernists faced other parallel or opposing movements. The followers of the picturesque were influenced strongly by the decorative, romantic brick architecture of Holland (Michel de Klerk), Germany (Fritz Höger), and Scandinavia (Lars Sonck in Finland and Ragnar Östberg in Sweden). Béla Rerrich's development of the square in front of the cathedral in Szeged (1930) is an outstanding example of brick romanticism (fig. 4.6); another is the crematorium in Debrecen (1931) by József Borsos. Both use arched colonnades and picturesque, imaginative brick details. Though fieldstone instead of brick, the romantic arches place Károly Weichinger's church for the Pauline order in Pécs (1937) and monastery in Budapest (1937) in this category (fig. 4.7).

Hungary's strong friendship toward and cultural ties with Mussolini's Italy heavily influenced a group of architects whose paradigms were the designers of the Italian *novecento,* a movement successfully combining neoclassicism with romanticism. The architects, painters, and sculptors who spent time at the Hungarian Academy in Rome, at the historic Palazzo Falconieri, brought home a strong affection for neoclassicism. Classical composition, stylized classical detail and sculpture, and columnar arcades characterize this movement. The best examples are the apartment building on the corner of Múzeum Boulevard and Rákóczi Avenue in Budapest (1935), by Béla Baráth and Ede Novák, the bank

building in Debrecen (1938), by Jenő Padányi-Gulyás, and the Roman Catholic church in the Pasarét district of Budapest (1934), by Gyula Rimanóczy (fig. 4.8). *Novecento* detail can be found on generally modern structures such as the apartment building by Bertalan Árkay on Irinyi József Street (Budapest, 1941); and *novecento* composition, arcades, and an arch

4.6. *Béla Rerrich. Dome Square. Szeged, 1930.*

infuse the brick-romantic apartment complex by Gyula Wälder on Madách Square (Budapest, 1938) (fig. 4.9). Even the Roman Catholic church by Aladár and Bertalan Árkay in Városmajor (Budapest, 1940), an otherwise modern structure, reveals the influence of the "Rome school," as this classicizing movement was generally called.

Several Hungarian architects, such as the National Romantic István Medgyasszay, stood for many years outside of the avant-garde camp but later switched, designing competent modern buildings. Architects, like other artists, are not immune to fashion. They also must survive, and in

order to get commissions they often agree to serve clients whose aesthetic preferences they may not share but accept. Architects of this period fortunately received thorough training in historic styles at the school of architecture in Budapest, and it was not unusual that their work spanned several styles or "isms." Béla Málnai, who designed one of the earliest Otto

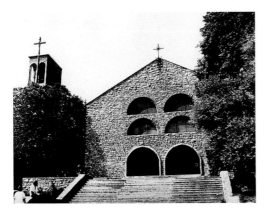

4.7. Károly Weichinger. Church for the Pauline order. Pécs, 1937.

Wagner-inspired modern buildings in Budapest (originally the Czech-Hungarian Bank on Nádor Street, 1912), also designed a number of successful neo-baroque structures. Béla Lajta, who in the 1890s was a talented National Romantic architect, just prior to World War I produced the most significant forerunners of architectural modernism in Budapest (originally the Erzsébetvárosi Bank on Rákóczi Avenue, 1911; the Rózsavölgyi House on Szervita Square, 1912; the Commercial High School on Vas Street, 1910). Dénes Györgyi, who in 1932 designed one of the finest modern apartment buildings, on Honvéd Street in Budapest, designed equally fine structures in

the National Romantic idiom before the war. Lajos Kozma, who died in 1951 a well-respected modernist, also started out in the National Romantic movement and during the 1920s designed numerous neo-baroque buildings. Farkas Molnár, the most talented and inventive of the Bauhaus architects, just a few years before his untimely death in 1945 switched from the political left to the right and in his last, rather romantic buildings one can hardly recognize the avant-garde leader of the Hungarian CIAM group of the 1930s. Finally, architects like Iván Kotsis did reputable work in any style in which they elected to work. They selected the style that they found appropriate for the commission: neo-baroque for a government structure, domesticated modern with gabled roof for a villa in a contextual setting, *novecento* with arches and dome for a church, and strict flat-roofed modern for an urban multistory apartment building.

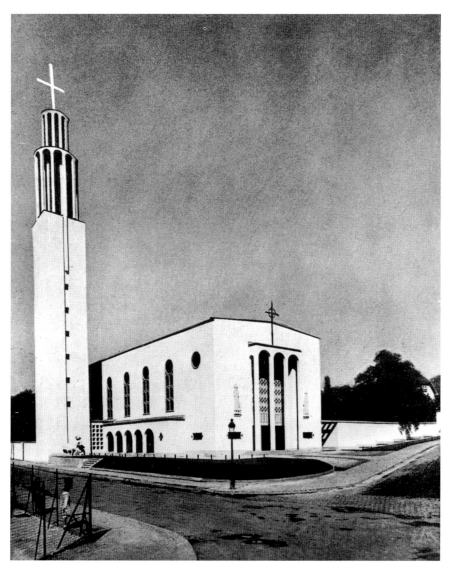

4.8. Gyula Rimanóczy. Roman Catholic church, Pasarét district. Budapest, 1934.

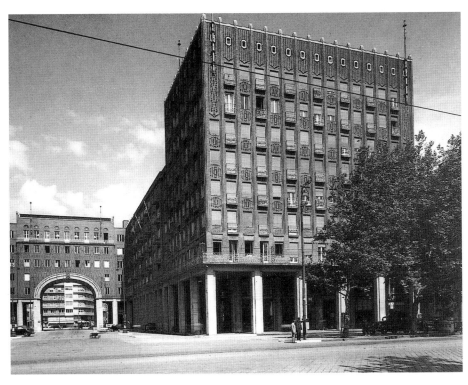

4.9. Gyula Wälder. Apartment building on Madách Square. Budapest, 1938.

Moruva

C

Z

Trnava

Vah

R

E

Nitra

ns)

atha

Bratislava
(Pressburg)

R.

Danube

Nova

edler

Magyaróvár

Moson

Lébény

Komárno

(Du

eustadt

ake

Csorna

Komárom

Győr

miklos

Kapuvar

Mihalyi

Győrszentmar

Csepreg

Varsány

Kisbér

Raba

F

Mór

Sárvár

Papa

Celldömölk

Zirc

Székesfeh

Varoslőd

Várpa

Rum

Devecser

Veszprém

ormend

Balatonfüred

Le

szentgrot

Sümeg

t

o

n

Sár

ard

Tapolcza

5

Zvolen

Stiavnica

Krupina

Lučenec

Sal.otarján

Szeczény

ámky

Balassagyarmat-

Pásztó
Romhány

Gyöngyös

Vác

Esztergom
(Gran)

Hatvan

ata

Szentendre

Bánhida

Ujpest

Gödöllő

Aszód

Bleske

Zsámbek

Rákospalota

BUDAPEST

scút

Budafok

Kispest

Ja.

Nagyká

Erd

Csepel

Jászladán

Vál

Soroksár

vár

Eresi

Monor
Pilıs

Abony

Ráckeve

Cegléd

Adony

Dömsöd

Nagykő

sény

Kunszentmiklós

gárd

Kerekegyháza

Lajosmizse

Kecskemet

FUNCTIONALISM IN HUNGARIAN ARCHITECTURE

JÁNOS BONTA

Modern architecture, in its Bauhaus inspired version, was born in Hungary under the most unfavorable conditions. Hungary bled to death during World War I and the two revolutions that immediately followed. A country that lost a significant portion of its territory in the 1919 Treaty of Versailles, that suffered from economic stagnation after the war and then again during the depression, was not the most fertile soil in which to plant the seed of modern architecture. That modern architecture flowered at all is due to the pioneering work of the two previous movements.

One of these movements, best defined as premodern rationalism, set out to create a functional, rational architecture that responded to the needs of a modern world using contemporary techniques. This movement sought a complete break with historicism and received inspiration from Vienna, the home of the Secession. The work of the Secessionist giants, Otto Wagner, Josef Hoffmann, Max Fabiani, and others, like Adolf Loos, influenced Hungarian architects who were turning away from eclecticism and the excesses of art nouveau. The most outstanding were Béla Lajta, Béla Málnai, and József Vágó.

The uniquely talented Lajta was influenced not only by Loos's anti-ornament stand but also by Max Fabiani, especially his office and apartment building, the Astaria House (Vienna, 1902). Lajta's Rózsavölgyi House (fig. 5.1), with similar functions (Budapest, 1912), was inspired by both the Astaria and Loos's Goldman & Salatsch department store (Vienna, 1910). All three buildings follow a strong Central European prototype with stores on the first floor, offices and stores on the second and third, and apartments above; however, Lajta's building is structurally more expressive than the other two. Lajta's other major buildings, especially his Commercial High School on Vas Street (Budapest, 1910) augured a great future for this talented and incredibly versatile young architect whose death at age forty-seven interrupted a career that likely would have placed him among the truly great modernists (fig. 5.2).

Lajta's Rózsavölgyi House and the Czech-Hungarian Bank (fig. 5.3) by Béla Málnai (Budapest, 1912) have both gained iconic significance in Hungarian architectural history as harbingers of modernism. Málnai's bank, however, together with his apartment buildings of simi-

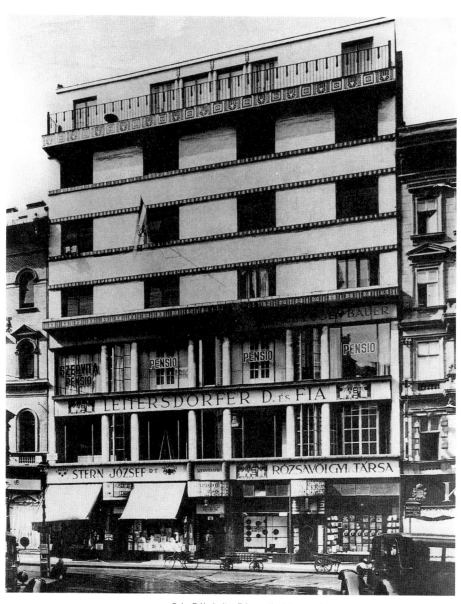

5.1. *Béla Lajta. Rózsavölgyi House. Szervita Square, Budapest, 1912.*

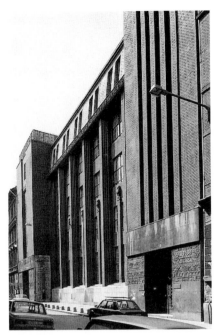

5.2. *Béla Lajta. Commercial High School. Vas Street, Budapest, 1910.*

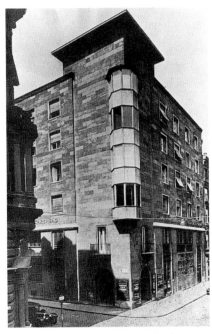

5.3. *Béla Málnai. Czech-Hungarian Bank. Nádor Street, Budapest, 1912.*

lar vintage, shows a simplified classicism in its projecting bays and vertical elements. This return to neoclassicism can also be found in the work of Loos and Hoffmann. Otto Wagner's work, particularly his Postal Savings Bank (Vienna, 1904) with a visible aluminum support system for its thin stone veneer, had a lasting effect on the commercial and apartment building (Budapest, 1909) by brothers József and László Vágó.

Though today we view Lajta, Málnai, and the Vágó brothers as precursors of modernism, there was no direct continuity between their work and that of Hungary's Bauhaus-inspired pioneers, Farkas Molnár, József Fischer, Marcel Breuer, Alfréd Forbát, and others. The artistic and literary avant-garde, however, directly affected the pioneers. Much of this came from abroad, where members of the Hungarian Left had emigrated after 1919. They coalesced around avant-garde publications like *Ma* (Today), edited in Vienna from 1916 on by Hungarian writer-painter Lajos Kassák. Those who gathered around Kassák, futurists, dadaists, various followers of geometric abstraction, as well as those in Budapest, including László Moholy-Nagy and Sándor Bortnyik, formed ties between the European progressives and Hungary. Their paintings, collages, and experimental photographs set the tone for the new art of a new world that, they believed, was to augur a happy future for mankind (fig. 5.4).

Most of the emigrants eventually left Vienna and settled in Berlin, Paris, or Moscow. They were joined by younger colleagues from

Hungary who wanted to dedicate their art to the new spirit of modernism and by Jewish students who were barred from the universities by the racist policies of the Hungarian regime. Many found a home in the Bauhaus of Walter Gropius, first in Weimar, then in Dessau, where their compatriot Moholy-Nagy had been in charge of the Vorkurs (the so-called foun-

5.4. *László Moholy-Nagy.* Great Train. *Painting, 1920.*

dation course), since 1923. At the Bauhaus Farkas Molnár designed his pioneering Red Cube House in 1922 (fig. 5.5). In 1925, Marcel Breuer created the world-renowned tubular chair there. Alfréd Forbát, who also studied with Theo van Doesburg, worked in Gropius's office. Other important Hungarians were active in the Bauhaus: the theorist Ernő Kállai; Andor Weininger, who experimented in the theater and dance school; and Gyula Papp, a metalsmith known for his lamps and serving dishes.

When the political situation improved in Hungary, several of the emigrants returned. Kassák continued his propaganda of the avant-garde in the magazine *Dokumentum* (Document), which he founded in 1926. Sándor Bortnyik started his own art school, the Műhely (Workshop). Molnár went to work in the Budapest studio of Pál Ligeti, an architect and philosopher whose book *Új Pantheon Felé* (Toward a New Pantheon) deals with art-historical cycles and attempts to prove the inevitability of the modern. There were also

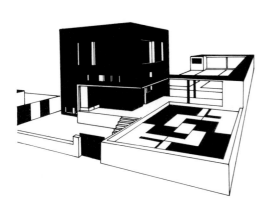

5.5. *Farkas Molnár. Red Cube House. Project, 1922.*

strong winds blowing from Holland, from the De Stijl movement, mainly through the work of van Doesburg. Parallel with those who brought home the avant-garde were several who spent their apprentice years in the West, including Károly Dávid and János Wanner, who worked in the Paris studio of Le Corbusier.

Fortunately, by the mid-1920s there developed, mainly in Budapest but also in some of the smaller towns, a middle class receptive enough of progressive ideas and

modern architecture, which in contrast to historicism also proved very practical in solving many functional problems of modern life.[1] This changed atmosphere allowed modern architecture to ripen in the hands of the talented young generation of architects in spite of the pseudo-feudal conservative policies of the government and poor economic conditions.

In 1929 Gropius invited Molnár and six of his friends to attend the Frankfurt meeting of the Congrès Internationaux d'Architecture Moderne (CIAM), the topic of which was "The Small Apartment." Among the Hungarians, Farkas Molnár and György Rácz contributed three designs. When the delegation returned from Frankfurt, they formed, under Molnár's leadership, the Hungarian branch of the CIAM and were joined by József Fischer and György Masirevich. The group, whose membership fluctuated, became the country's strongest propagator of modern functional architecture. Its philosophy and goals as well as projects found a forum in the periodical *Tér és Forma* (Space and Form). The publisher, Virgil Birbauer (Borbiró) devoted six entire issues to the work of the CIAM members.

The group's social and political views were almost inseparable from its architecture. Naturally, ideology could be applied to practice only insofar as the clients' attitudes and programs permitted. However, the CIAM's articles and the three exhibitions they organized (interior design and handicraft

shows, one in 1931 and two in 1932) gave them unhampered opportunities to express their goals. All three shows exhibited improved housing for the masses. In the first show, the group exhibited the plans for *Kolház* (Collective House), a slab apartment building whose units consisted only of the bathroom surrounded by so-called living-sleeping cells (fig. 5.6). One of these dwelling units was actually built at full scale for the show. In addition, the floor plans called for a communal kitchen-dining room, music room, and children's play room on each apartment floor. Other communal facilities, serving the entire building, were on the ground floor. The design showed how the advantages of communal living could be combined with privacy. The result was an intellectual's utopia far from the actual lifestyle and aspirations of the average citizen. In the second show, the group juxtaposed the typical speculative apartment building of the period with a well-designed modern structure in a garden suburb. As architects vitally involved in social and political criticism, the group successfully illustrated that the masses lived in poverty and overcrowding while many expensive luxury apartments stood unrented. The title of the third show was "Dwelling, City, and Society," further connecting the architectural problem to the social one. It used statistical tabulations and graphs illustrating income distribution, housing conditions, educational opportunities, abortion rates, child mortality, etc. According to the district police captain at the time, the charts and illustrations looked very much like anti-government

agitation, and before the exhibit even opened, the police confiscated the material. Molnár and his six colleagues were indicted, tried, and granted a one-month suspended prison sentence. The CIAM show was not alone in publicizing the inhumane conditions existing in the country:

> Half of the Hungarian population lives in rooms with floors of tamped earth and drinks impure water . . . 78% of the houses in the country are still constructed of mud and adobe. . . . The population of Budapest is 980,000 and there are only 70,000 bathrooms in the city resulting in 75% of the people living in dwelling units without bathrooms.[2]

The strength of the CIAM group and of the architects who joined them proved inadequate to change deep-seated social ills. Their major merit was to call attention to the gravity of the problem and to the possibility of functional architectural and urban planning solutions. They also disseminated the ideas of modern architecture among increasing numbers of architects and clients.

In spite of this widening understanding of the modern, the activity of the CIAM group while it existed (1928–38) was rather limited. The special issues of *Tér és Forma* show altogether fifty projects credited to the group. However, it is not the number of projects but their quality that is noteworthy. These buildings constitute a significant chapter in the history of Hungarian architecture. Out of the fifty, twenty-eight are by Molnár or Fischer (two are joint projects) and the balance by

ten other architects. The majority are single-family houses of modest size. The Hungarian clients for whom they were designed would not have been considered rich in the United States or Western Europe. The technology was not especially unique. They are predominantly white-stuccoed cubic volumes sit-

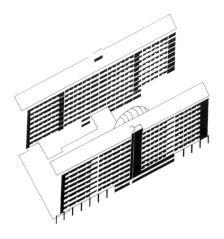

5.6. Hungarian branch, Congrès Internationaux d'Architecture Moderne (CIAM). Kolház (Collective House). Project, 1931.

ting on the sunlit southern slopes of the Buda hills. Surrounded by flowering fruit trees or horse chestnuts, they appear to grow out of a Mediterranean world.

The houses take advantage of reinforced concrete skeletons with bold cantilevers and deep terraces, both of which create intense shadows on the pure white volumes only interrupted by the deep-set oblongs of the windows. The houses are freestanding, and as one circles them, the elevations generate a space-time continuum. The balance of white surface and dark window openings recalls the De Stijl masters, including the graphic designs of the Hungarian Vilmos Huszár.

This is hardly a loquacious style, almost puritanical in its absence of architectural embellishments or details.

To minimize ground coverage on relatively small and expensive lots, the houses have more than one level. Usually the bottom floor facing the slope contains a garage, storage, and a caretaker's apartment; the next level, the first floor, a living room, dining room, kitchen, and terrace; the second floor houses bedrooms and bathrooms; the third floor (when there is one) is for special uses—library, study, or studio. Two-story spaces are rare and rooms, even the living-dining rooms, are not large, though they can combine with other rooms and open up into flowing spaces, providing a variety of spatial combinations through the use of "sliding walls," a favorite Molnár device. Glass sliding doors connect living spaces with terraces, from which stairs lead down to the garden, creating an interior-exterior sequence. Within this general arrangement, the Hungarian CIAM houses show great variety.

Molnár, a student of the Bauhaus, a moving force behind the CIAM, and a convinced leftist, never received major commissions except houses and apartment buildings. But his houses represent the highest level of achievement. In spite of their small scale, they are paradigms of the pristine modern. One of the earliest, on Cserje Street (Budapest, 1931), is a simple two-story box with the upper floor stepping back to provide space for a terrace (fig. 5.7). The house's lightness and elegance are underscored by the terrace railing consisting

5.7. Farkas Molnár. House on Cserje Street. Budapest, 1931.

5.8. *Farkas Molnár. House on Lejtő Street. Budapest, 1932.*

5.9. *Farkas Molnár. House on Lejtő Street. Budapest, 1932.*

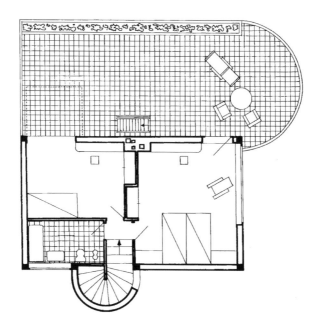

5.10. *Farkas Molnár. Second floor plan, House on Lejtő Street. Budapest, 1932.*

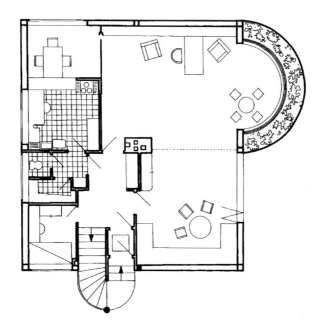

5.11. *Farkas Molnár. Ground floor plan, House on Lejtő Street. Budapest, 1932.*

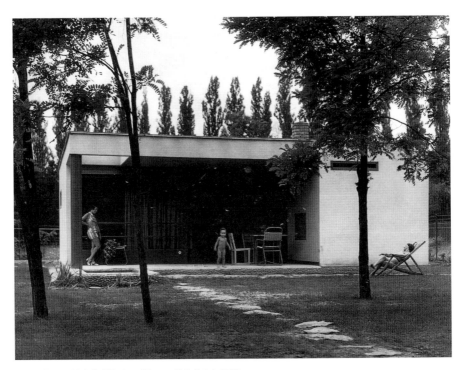

5.12. Farkas Molnár. Weekend House. Felsőgöd, 1933.

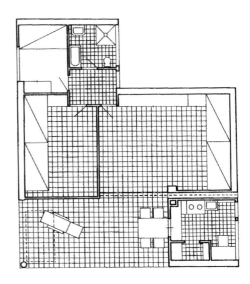

5.13. Farkas Molnár. Floor plan, Weekend House. Felsőgöd, 1933.

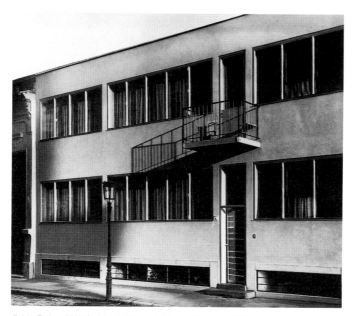

5.14. *Farkas Molnár. Manó Schwartz House. Szeged, 1932.*

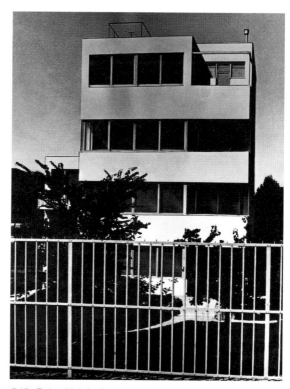

5.15. *Farkas Molnár. Co-op apartment building on Lotz Károly Street. Budapest, 1933.*

of bent metal frames made out of reinforcing rods with wire mesh welded inside.

Far more sophisticated and internationally known is his house on Lejtő Street (Budapest, 1932), which received first prize in the Milan Triennale (figs. 5.8, 5.9, 5.10, 5.11). This is a practical, well-functioning, delightful house with the garage on the lower level. A winding stair leads from the main level to the bedrooms above. The rounded white stair volume, separated from the house by a narrow strip of glass, is further emphasized by the spiral undercut over the entrance. On the main level is the living room with a semicircular window-bay, the double glazing of which accommodates planters between the two layers of glass. Curtains separate the living room from the dining room and from the breakfast area that is spatially part of the kitchen, thus forming a variety of visual sequences. The house is enriched by built-ins: bookcases in the living room and dressing tables and wardrobes in the bedrooms, which open up to the roof terrace with its spectacular view. On the exterior, a staircase with rounded landing forms a powerful upward-moving element while providing rain protection over the entrance door. Its shape is echoed in the living room bay and the rounded rail of the stair that leads up to the roof terrace above the bedrooms. Another example of Molnár's inventiveness is the house known as the Weekend House (Felsőgöd, 1933) (figs. 5.12, 5.13), a simple, minimalist but powerful cube.

Molnár's single-family house for Manó Schwartz (Szeged, 1932) is the only infill building by members of CIAM. Its height matches the eave line of the adjacent eclectic residences, but otherwise this straightforward modern statement expresses two levels with ribbon windows that span the facade (fig. 5.14). This bold horizontality, further strengthened by the narrow, elongated basement fenestration, is asymmetrically interrupted by the vertical element of an entrance-door and balcony-door ensemble, with the balcony adding accent. The simple, elegant facade is enriched by the delicate balance of the vertical balcony rails and horizontal mullions of the entrance door.

Also using horizontal banding of windows and white-stuccoed surfaces is Molnár's co-op apartment building on Lotz Károly Street (Budapest, 1933) (fig. 5.15). It consists of two simple volumes connected by a staircase: the front volume is four stories high and contains two-story apartments; the rear volume has a small apartment on each of its three levels as well as tenants' storage on the first. In the front volume, the dark glass bands recede on the corners, resulting in indented terraces. Important interior features are sliding doors in each unit that separate the library from the living room and the living room from the dining room, providing a variety of spatial experiences similar to those in Molnár's villa on Harangvirág Street (Budapest, 1934).

During the years just prior to World War II, Molnár experimented with various directions within modernism but he never completely abandoned the avant-garde (fig. 5.16). The cooperative apartment

building on Pasaréti Avenue (Budapest, 1937) consists of two buildings on a triangular corner lot, forming a 45-degree angle, connected by a common stair hall (fig. 5.18). The gridded facade on Pasaréti Avenue casts deep shadows, the result of recessed terraces. The horizontal planting boxes that overlap the grid add an essential playfulness to its severe geometry. The lobby entrance features aluminum panels and round openings glazed with colored slots. These cast unique light across the wall, on which is mounted one of Molnár's early colored glass collages (fig. 5.19). Also from this period is the fan-shaped house in Mese Street (Budapest, 1937), which has a corrugated asbestos siding exterior, bold ribbon windows, and flexible interior spaces (fig. 5.17).

In his last design, the Holy Land Church in Hűvösvölgy, Molnár abandoned modernism. He died young, during the siege of Budapest in 1945, from a bullet wound. Gropius considered him a master in the field, "one who died before his life work was completed." Even his abbreviated oeuvre represents the highest achievement of modern Hungarian architecture.

Horizontal "ribbons" characterize one joint work of Molnár and József Fischer—next to Molnár the leading figure of the Hungarian CIAM—a house in Csévi Mews (Budapest, 1935) (fig. 5.20). Both the strong horizontals and the rounded structural columns show the influence of Le Corbusier.

Behind the horizontal spandrel the glass wall steps back twice, creating an interesting terrace configuration. More significant is the other collaborative venture of Molnár and Fischer, the apartment building for the staff of a hospital (Budapest, 1936) (fig. 5.21). Their experience in designing the *Kolház* for the CIAM exhibition

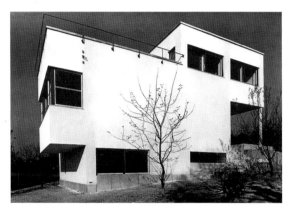

5.16. Farkas Molnár. House on Hankóczy Jenő Street. Budapest, 1933.

came in handy here. The ground floor contains small apartments, housing four people, with covered terraces and exterior access. The upper floors have central corridors along one side of which lie bedrooms and along the other, communal showers, kitchens, and dining rooms (figs. 5.22, 5.23). Each floor ends with a complete two-bedroom apartment. The exterior is strongly horizontal, the projecting end apartments offering relief and counterpoint. Fischer, a socialist, served after 1945 as undersecretary of construction and later as president of the Budapest public works bureau. In 1956, he was secretary of construction in the short-lived government of Imre Nagy.

Fischer's most interesting house, on Csatárka Street (Budapest, 1932), is a cube in the true meaning of the word. Making it pleasant, almost playful on the exterior, is a graphic composition of openings in its taut, white skin (figs. 5.24, 5.25, 5.26). The shape and size of these openings is appropriate for the rooms they serve. The living-dining room occupies much of the ground level, and its large opening logically faces south; the second floor houses the bed-

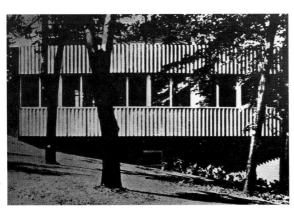

5.17. Farkas Molnár. House on Mese Street. Budapest, 1937.

room and the owner's fifteen-thousand-volume library, which requires minimal southern light. The large, bold horizontal window on the first floor and the narrow, small vertical balcony door above—allowing the occupant to step out to the tiny balcony for a breath of fresh air— form a unique balance enhanced by the delicate balcony railings. On the other hand, the east facade, with minimal openings on the first floor and large windows and balcony on the second, provides a counterpoint.

The most interesting feature of another Fischer house, on Szépvölgyi Avenue (Budapest,

1935), is the spiral stair solution that he borrowed from Molnár (figs. 5.27, 5.28). The verticality of the projecting stair enclosure is well balanced by the glass wall that also turns the corner. The scattered narrow openings near the stair, relieving the otherwise plain surfaces, call to mind a later Le Corbusier solution.

In contrast to the puritanism of Fischer's two previous houses and to the twin houses on Palánta Street (Budapest, 1935) (fig. 5.29), the one that he built for famous Hungarian opera singer Rózsi Walter on Bajza Street (Budapest, 1936) is elaborate, designed for large parties and home concerts (fig. 5.30). The ground floor houses, in addition to a garage and an entrance hall with a grand stair, the caretaker's apartment, kitchen, and laundry. Above this service level, on the main floor are the living and dining rooms that can form one large space for musical events. From the terrace, the curved stair leads down to the garden. The third level contains bedrooms and bathrooms. A spiral service stair connects all levels to the kitchen and laundry. Compared to the solid street facade, the rear elevation is open. Terraces, pergolas, overhangs, and large expanses of glass break down the boundary between interior and exterior space very much in the spirit of the Villa Stein (Garches, 1927) by Le Corbusier.

Some of Fischer's other projects should also be touched upon here. Far from the heroic early

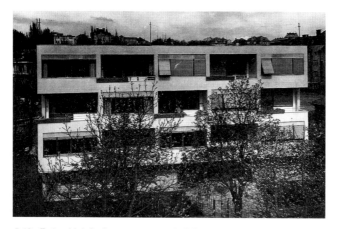

5.18. Farkas Molnár. Co-op apartment building on Pasaréti Avenue.
Budapest, 1937.

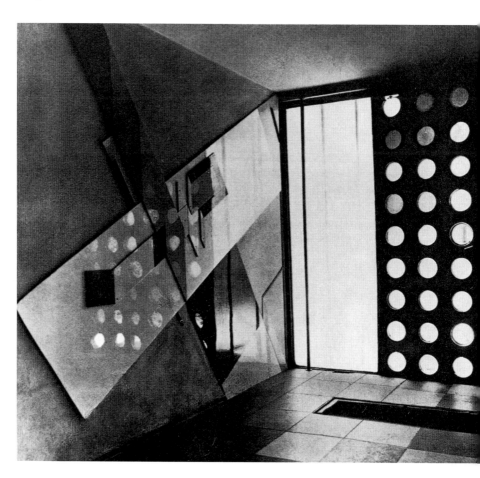

5.19. Farkas Molnár. Lobby, co-op apartment building on Pasaréti Avenue. Budapest, 1937.

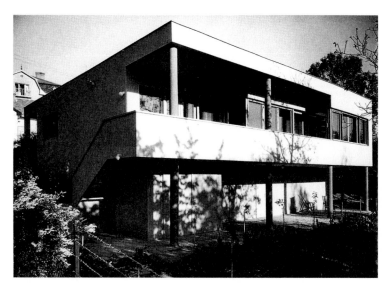

5.20. *József Fisher and Farkas Molnár. House in Csévi Mews,
Budapest, 1935.*

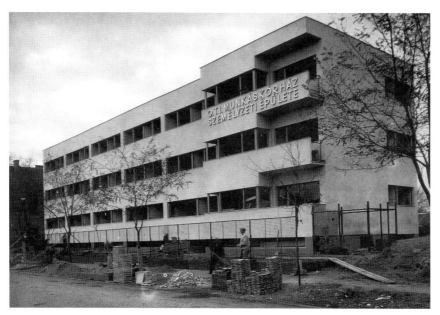

5.21. Farkas Molnár and József Fisher. Hospital staff apartment building. Budapest, 1936.

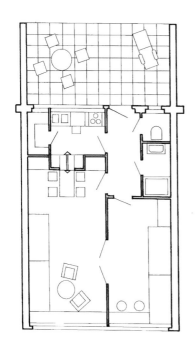

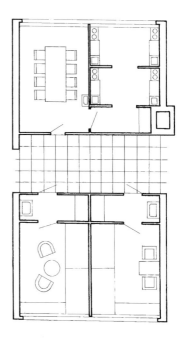

5.22. József Fisher and Farkas Molnár. Ground floor plan, hospital staff apartment building. Budapest, 1936.

5.23. József Fisher and Farkas Molnár. Typical floor plan, hospital staff apartment building. Budapest, 1936.

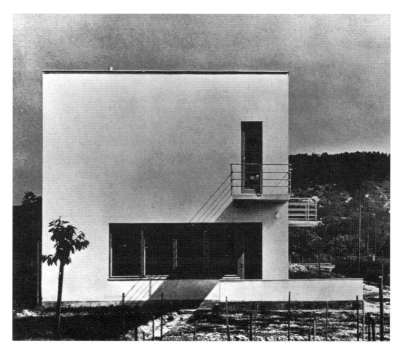

5.24. József Fisher. House on Csatárka Street. Budapest, 1932.

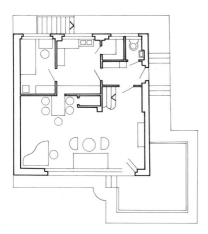

5.25. József Fisher. Ground floor plan, House on Csatárka Street. Budapest, 1932.

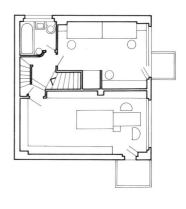

5.26. József Fisher. Second floor plan, House on Csatárka Street. Budapest, 1932.

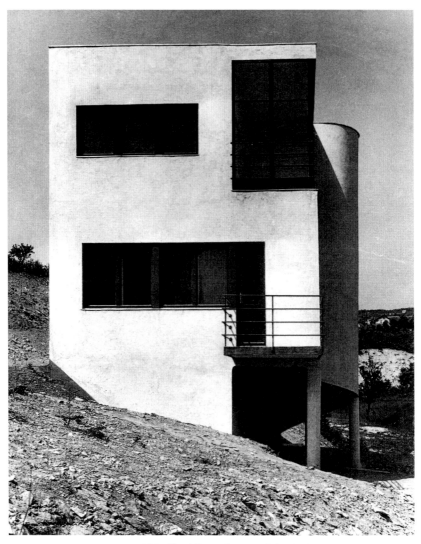

5.27. *József Fisher. House on Szépvölgyi Avenue. Budapest, 1935.*

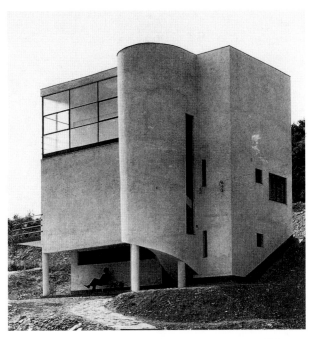

5.28. József Fisher. House on Szépvölgyi Avenue. Budapest, 1935.

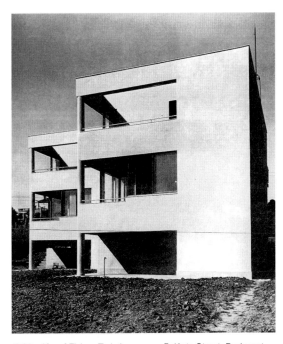

5.29. József Fisher. Twin houses on Palánta Street. Budapest, 1935.

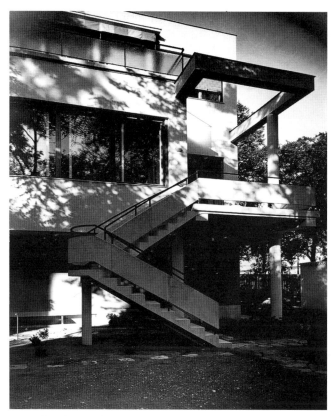

5.30. *József Fisher. Rózsi Walter House. Bajza Street, Budapest, 1936.*

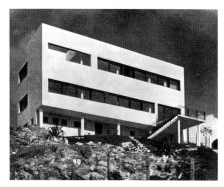

5.31. *Károly Dávid. House on Somlói Avenue. Budapest, 1933.*

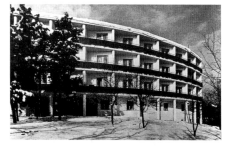

5.32. *József Fisher. Hotel Gyopár. Sváb Mountain, Budapest, 1942.*

style of the CIAM group, they are looser, less avant-garde. Both the Hotel Rege (Budapest, 1940) and the Hotel Gyopár (Budapest, 1942) are well adapted to the sloping terrain and follow the curved contours of Sváb Mountain in order to take advantage of the excellent view (fig. 5.32). The bold curves and the use of local stone are a far cry from the rigid composition and material puritanism of the Bauhaus.

Other members of the CIAM group continued to adhere to its spirit and puritan principles. The house on Somlói Avenue (Budapest, 1933) by Károly Dávid, who after graduation worked in the Paris office of Le Corbusier, is a white cube with horizontal banded openings, recessed terraces, and open stairs, lifted on pilotis (fig. 5.31). It is as if a Le Corbusier building had been transplanted to the side of the Gellért Mountain along the Danube. Another extremely bold, cubist solution is the house on Széher Avenue (Budapest, 1934) by Zoltán Kósa. The bold cantilever toward the valley and the receding roof terrace facing uphill balance each other.

Two apartment buildings by Máté Major, a CIAM member and after 1949 a widely published professor of architectural theory and history, deserve mention. The one on Sasfiók Street (Budapest, 1934) is a three-story cooperative with an apartment on the third and second floor; the first floor contains the caretaker's and maid's quarters (fig. 5.33). The floor plan is basically two squares biting into each other. The exterior is a white cube strongly articulated with ribbon windows that continue as indented balconies.

The rental apartment building on Attila Street (Budapest, 1934), designed in collaboration with Pál Detre, is six stories high. Both buildings are puritanically simple volumes relieved by horizontal windows. Major, who built very little, was an ardent defender of modern architecture. Though a Marxist, in 1951 he dared to oppose his Stalinist comrades, who advocated a return to historicism.

Alfréd Forbát, another CIAM member, was an associate of Walter Gropius from 1920 until 1924. He later worked in Macedonia, planning the new district of Saloniki; after 1928, he taught in Berlin at the art school of Johannes Itten and traveled in Greece and the Soviet Union. In 1933 he returned to the southern town of Pécs, where he was active until 1938 building single-family houses. In 1938 he emigrated to Sweden. His houses are less dogmatic than those of the rest of the CIAM group; they often use natural materials, face brick, or local stone. One of the most noteworthy is the house on Batsányi Street, on the slopes of the Mecsek Mountain (Pécs, 1936) (fig. 5.34).

During the second half of the 1930s, members of the CIAM worked under increasingly difficult conditions. First, they received no significant public commissions. Second, political events in Europe—and in Hungary—did not augur a happy end. Under these conditions, many fought depression and felt lost in a society that did not accept them. Some, like György Rácz and Farkas Molnár, gravitated toward nationalism. (On Molnár's last, unfinished, design for the Holy Land Church, Gothic forms start to appear!)

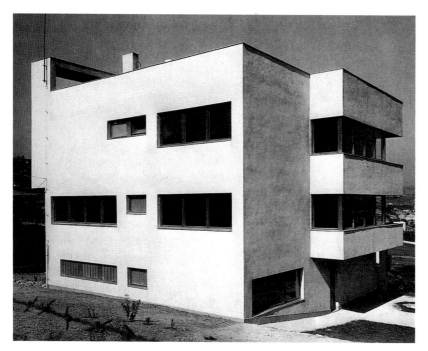

5.33. *Máté Major. Apartment building on Sasfiók Street. Budapest, 1934.*

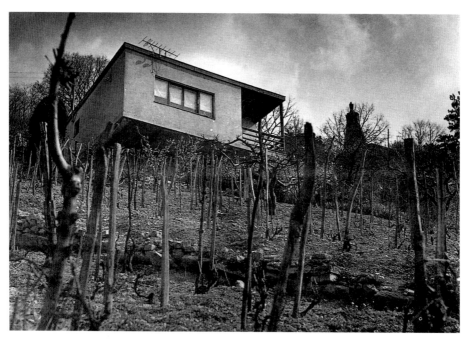

5.34. *Alfréd Forbát. House on Batsányi Street. Mecsek Mountain, Pécs, 1936.*

In 1938, Molnár recommended that the CIAM in Hungary disband. "Since achieving results in the social sphere became impossible, to try to achieve technical or formal results became meaningless"—so one historian characterized this disappointing period. This is not the entire story. The CIAM group's formal achievements in simplicity, purity, and formal logic and the group's unrelenting optimism, which may appear naive today, constitute a unique creative chapter in the history of modern architecture.

History has its ironies. The revolutionary young architects of the Hungarian CIAM built not a single building in which their social ideology could be realized. Instead, they mostly designed luxury villas for the well-to-do middle classes. Even more ironically, the formal inventions of these luxurious houses had a stronger effect on the development of modern Hungarian architecture than that which might have resulted had the architects built monotonous parallel rows of socialist housing, as did their more fortunate colleagues in the Weimar Republic of Germany.

To seek the origins of modern Hungarian architecture only in the buildings of the CIAM members would be a gross simplification. Those outside the CIAM—with rare exceptions—created buildings with softer forms, more "decorative" than the "tough," "hard" modern structures. However, among these more pliable, even compromising, modern buildings were a number of outstanding designs. An interesting stone plaque in the midst of the housing development on Napraforgó Street on the hills of Buda (Budapest, 1931), which consists of twenty-four single-family houses, states that "they were designed in the artistic spirit of the age" (fig. 5.36). Indeed, CIAM members Pál Ligeti, Farkas Molnár, József Fischer, and György Masirevich, along with eighteen nonmembers, represented many directions, even the conservative. But the end result was a predominantly functional development, not avantgarde though clearly modern.

Outstanding among the architects outside the CIAM was Lajos Kozma, who tried his hand at almost all styles prevalent between the two world wars. He started his career in the office of Béla Lajta where he picked up a deep affection for folk art and architecture. Kozma's neo-baroque furniture designs using Hungarian folk motifs became popular among the well-to-do. During the 1930s, he switched—unexpectedly—to modernism but never lost his affinity for the decorative. Modern architecture for him was a style rather than an ideology. However, even without the polemical content, his talent and formal sensitivity produced some outstanding buildings, the majority of which are single-family houses. Most are larger and more luxurious than those built by the CIAM membership, suggesting a richer clientele.

Unfortunately, their design quality, the strength of formal composition, falls below that of the CIAM. They lack immediate power. Their volumes are less comprehensible. The composition, balance, and counterpoint of the elevation openings could be improved upon. Kozma's

5.35. Lajos Kozma. Interior. Budapest, 1934.

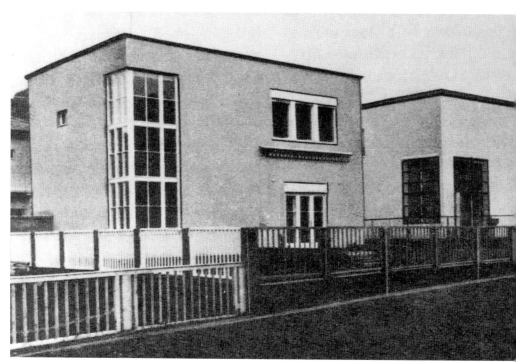

5.36. Hungarian branch, Congrès International d'Architecture Moderne (CIAM). Housing development on Napraforgó Street. Budapest, 1931.

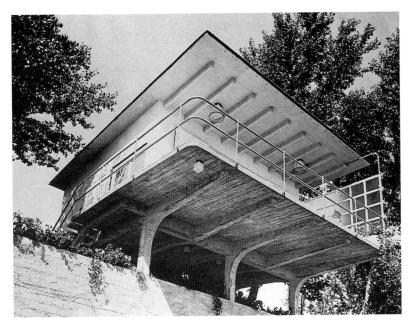

5.37. Lajos Kozma. Weekend house. Lupa Island, Budapest, 1935.

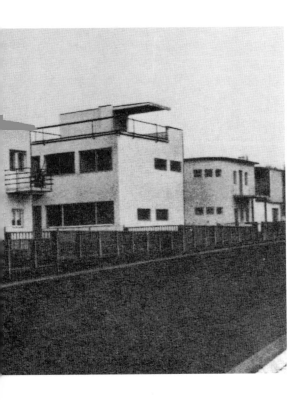

houses are also more decorative, mixing materials (stucco with face brick), using contrasting colors (on window and door frames), and containing rich furnishings. Compared to the CIAM puritanism and minimalist tubular furniture, Kozma's interiors are warmer, more comfortable and generally more appealing (fig. 5.35). The weekend house on Lupa Island (Budapest, 1935) is the most interesting of all the Kozma houses, with its boldly cantilevered concrete frame lifting up the single-space volume to create a shaded, cool terrace underneath (fig. 5.37).

Kozma's finest projects are large apartment and commercial buildings, such as the apartment house on Régiposta Street (Budapest, 1933), the Atrium House on Margit Boulevard (Budapest, 1934), and the glass house on Vadász Street (Budapest, 1935). The delicate play and variations of solid walls and fenestration, such an integral part of the early avant-garde, were not possible on these large buildings. Both the high-rise apartment building and the office structure are repetitive, with the usual monotony of the "layer cake" only rarely broken. To express faithfully the inner function on the exterior—even if it was monotonous—was one of the Bauhaus dogmas. Kozma achieved a unique legibility in these buildings, and his detailing of steel frame and glass foreshadows much later curtain-wall construction.

On the Atrium House (named after the movie theater on the first floor), the spandrels are white; the columns are covered with black glass and consequently melt into the window ribbons (figs. 5.39, 5.40). The two-story lobby, where mirrors abound and columns are made into large light fixtures, tends to deny the supporting role of the columns; however, it well prepares the audience for the illusionistic world of the movies. The pleasantly shaped, slightly askew, sloping auditorium, with its colored harmony of walls, ceilings, and upholstery, is one of the city's most successful theater interiors.

The facade of the rental apartment building on Régiposta Street is an almost perfectly flush, taut skin where travertine spandrels, ribbon windows, and the first-floor storefronts form a unified surface enriched by the ceramic plaque over the entrance, the work of the uniquely talented sculptress Margit Kovács (fig. 5.38). The "glass house" on Vadász Street, an office building and showroom for a glass company, is both functional architecture and advertisement. Here, as elsewhere, one finds a meticulous attention to detail, the thorough understanding of the processes of both manufacture and handicrafts (Kozma's great strength as a designer), though the use of a large variety of glass on the first floor detracts from the overall unity.

As versatile a designer as Kozma was, Gyula Rimanóczy, who, if the client so desired, worked in the conservative neo-baroque style (Vajna Villa, Budapest, 1932), designed neoclassical public buildings (National Sport Palace, Budapest, 1941), and, when socialist realism required it, could satisfy that too with slightly art nouveau designs (new buildings at the Polytechnical University, Budapest, 1954). Rimanóczy felt most at home, however, in the modern, demonstrated by

5.39. Lajos Kozma. Atrium House.
Margit Boulevard, Budapest, 1934.

5.38. Lajos Kozma. Apartment house on
Régiposta Street, Budapest, 1933.

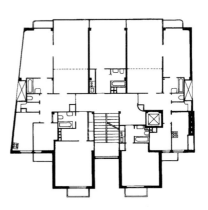

5.40. Lajos Kozma. Typical floor plan, Atrium House.
Margit Boulevard, Budapest, 1934.

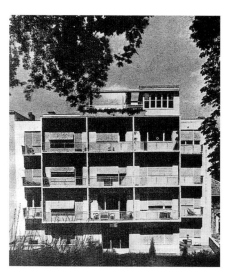

5.42. *Aladár and Viktor Olgyay. Apartment building on Városmajor Street. Budapest, 1941.*

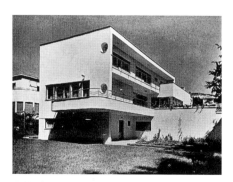

5.41. *Gyula Rimanóczy. House on Pasaréti Avenue. Budapest, 1934.*

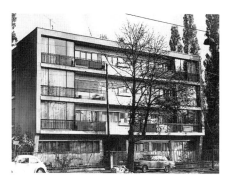

5.43. *János Wanner. Apartment building on Pasaréti Avenue. Budapest, 1935.*

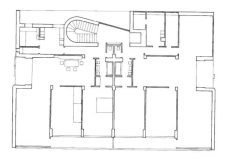

5.44. *János Wanner. Typical floor plan, apartment building on Pasaréti Avenue. Budapest, 1935.*

his tasteful house on Pasaréti Avenue (Budapest, 1934) with its projecting terrace overlooking the garden (fig. 5.41). The Franciscan monastery in the courtyard of his rather romantic church is a pleasantly proportioned residential addition (Budapest, 1934).

Another modernist, though not a CIAM member, was János Wanner, who from 1931 to 1932 worked in the office of Le Corbusier. One of Wanner's most successful projects is the rental apartment building on Pasaréti Avenue (Budapest, 1935). Besides an intelligent plan, long balconies with frosted wire glass railings and well-placed flower boxes result in an elevation of great visual variety, suggesting a residential quality rare among Bauhaus buildings (figs. 5.43, 5.44).

Best known for an industrial project discussed below (p. 170), the Olgyay brothers, Aladár and Viktor, deserve mention. Their rental apartment building on Városmajor Street (Budapest, 1941) has a remarkably light, airy facade facing the garden while the street elevation, with the main stairway enveloped by glass blocks, is more solid (fig. 5.42).

Multistory, freestanding apartment houses have been previously discussed. Here we will examine apartment buildings, either rental or co-op, that fit the zero lot-line planning principle of the typical European urban block. Most were built in Budapest, a few in smaller towns like Sopron, Pécs, and Debrecen. In contrast to other building types, apartment buildings were built primarily to generate income. Consequently, they left little artistic leeway to their designers.

In 1932, at the height of the Hungarian economic crisis, neither the U.S. dollar nor the Swiss franc—two otherwise solid currencies—were as secure investments as real estate. Construction costs were low due to unemployment. In order to boost the economy, municipal governments induced developers to build by declaring a moratorium on taxes. The greatest tax advantages were offered in parts of the city most in need of development. As a condition (and in accordance with the new zoning ordinance of 1940) all so-called inner-court apartments were prohibited. These used to be without street view, facing an often dark and narrow courtyard with public traffic on the corridors that hung right in front of the apartment windows, not to mention the dark, rear stairs for the maids or deliverymen who were prevented from using the main, front stairway. The new zoning ordinance eliminated this kind of second-class citizenship.

Many of the CIAM principles were adopted in the new apartment buildings. Apartments became smaller; kitchens and bathrooms, though compact, were much improved. The new zoning permitted forty to fifty feet of building depth, unfortunately too deep for the apartment layout to avoid the deep interior hall, but not so deep as to make this hall unbearably dark. Most apartments, being through-units (facing two exposures), enjoyed cross-ventilation. The wonderful, ubiquitous balconies unfortunately have lost some of their attraction today, with increased street noise and serious pollution. Ninety-five percent of the new apartments had

bathrooms. To maximize income, a large number of studio and one-bedroom units were introduced.

One of the earliest of modern apartment buildings in Budapest is the slightly art deco structure by Dénes Györgyi for the electric company, on Honvéd Street (1926) (fig. 5.45). The strong feature of the building is the projecting bay windows above the first floor. The average apartment building in Budapest was six to seven stories high with a central stair and elevator serving two or three apartments on each floor with no long central corridor. The middle section of the street facade (two or three rooms wide) usually projected out above the first floor over the sidewalk and had balconies on either side. The finishes of the stair hall with its marble floor, paneled walls, well-designed stair rail, chrome-finished elevator door, and elegantly lettered tenant list conjured up an upper-middle-class image. This strongly contrasts with the visual poverty of housing built since World War II. Naturally, the rents charged during the 1940s not only covered proper maintenance and repair but also provided a reasonable return on investment, while postwar socialist rents, artificially kept low, covered only a fraction of the expenses.

Besides the many routine, dull apartment buildings built during the 1930s and 1940s were many outstanding ones. Those of József Fischer, Lajos Kozma, and Máté Major have already been mentioned. One with great power and simplicity, in Kékgolyó Street (Budapest, 1938), is the work of László Lauber and István Nyiri (fig. 5.46). Unfortunately, the very effectively rounded termination of the solid balcony, like other stylistic motifs of the CIAM, became in the hands of less talented designers part of the streamlined language used on many otherwise mediocre projects. The novelty of this building is its beautifully developed and landscaped fifteen-hundred-square-foot roof terrace in the spirit of Le Corbusier.

Another project much influenced by the CIAM spirit is the

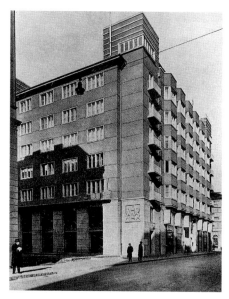

5.45. *Dénes Györgyi. Apartment building on Honvéd Street. Budapest, 1926.*

housing development for Országos Társadalombiztositó Intézet, the national health insurance company, on Tisza Kálmán Square (Budapest, 1934) by a large team of architects (Bertalan Árkay, Sándor Faragó, József Fischer, Károly Heysa, Pál Ligeti, Farkas Molnár, Frigyes Pogány, Gábor Preisich, and Mihály Vadász) (fig. 5.47). The building blocks are perpendicular to the street and far enough apart to provide all tenants with diagonal street

views. This simple, straightforward project avoids unnecessary embellishments. The base on which the apartment blocks sit is for commercial use. Similar in spirit and formal simplicity is the apartment house on Bartók Béla Avenue (Budapest, 1934) by Gábor Preisich and Mihály Vadász.

Two outstanding apartment projects of the period are by Béla Hofstätter, a victim of the fascist

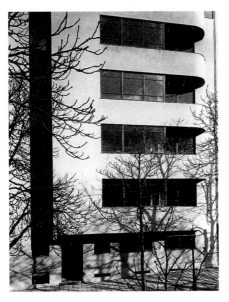

5.46. László Lauber and István Nyiri. Apartment building on Kékgolyó Street. Budapest, 1938.

regime in 1944, and Ferenc Domány, who emigrated to London in 1939 and received first prize in the competition for the central post office. The structure on Margit Boulevard (Budapest, 1937) has a central stairway connecting two parallel apartment blocks (figs. 5.48, 5.49). Moderate use of rounded forms characterizes the design. Several buildings in a row form the luxurious apartment complex by the same architects on Pozsonyi Avenue

(Budapest, 1936) (fig. 5.50). The well-laid-out apartments face the park and, across the Danube, the hills of Buda. Bathrooms and kitchens feature mechanical exhaust systems, a novelty at the time. The travertine-paneled, chrome-railed, ellipsoid entrance lobbies with cylindrically shaped elevators conjure up Hollywood. There are separate maids' efficiency units on the seventh floor, and the roof serves as a sunbathing terrace with dressing rooms and showers. The well-unified facades of this series of apartment buildings contribute considerably to the pleasant streetscape of the Danube shore.

One of the largest modern apartment buildings in Budapest was built on a corner lot in the inner city by the Münich-trained Gedeon Gerlőczy on Petőfi Sándor Street (Budapest, 1942) (fig. 5.51). The first floor, like many buildings in this district, contains a shopping arcade. The building pays respect to the corner by bold rounding, and the long bands of balconies intelligently step back along the narrow side street, conserving light for the street while generating pleasing and playful forms very much in harmony with the rounded corner. Elsewhere in the country, Oszkár Winkler in Sopron, László Gábor and Aladár Münnich in Debrecen, Alfréd Forbát and Gyula Kőszeghy in Pécs, and Viktor Bőhm in Miskolc designed apartments of high quality (figs. 5.52, 5.53).

In ecclesiastic architecture, it was not so much the churches as the parishioners who resisted the modern. Consequently, even those who liked to design modern buildings compromised. The basic forms

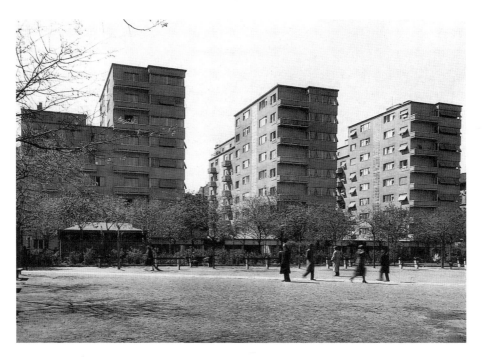

5.47. *Bertalan Árkay, Sándor Faragó, József Fisher, Károly Heysa, Pál Ligeti, Farkas Molnár, Frigyes Pogány, Gábor Preisich, Mihály Vadász. Housing development for the national health insurance company. Tisza Kálmán Square, Budapest, 1934.*

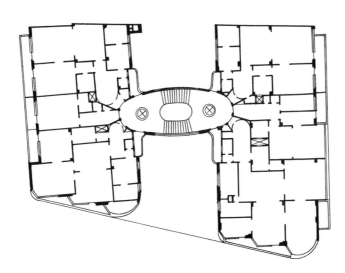

5.48. *Béla Hofstätter and Ferenc Domány. Typical floor plan, apartment building on Margit Boulevard. Budapest, 1937.*

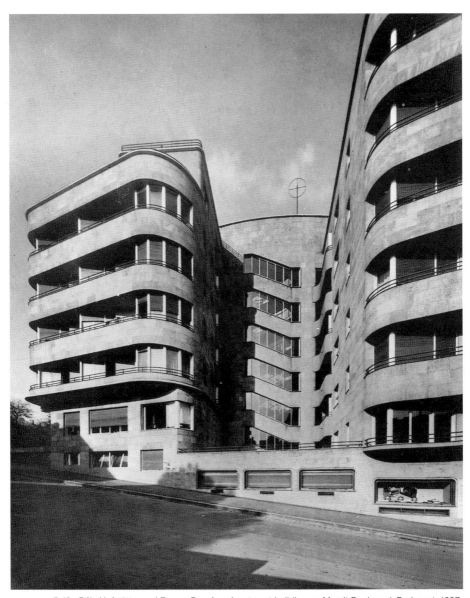

5.49. *Béla Hofstätter and Ferenc Domány. Apartment building on Margit Boulevard. Budapest, 1937.*

of the Roman Catholic church by Iván Kotsis (Balatonboglár, 1932) are quite modern in their simplicity, but the details are not. The same can be said about the Franciscan church on Pasaréti Square (Budapest, 1931) by Gyula Rimanóczy. The closest to a modern building is the monumental Roman Catholic church in the Városmajor district (Budapest, 1933) by Aladár Árkay, who came to modernism via art nouveau and turn-of-the-century National Romanticism, and his son, Bertalan Árkay, who apprenticed with Peter Behrens in Berlin.

Among the dull, repetitious government office buildings where the authorities' desire to appear important created additional problems, are two successful examples. Both were built around the same time and are similar in scale. One is the Postal Headquarters on Dob Street (Budapest, 1940) by Gyula Rimanóczy, Lajos Hidasi, and Imre Papp (fig. 5.54). The other is the Finance Center on Szabadság Square (Budapest, 1938) by László Lauber and István Nyíri. Both are asymmetrically composed with asymmetrical entrances. The corner and the ground level on each receive special treatment and the crowning floor is also handled differently. Unfortunately, the large, travertine-covered volume of the floors in between is monotonously patterned with identical punched windows. The sculptural elements do not succeed in relieving this rigidity. More successful is the headquar-

ters of the Material and Price Control Office on Fő Street (Budapest, 1942) by István Janáky and Jenő Szendrői. The building is lifted on pilotis; thus the first floor is recessed, echoed by the recessed top floor. On the main facade, much of the third floor is cantilevered. The vertically elongated windows on the face-brick exterior, a surface less rigid than stone, are more

5.50. Béla Hofstätter and Ferenc Domány. Luxury apartment building on Pozsonyi Avenue. Budapest, 1936.

pleasantly proportioned than the square windows of the previous two buildings.

More in the spirit of modern architecture than the previous buildings is the Engineer's Guild Headquarters by János Wanner (Budapest, 1940) (fig. 5.55). While it clearly expresses the different functions of the floors, it succeeds to provide a unified facade.

Among school structures, the Szilágyi Erzsébet High School on Mészáros Street (Budapest, 1937) by Károly Weichinger and Tibor Hübner is noteworthy. This red-brick building with simply organized, well-proportioned fenestration, makes no pretenses. The slightly arched side elevation conveys

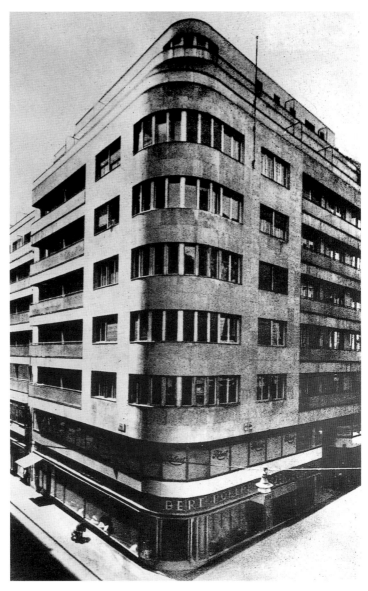

5.51 Gedeon Gerlőczy. Apartment building on Petőfi Sandor Street. Budapest, 1942.

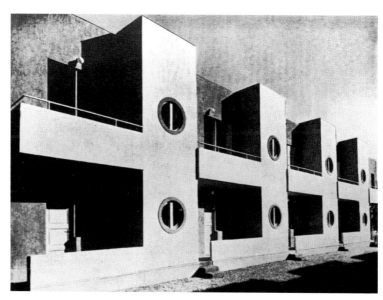

5.52. Viktor Bőhm. Rowhouse apartments. Miskolc-Tapolca, 1933.

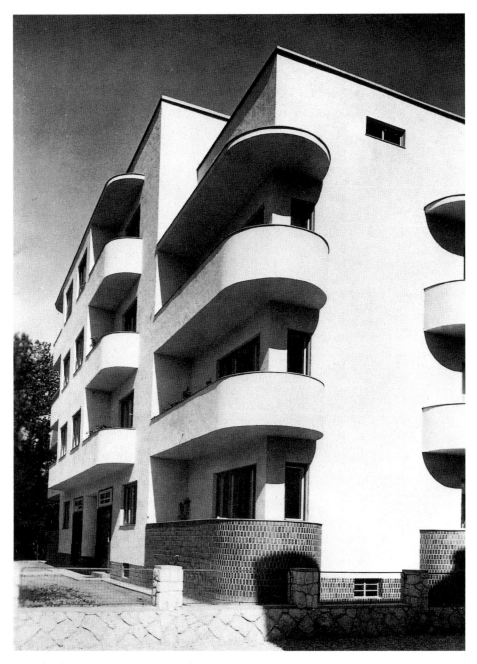

5.53. *Oszkár Winkler. Apartment building. Sopron, 1935.*

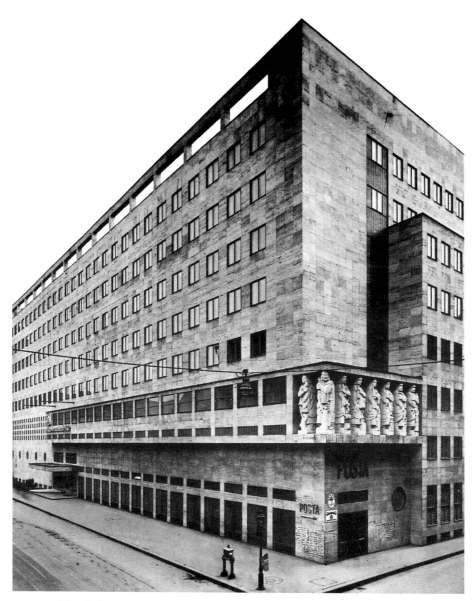

5.54. *Gyula Rimanóczy, Lajos Hidasi, Imre Papp. Postal Headquarters. Dob Street, Budapest, 1940.*

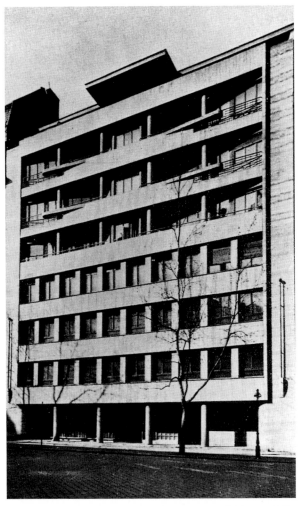

5.55. *János Wanner. Engineer's Guild Headquarters. Budapest, 1940.*

movement, and the single, idiosyncratic window on the top floor is a surprising gesture.

Among the hospitals of the period, two deserve notice. The Magdolna Hospital for accident victims (Budapest, 1939) by Gedeon Gerlőczy and Nándor Körmendy is a simple slab building covered with light-green precast-stone panels (fig. 5.56). The patient rooms on the middle five floors are expressed by continuous balconies with glazed railings, a pleasant place for patients to sit if weather permits. The hospital on Kútvölgyi Avenue (Budapest, 1942) by Elemér Csánk is a simple, functional cross shape with common and service facilities in the center of the cross and patient rooms in the wings. Both buildings have been significantly altered.

Any discussion of the public buildings of the interwar period should include the entrance pavilion to the Palatinus baths on Margit Island (Budapest, 1937) by István Janáky. The slender colonnade with humorous murals by István Pekry in the back and a female figure by Géza Csorba in the front makes an inviting entrance to a popular recreation spot. The main building of the airport (Budaörs, 1935) by Virgil Birbauer and László Králik also deserves mention (figs. 5.57, 5.58). The round central hall with its wings and emphasis on horizontal overhangs and railing brings to mind the dynamics of transportation. The pioneering design used to provide separate levels for arriving and departing passengers with separate luggage handling.

Among industrial buildings noteworthy in this category is the delicate factory structure (Medgyes, 1929) by Pál Ligeti and Farkas Molnár, and the market hall on Csepel Island (Budapest, 1931) by Aladár Münnich, with its roof structure of thin concrete shells (fig. 5.59). The workers' locker building at the Shell Oil Co. plant on Csepel Island (Budapest, 1934) by Zóltán Kósa is surprisingly like an early Bauhaus villa, as are the administration building and staff apartments at the stockyards (Székesfehérvár, 1933), with circular windows and rounded corners, by László Králik and Gyula Rimanóczy. The automobile service station on Fehérvári Avenue (Budapest, 1930) by László Lauber relies on the balance of the horizontal overhang and ribbon window with the combined vertical tower and signage. The largest, most significant industrial building of the period, the Stühmer Chocolate Factory (Budapest, 1941) was designed by the Olgyay brothers (fig. 5.60). The endlessly long horizontal window ribbons, interrupted only by two vertical rows of balconies, recall the length and power of industrial production lines.

Furniture design and interior architecture stood at the highest level in Hungary between the wars. The internationally famous architect and designer Marcel Breuer was born in Pécs. He conceived of his tubular metal furniture during his years at the Bauhaus (1925–27) (fig. 5.61). After the dissolution of the school, he returned to Hungary, joined the CIAM, and collaborated with József Fischer and Farkas Molnár on the prizewinning entry for the master plan of the Budapest International Fair. Regretfully, as a graduate of the Bauhaus he was

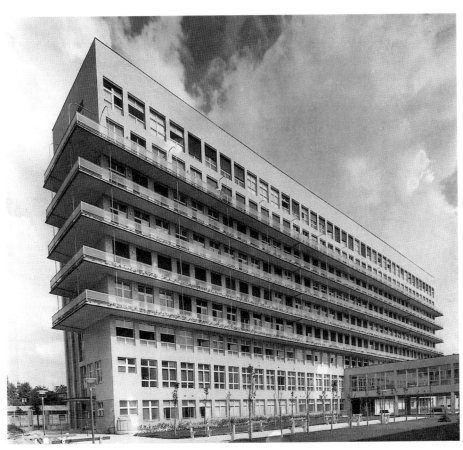

5.56. *Gedeon Gerlőczy and Nándor Körmendy. Magdolna Hospital. Fiumei Avenue, Budapest, 1939.*

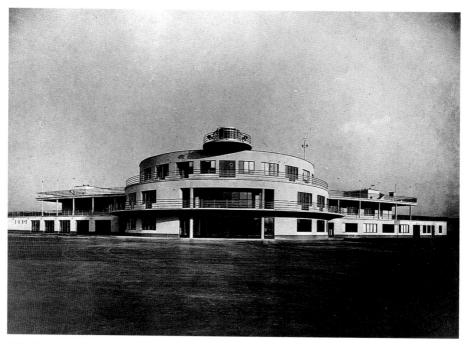

5.57. *Virgil Birbauer and László Králik. Airport. Budaőrs, 1935.*

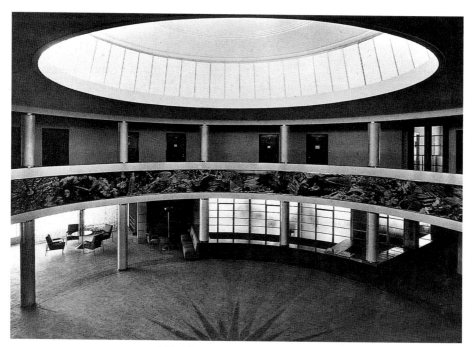

5.58. *Virgil Birbauer and László Králik. Central hall, airport. Budaőrs, 1935.*

denied membership in the Architectural Guild, a precondition to practicing in Hungary. Nonetheless, his tubular furniture became popular among the moderns in Budapest. Fischer furnished his own apartment with it. Breuer's minimalist furniture and the puritan architecture of CIAM made an exemplary combination, and Fischer and Molnár, who both selected the furnishings for the interiors of the homes they designed, used Breuer furniture often. This is not to say that the majority of homes, even those that purported to be modern, used furniture of equal quality and simplicity.

The furniture and interior design talent of Lajos Kozma has already been discussed. Gyula Kaesz, one of the most important furniture designers of the period and creator of elegant, Vienna-inspired designs, did equally important commercial work: the National Savings Bank interiors (Budapest, 1940) and the Hungarian Tobacco Industry Pavilion at the National Fair (Budapest, 1938) (fig. 5.62).

Among the fair's pavilions, the most architecturally successful was designed by Virgil Birbauer for a steel company and railroad car and machinery factory (Budapest, 1938). Its exposed, light steel frame is remarkable for its time (fig. 5.63). Unfortunately, Hungary's pavilions at the various international fairs and exhibitions attempted to propagate the country's nationalistic politics with romantic designs of mediocre quality. The first time Hungary was represented by a well-designed modern pavilion by the Olgyay brothers was in 1943 at the Izmir International Fair.

The characteristic interior design problem that faced the period's architects was the motion-picture theater. One of the most successful cinema interiors, that of the Broadway on Dohány Street (Budapest, 1938), designed by Ferenc Domány, emphasized curves and streamlining, devices alien to puritan modernism but suited to the illusionistic world of the movies (fig. 5.64). Another successful theater of similar qualities was the Corso on Váci Street (Budapest, 1937) by Andor Wellisch, Elek Falus, and Károly Staudhammer.

The city's growing commercial life after the depressed early 1930s demanded high-quality storefronts and eye-catching interiors. The best designs of the period served both function and advertising. Among the finest is the Mocca Coffee Bar (Budapest, 1930), whose storefront was designed by Zoltán Révész and József Kollár; the interiors were the work of Zsuzsa Kovács, a well-known interior designer. Among commercial projects, two more deserve mention: the storefront on Kigyó Street (Budapest, 1939) by György Koródy (fig. 5.65), and the shopping arcade on the first floor of the apartment building on Petőfi Sándor Street (Budapest, 1944) by Gedeon Gerlőczy.

Modern architecture in Hungary reached a very high level between 1919 and 1944 in spite of the difficult conditions. Repression made this architecture tough and disciplined; the poverty of available means and materials made it even simpler and more straightforward. This need to succeed against all odds, the desire to make the most of nothing, the urge to "show them,"

5.59. Aladár Münnich. Market hall on Csepel Island. Budapest, 1931.

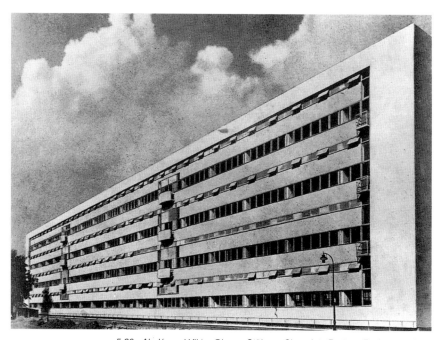

5.60. Aladár and Viktor Olgyay. Stühmer Chocolate Factory. Budapest, 1941.

could be considered a unique motivating force of all modernism in East-Central Europe. Fortunately, building activity continued in Hungary throughout World War II. At the height of Nazi terror, courageous members of the progressive Hungarian Comité Internationale pour la Résolution des Problèmes de l'Architecture Contemporaine (CIRPAC) group (József Fischer, Pál Granasztói, Jenő Kismarty Lechner, Máté Major, and János Weltzl), publicly stated their belief in rebuilding the country "under a more progressive social and economical order."[3]

The spirit of modern architecture was not damaged by the war. Budapest, however, suffered serious damage during the retreat of the German army. A third of the city's buildings were either destroyed or left in very poor shape; none of the Danube bridges survived intact; and the city's showplaces, the buildings along the Danube embankment and up on Castle Hill, were almost totally destroyed. Reconstruction started almost immediately after the Germans left the city. By 1946 architects and planners were already busy at the drawing boards. Some of the players changed, however. Farkas Molnár was fatally wounded during the siege of Budapest, Jánow Weltzl died in 1944, and Béla Hofstätter fell victim to the Nazis during November of the same year. Some, afraid of the occupying Soviet troops, emigrated west (János Wanner, the Olgyay brothers). Others returned home from self-imposed exile: Károly Percel from France, Imre Perényi from the Soviet Union, and Tibor Weiner from Chile.

While the majority of the players did not change, their thinking and the conditions under which they created did. Neo-baroque conservatives and followers of the folkish, vernacular direction almost completely disappeared. Those who had created modern buildings in an atmosphere of fear and oppression could now work freely. There was a seemingly unified belief in the modern and in the need and urge to reconstruct the city. Máté Major and Imre Perényi started the Új Építészek Köre (New Architects' Circle) in 1946, and those architects affiliated with the recently established magazine *Új Építészet* (New Architecture) organized various exhibitions, mainly about workers' housing. *Tér és Forma* continued to appear under the less radical direction of Pál Granasztói.

These years were not only filled with discourse. Architects, both privately and in government institutes, were feverishly planning as well as building. All of the outstanding products of this period and their designers cannot be listed here. Yet the intense activity did not improve the quality of most buildings. The puritanism of the Bauhaus years was gone. Buildings tended to be over-designed and over-detailed, almost as if architects were making up for the many years lacking in opportunities. The most significant, almost paradigmatic, building of the period, the headquarters of the Union of Hungarian Construction Workers (Budapest, 1950) by Lajos Gádoros, Imre Perényi, Gábor Preisich, and György Szrogh, with exposed columns running its full four stories, was later picked by the Stalinist critics as

the prime example of "formalism."

This late flowering of modern architecture after World War II was forcefully stopped in 1951 when, under communist pressure, the Magyar Épitőművészek Szövetsége (Institute of Hungarian Design Architects) was formed and its first congress held. At this congress pressure from the Communist Party leaders forced Hungarian architects to begin designing in the neoclassical, provincial-eclectic style of socialist realism, invented in the Soviet Union under Stalin. This virtually ended the first successful period of modern architecture in Hungary. Its revival had to await the revolution of 1956.

NOTES

1. The adjective *modern* as used here refers to the pure Bauhaus variety and not to the more elaborate, commercial version that came later with the wider acceptance of modernism. Nor does the modern here encompass the so-called transitional phases between eclectic and modern or between romantic and modern. (This implies no value judgment, since these transitional phases did produce some excellent work that attempted to improve upon the rigidity and dogmatism of the avant-garde modern.)

2. József Fischer, "Internacionális új épitészet" (International new architecture), *Munka* (Labor), 1930.

3. "Az épitészet háború utáni feladati Magyarországon" (The role of architecture in postwar Hungary), *Tér és Forma* (Space and Form), November 1944.

5.61. Marcel Breuer. Tubular metal furniture. 1925–27.

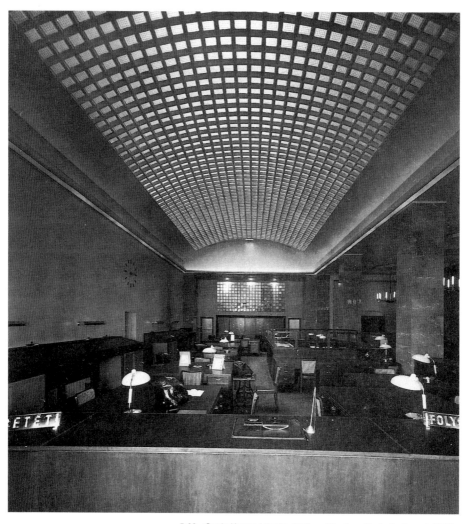

5.62. *Gyula Kaesz. Interior, National Savings Bank. Budapest, 1940.*

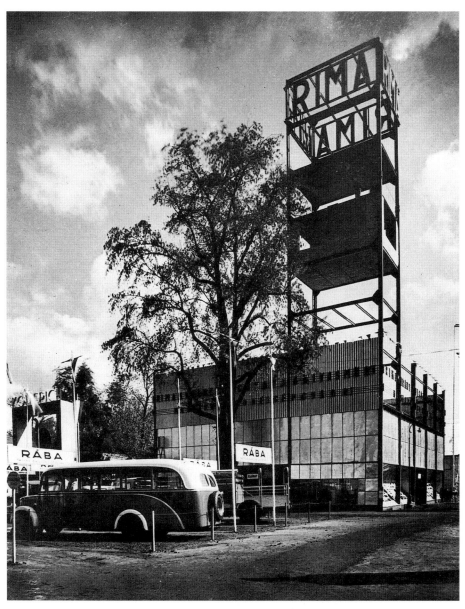

5.63. Virgil Birbauer. Pavilion for a steel company and railroad car and machinery factory. *National Fair, Budapest, 1938.*

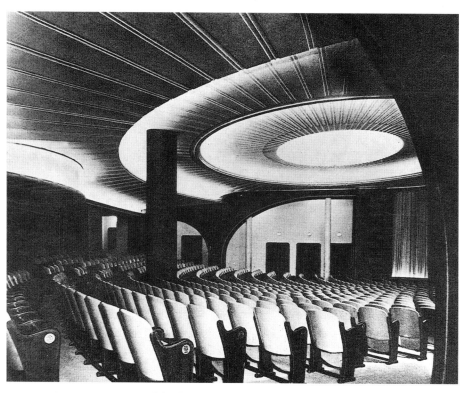

5.64. Ferenc Domány. Broadway Theater. Dohány Street, Budapest, 1938.

5.65. *György Koródy. Storefront on Kigyó Street. Budapest, 1939.*

OLAND
AND
IOSLOVAKIA

SCALES

te Miles, 66 — 1 Inch.
75 100 150

meters, 107 — 1 Inch.
75 100 150 200

Rand McNally & Company, Chicago.
Made in U. S. A.

Stralsund
RÜGEN I.
Pomeranian Bay
Swinemünde
Kolberg
Köslin
Stettin
Neustrelitz

Rixhöft
Puck
Wejherow
Odynia Gulf of Danzig
Kartan
DANZIG
(FREE)
Kestjelzina
Skarszowy Tcher
Elbing
Czersk Starogrod Marienburg
Khoinitse Nowe
Kamien
Svletzte D. Eyla
Wiecbrok Lasin Löbav
Wysoka Mrocza Grudzia:iz Kurzebin
Schneidemühl Wabrzezno Brodnica
Naklo Khelmno Lidzbar
Czarnkow Chodzi?r Znin Golub Rlpin
Wagrowiec Bidgoshch Torun
Wielen Nieszawa Lipno
Miedzych Szamotuy Oborniki Mogilno Sierpc
Poznan Kostiryn Witkowo Chodeczo Plot
Zbaszyn Opalenica Gniezno Zempolno Gabin
Grodzisk Wrzesnia Kutno WA
Kostsian Srem Konin Lowicz
Gostin River Yarotsin Kolo Leczyca Ozorkow
Lesno Pleszew Turek Zgierz
Kozmln Kalisz Lodz
Krotoshin Warta Pabjaulce
Ostrow Sieradz Tomaszow
Zdanska Wola
Repno Lutatow Piotrkow
Wielun
Chestoknova
Oppeln Przedborz Kons
Radom
Janow
Zarki
Lubliniec
Pilica
Tarnowitse
Beuthen Bedzin
Hutakrolewsko
Ratibor Krakuy
(Cracow)

BERLIN
Moder
Frankfurt
River
Kottbus
Dresden
Görlitz
Breslau Rychtal

MTS
AZ GEBIRGE Podmo
Rumb
Uti Decin Liberec
Teplice Ces. Lipa
Most Litomerice Turnov
Chomutov Mlada Boleslav
Karlovy Vary Yichin
(Carlsbad) Zhatets Lysa
Kladno Nymburk
hyse Hakovnik Hradets Ri
anske Beroun Rosytalce
rne PRAHA Kolin
(PRAGUE)
lzen Dobris Kutna Hora
Dobrany Pribram Caslav Khrudim
Rozmital Jenikov Svitavy
Klatovl Benesov Lvetta
alice Tabor Policka
mperk Pisek Bechyne Nem. Brod
Strakonice Bystrice
Tyn Sobeslav Vihlava
Budeyovitsu Trebich Humpolets
(Budweis) Jindrichu Tele
Kremze Trebon Hradec
Gmünd Znoim

KORKONOSE
RIESENGEBIRGE MTS

River

Trutnov
Dvur Kralove

Josef

Neisse

Zampreck
Usti Sumberk
Rymarov Opava Bottum
Mor. Ostrava
Sternberk Mistek
Olomouts Frydek Tesin Cieszyn Zhl lets
Novi Yichin
Prerov Boskovice
Prostejov

BRNO
(Brün)
Slavkov

Kromerizh

CZECHO
(CESKOSL)
SI

Nove
Tstena
Zakopane
Ruzomberok

FORMAL DIRECTIONS IN POLISH ARCHITECTURE

OLGIERD CZERNER

Poland's recovery of her national independence in 1918 after 123 years of foreign domination was an exceptionally important political and socioeconomic event; it did not, however, immediately yield any significant and fundamental changes in architectural and artistic development. The independent development of Polish architecture was furthermore slowed by the armed conflict with Soviet Russia and with Germany over the ownership of Upper Silesia. Architects practicing in Poland were trained at the educational facilities of the occupying powers, and architecture commissioned prior to 1914, particularly in the government sector, had to conform to the ideas and trends current in major foreign cultural centers such as St. Petersburg, Berlin, and Vienna. Some architects attempted to apply forms characteristic of Polish architecture, such as specific forms of the Gothic originating in the vicinity of the Vistual River, or to invent national styles derived from sources such as the vernacular architecture of the mountainous Zakopane region. Because architects from the various parts of partitioned Poland remained in close contact with one another and because they gener-

ally wished to remain in the mainstream, the overall creative output reflected principles familiar to most architects.

Thus, Polish architecture entered the period of national independence in a transitional, creative condition. Among the most characteristic of such transitional buildings are the Cooperative Bank on Jasna Street (Warsaw, 1912–17) designed by Jan Heurich, Jr. (fig. 6.1), the Sprecher's House at Mariacki Plaza (Lwów, 1914–21) by Ferdynand Kassler, and the St. Jakub church (Warsaw, begun in 1909 and completed after World War I) by Oskar Sosnowski. Such buildings updated specific historical styles: for instance, the modernization of Romanesque forms used in St. Jakub's.

On the other hand were architects who wished to remove from their work any references to the partition years, which this transitional architecture signified. These architects drew on the pre-partition era, reaching for examples as far back in history as the Greater Poland, when the country was a great European power. The principal architectural language that stood for such an attitude derived from the neoclassical eighteenth-

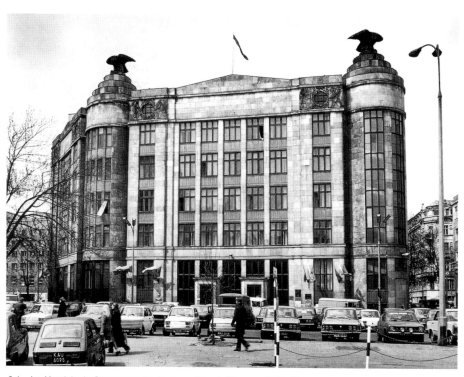

6.1. Jan Heurich, Jr. Cooperative Bank. Jasna Street, Warsaw, 1912–17.

century sources and was subsequently named the Polish Manor Style. The first manifestation of this tendency appeared in the early years of the twentieth century,

6.2. Roman Feliński. Individual house. Warsaw, 1924.

but after Poland regained her independence in 1918, its popularity rapidly increased. The rationale behind the adaptation of the Manor Style was a desire to imitate historic Polish forms in order to preserve the native landscape. Many projects prepared during the First World War in anticipation of the future reconstruction of Polish villages assert this claim. The Manor Style was subsequently applied to many public worker settlements, especially in the eastern towns such as Brześć, Baranowicze, Pińsk, Równe, and Lwów. On the other hand, it can also be found in major cities such as Katowice and Warsaw and in individual houses in their vicinities. Many architects prac-

ticed this approach; an example is Roman Feliński, who in 1924 realized an individual house in this style in Warsaw (fig. 6.2). Perhaps the most monumental form of this expression, enriched by interior decorative elements such as furniture, light fixtures, and ornamental details of doors, windows, and bas-reliefs conceived by many distinguished Polish artists, was the Polish Embassy in Ankara, Turkey, built around 1930. A more modest but sophisticated representation of this style is the public baths built in Kazimierz Dolny on the Vistula River between 1920 and 1922 by architect Jan Witkiewicz-Koszczyc.

More rare are cases derived from Renaissance and early baroque architecture. The Stefan Batory Secondary School in Warsaw, designed in 1923 by Tadeusz Tołowiński and of baroque derivation, became well known in Poland through its appearance in a number of publications (fig. 6.3). This type of architecture also appears in Paweł Wędziagolski's building for the Free University on Banacha Street (Warsaw, 1928–29), later used by the military; in educational buildings designed and built between 1928 and 1929; in Romuald Miller's train station (Gdynia, 1926, since destroyed), which had a historicized attic (a decorative parapet wall widely used in traditional Polish architecture to hide sloping roofs behind); and in Stefan Narębski's building in Montwiłłowski passage (Wilno, 1929). Such forms were easily adapted for church purposes, as in the church in Raduń (1929–33) by Jan Borowski.

6.3. *Tadeusz Tołowiński. Stefan Batory Secondary School. Warsaw, 1923.*

The drawings of famous Polish architect-renderer Stanisław Noakowski, which depicted the Polish architectural heritage, also brought public attention to national traditions, as did publications such as *Wieś i Miasteczko* (Village and Town). Such concepts were mainly applied to the architecture of small towns. Nevertheless, their influence appears in the work of distinguished architects such as Romuald Gutt, Bogdan Treter (church in Dzianisz, 1932–37), and particularly Jan Witkiewicz-Koszczyc, whose school of building arts (Kazimierz Dolny, after 1922), in which masonry, stone cutting, carpentry, and metal crafts were taught, maintained such a spirit.

The principal direction of the 1920s and 1930s in Polish architecture, however, was academic classicism. It was practiced with the greatest intensity in the 1920s, but its simplified and monumentalized forms were also used in the 1930s. During the first period many important state churches, institutions, banks, schools, and miscellaneous buildings were designed in the neoclassical style. Among the best-known state buildings are the headquarters of the Polish National Bank (Siedlce, 1924) by Marian Lalewicz (fig. 6.4); the District Government and Parliament of Silesia (Katowice, 1924) by architects Kazimierz Wyczyński, Piotr Jurkiewicz, Ludwik Wojtyczko, and Stefan Żelenski; the Ministry of Religious Affairs and Public Enlightenment (Warsaw, 1927–30)

by Zdzisław Mączyński (fig. 6.5); and the courthouse in Łódź (1927–32) by Józef Kaban. Neoclassicism was particularly popular as the language for bank buildings. Among the most famous designs in this domain are Adolf Szyszko-Bohusz's Palladian-style savings bank (Kraków, 1925), with its gigantic order of columns (fig. 6.6); Kazimierz Wyczyński and Teodor Hoffman's National Polish Bank (Kraków, 1925); the Treasury Building in Krakow (1922–25) by Wacław Krzyżanowski; the State Agricultural Bank of

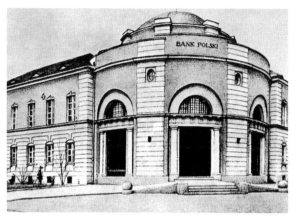

6.4. *Marian Lalewicz. Polish National Bank headquarters. Siedlce, 1924.*

Warsaw (1928) by Marian Lalewicz; and many banks in smaller towns such as Siedlce, Ostrowiec Świętokrzyski, and Brześć. Among school buildings are the High Economic School (Poznań, 1929) by Adam Ballenstedt, and the School for Girls (Łódź, 1925) by Józef Kaban. The outstanding churches carried out in this style are the Church of the Victorious Mother of God (Łódź, 1926) by Józef Kaban, the parish church in Trembowla (1927) by Adolf Szyszko-Bohusz, and the parish church in the Dębniki

suburb of Kraków (1931–38) by Wacław Krzyżanowski. Many residential buildings were also designed in the style of academic classicism, such as the Savings Bank Employees' Apartment House in Kraków (1925) by Adolf Szyszko-Bohusz, and the beautiful Palla-

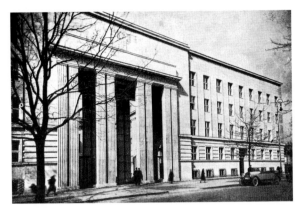

6.5. Zdzisław Mączyński. Ministry of Religious Affairs and Public Enlightenment. Warsaw, 1927–30.

dian-style Bielski Palace in Lwów (1923) by Jan Bagieński (fig. 6.7). Other well-known examples of this style are the Mineral Water Baths in Krynica (1924–26) by Władysław Klimczak (fig. 6.8) and the Telephone Exchange building (Łódź, 1927) by Józef Kaban.

In contrast to the neoclassicism of the 1920s, the architecture of the 1930s is distinguished by far-reaching simplification of forms based on maintenance of proper proportional relationships and later by stone and ceramic cladding (with frequent sculptural ornamentation) applied to concrete or steel skeletons of monumental scale. This second tendency was powerfully influenced by the works and teaching of Rudolf Świerczyński, who was professor of architecture at the Warsaw Polytechnic. The first tendency appears in such buildings as the National Museum in Warsaw (begun in 1926 but terminated in 1934) by Tadeusz Tołowiński and the National Museum in Kraków (1936–39) by the team of Bolesław Szmidt, Juliusz Dumicki, and Janusz Juraczyński (fig. 6.9). The imposed decorative attic on this building is supposed to help bridge the gap between the universality of neoclassicism and local Kraków traditions.

Another important conceptual movement appears to have influenced the evolution of neoclassicism in the 1930s: the expressionism connected with the ideology of the so-called Kraków Workshops, an association that existed between 1913 and 1926 and encompassed the activities of the Formists, a group of expressionists founded in 1919. This group was active in Kraków, Lwów, Warsaw, and Poznań and published a theoretical magazine, *Formizm* (Formism), between 1919 and 1921. The expressionists used Gothic glass traditions, as in the Collegium Maius of Jaggielon University in Kraków, and the regional tradition of deriving art from vernacular sources. Similar tendencies manifested west of the Polish borders, in the work of Bruno Taut.

The works that emerged from this approach acquired pointed decoration, triangulations, and forms that imitated natural crystals, but also folkloric ornamentation. The

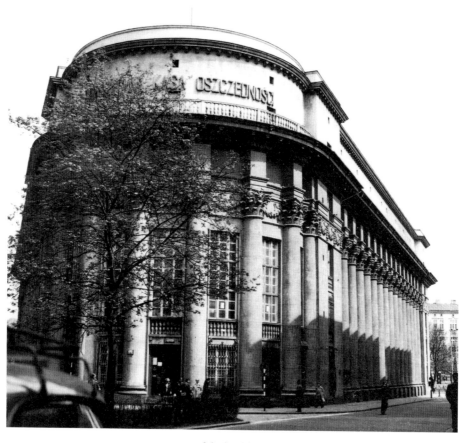

6.6. *Adolf Szyszko-Bohusz. PKO Savings Bank. Kraków, 1925.*

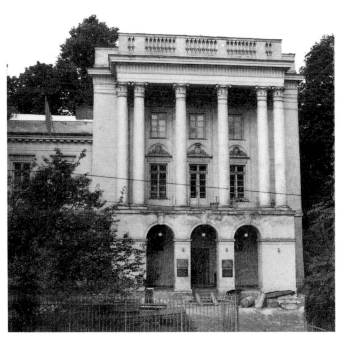

6.7. *Jan Bagieński. Bielski Palace. Lwów, 1923.*

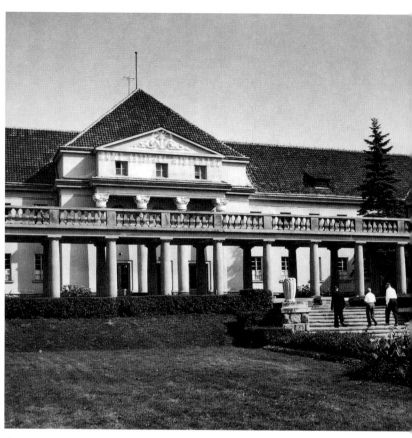

6.8. Władysław Klimczak. Mineral Water Baths. Krynica, 1924–26.

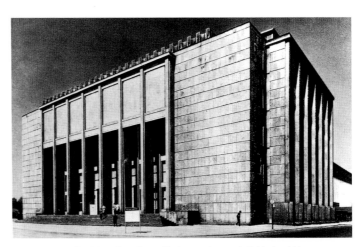

6.9. *Bolesław Szmidt, Juliusz Dumicki, Janusz Juraczyński. National Museum. Kraków, 1936–39.*

ephemeral Polish Pavilion at the 1925 Exposition International des Arts Décoratifs et Industriels Modernes in Paris, designed by architect Józef Czajkowski and artists Zofia Stryjeńska, Wojciech Jastrzębowski, and Karol Stryjeński (fig. 6.10), is the most prominent example of this direction, along with the Pavilion of the Glass Manufacturers at the Poznań exhibition of 1929, no longer extant, by Jan Goliński and Henryk Łagowski. Among the surviving examples of this style are the 1929 apartment building in Kraków at the intersection of Sienkiewicza and Wybickiego streets by Wacław Nowakowski and the house for the professors of Jagiellon University on Inwalidów Plaza (Kraków, 1929) by Ludwik Wojtyczko, Stefan Żeleński, and Piotr Jurkiewicz, the facade of which is covered with triangular decoration. The triangle motif was also applied by Tadeusz Michejda in the arcades of the town hall in Nowa Wieś, near Katowice (1930). The architect who moved furthest in the direction of applied glass forms was Oskar Sosnowski in his St. Roch's Church in Białystok (1927–46), built in reinforced concrete (fig. 6.11). Sosnowski concluded that late-Gothic forms and Gothic geometric and structural concepts could be translated into the new material.

Sosnowski was not the only architect, however, who transplanted onto Polish soil the practical achievements of Auguste Perret in the domain of reinforced-concrete church constructions. Tadeusz Ruttie, who designed the church in Borek Fałęcki in Kraków (1937–39), worked in a similar mode. However, Jan Witkiewicz-Koszczyc achieved

the greatest integration of reinforced concrete and traditional monumentality, in his Workshops of the Higher School of Trade in Warsaw (1925–26) and in the school's library (1924–30), which is topped by three enormous zigguratlike skylights. The characteristic feature of both buildings is steps recessing toward the windows in the concrete frame, which projects as a gigantic

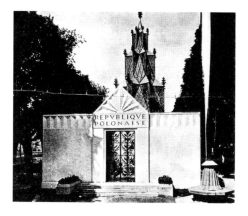

6.10. Józef Czajkowski with Zofia Stryjeńska, Wojciech Jastrzębowski, Karol Stryjeński. Polish Pavilion. Exposition Internationale des Arts Décoratifs et Industriels Modernes, Paris, 1925.

order of piers; placed on the top of the building's corners are gigantic ornamental acroteria.

Another project by this remarkable architect, a masterpiece of reinforced concrete architecture, was unfortunately not realized—the 1930 competition project for the Church of Holy Providence in Warsaw (fig. 6.12). In the same competition the parallel first prize was received by Bohdan Pniewski, who converted in 1929 from being an early functionalist to become Poland's foremost representative of academic, classical, and monumental architecture. Several versions of his church project (1932–38) re-

vealed a volume stepping up like an American skyscraper, articulated on the exterior via a dense rhythm of vertical ornamental ribs (fig. 6.13). Eventually the progressive and gradual tightening of the vertical rhythm of such ribs, often clad in expensive materials, became synonymous in Poland with the neoclassical architecture of the 1930s. The real source of this concept

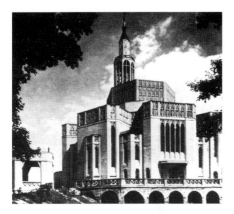

6.11. Oskar Sosnowski. St. Roch's Church. Białystok, 1927–46.

lies in the earlier projects of Rudolf Świerczyński, who around 1928 invented this style and expressed it in such projects as the Ministry of Communication (Warsaw, 1928), clad in pinkish terra-cotta, and the Bank of National Development in Warsaw (1928–31), clad in gray andesite (fig. 6.14).

Among other buildings in this tradition erected during the 1930s are the high-rise office of the Prudential Insurance Company (Warsaw, 1931–32) designed by Marcin Weinfeld and renowned engineer Stefan Bryła, the Railroad Workers Club (Lwów, 1935) by Jan Zaręba, the monumental grain elevator (Gdynia, 1934 and 1936) by Bolesław Szmidt, and the Jagiellon

Library (Kraków, 1937–39) by Wacław Krzyżanowski. The elevations of all of these buildings display a vertical order of decorative ribs and piers in the interest of monumental expression. On some occasions the vertical ribs are expressed in a more traditional manner, as demonstrated by the library of the Lwów Polytechnic on Nikorowicza Street (1932) by Tadeusz Obmiński (fig. 6.15). In still other cases the vertical ribs and piers have been completely eliminated from elevations without any loss of the subtle and sober spirit of classical aesthetics. A good example of such minimalist handling of neoclassical architecture is in Bohdan Pniewski's Warsaw courthouse on Solidarności Avenue (1935–39).

Once the world economic crisis was over, the 1930s brought considerable wealth to many citizens of Poland. They often invested in the construction of luxurious private residences. This architecture excelled in the use of expensive and refined domestic and imported stone, imported wood, bronze, brass, and stainless steel, and in first-rate precision craftsmanship. The best examples of such architecture are the residence of the foreign minister (1933–36, destroyed) erected by Bohdan Pniewski on a site next to the Bruhl Palace in downtown Warsaw, the Hotel Patria in Krynica (1932–34), which belonged to the famous Polish opera star Jan Kiepura, also designed by Pniewski, and the vacation villacastle of the Polish president built by Adolf Szyszko-Bohusz in 1930–31 in the mountain resort of Wisła (fig. 6.16). The importance of neoclassicism in Poland is proven by

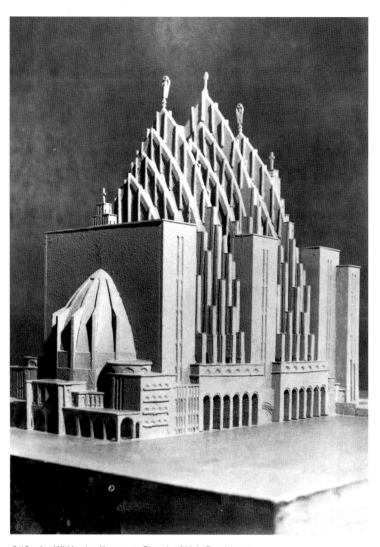

6.12. Jan Witkiewicz-Koszczyc. Church of Holy Providence.
Competition project. Warsaw, 1930.

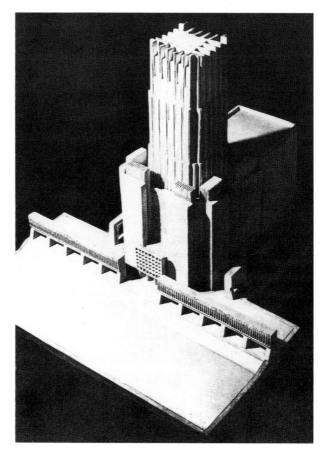

6.13. Bohdan Pniewski. Church of Holy Providence. Version of competition project. Warsaw. 1932–38.

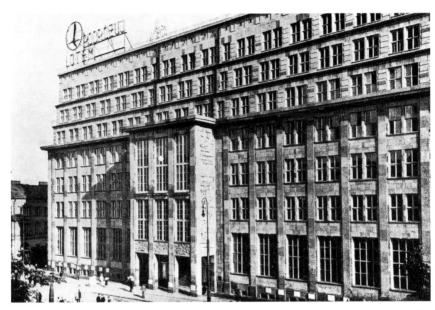

6.14. Rudolf Świerczyński. Bank of National Development. Warsaw, 1928–31.

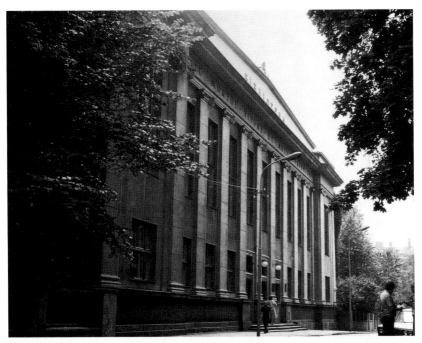

6.15. Tadeusz Obmiński. Lwów Polytechnic Library. Nikorowicza Street, Lwów, 1932.

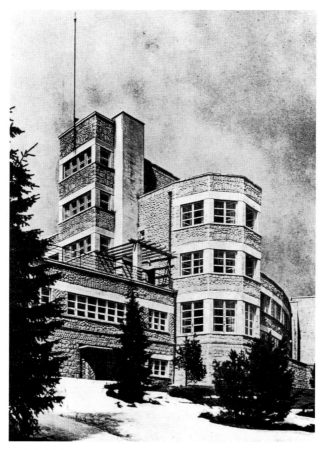

6.16. *Adolf Szyszko-Bohusz. Villa-castle of the Polish president.*
Wisła-Kubalonka. 1930–31.

the fact that the main part of the Polish Pavilion at the 1937 Paris International Exposition, designed by Bohdan Pniewski and Stanisław Brukalski, was carried out in this style (fig. 6.17). This main pavilion was a neighbor and perhaps competitor of the so-called Economic Pavilion, which was conceived in the constructivist spirit by architects Bohdan Lachert and Józef

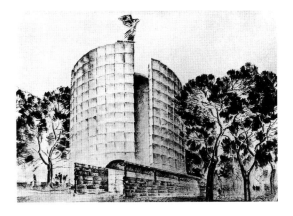

6.17. Bohdan Pniewski and Stanislaw Brukalski. Polish Pavilion. Paris International Exposition, 1937.

Szanajca. The existence of those two official Polish pavilions at the foreign exhibition is the best evidence that architecture in Poland advanced along different conceptual paths. However, the proposed and unrealized project for the Polish Pavilion at the 1939 World's Fair in New York, by Bohdan Lachert, could have prophesized which current in Polish architecture would emerge victorious, had the eruption of World War II not put an end in Poland to everything connected with national life, including the development of architecture.

Kcstsierzina
Skarszowy Tehev
Starogrod
Czersk
Elbing
Marienburg
Rastenburg

Khoinitse Nowe
Allenstein
Kamien
Svietse
D. Eylau
Lubawa
Lasin
Wieebrok
Mrocza
Grudziadz
Kurzcrnik
Janow
Kolno
Naklo
Wabrzezno
Khelmno
Brodnica
Lidzbark
Dzialdowo
Myszyniec

Bidgoshch
Wisla
Golub
Torun
Rlpin
Mlawa
Przasnysz
Maków

Chodziez
wiec
Znin
Nieszawa
Lipno
Ciechanow
Ostro
Ma

Rogów
Inowrotslaw
Sierpc
Wloclawek
Plonsk
Bug
Brok

orniki
Mogilno
Kruszwica
R.
Pultusk

Strzeino
Gnlezno
Gostynin
Plotsk
Modlin
Radzymin
Wegre

Kostiryn
Witkówo
Chodeczo
Gabin
WARSZAWA
(WARSAW)
Praga
Kalu

iroda
Wrzesnia
Zempolno
Kutno
Srem
Kolo
River
Konin
Leczyca
Sochaczew
Minsk

P
Yarotsin
Turek
Lowicz
Grodzisk
Pleszew
Ozorkow
Zgierz
Skiernievits
Kozmin
Kalisz
O
Lodz
Groyets
L

toshi
Ostrów
Warta
Lask
Pabjanice
Rawa
Warka

Sieradz
Zdanska Wola
Tomaszów
Odrzywol
Deblin

Kepno
Lututow
Plotrków
Opochno
Radom
Wielun
Szydtowiec
River

Rychtai
Przedbórz
Konskiye
Itza
Solec
Dzialoszyn
Radomsk
Radoszyce

Janow
Chestokhova
Wloszczowa
Kieltse
Opatów
Oppeln
Chmielmik
Sa
Lubliniec
Zarki
Jedrzejów
Staszów
Neisse
Pilica
Miechów
Pinczów
Wisla
Tarnowitse
Dziatoszyce
Ma
Beuthen
Bedzin
Korczyn
Mielec
Hutakrolewska
Proszowice
Radomysl
Ratibor
Katowice
Chrzanow
Debica
Rzesze
Opava
Sosnowice
Krakuy
(Cracow)
Tarnów
Ropc
ov
Mor. Ostrava
Bohumi
Wieliczka
Ma
erk
Mistek
Tesin
Bielsko
Maków
Limanova
Tuchow

uwalki
Sejny
Augustow
Lida
Niemen
Grodno
Nowogródek
Grajewo
Suchowola
Mir
R.
aczyn
Osowiec
Kuznica
ilow
Sokólka
Wolpa
N. Mysz
Baranowicz
Tykocin
Wasilkow
Slonim
Ostrow
Sinawka
za
Bialystok
Wolkowysk
7
eck
Narew
Nowy Dwor
Bitteń
Lipsk
owia
Suraz
Kosowo
Telemany
Bielsk
Bransk
Hajnówka
Sokolów
Kieszczele
Pruzana
Lohiszyn
Luniniec
Koz
Drohiczyn
Mielnik
Kamieniec Lit.
River
Czerniawczyce
Pinsk
Siedlce
Janów
Kobryn
Janow
Biala
Brześć Litewski
edzyrzec
Koden
Mokrany
N
Newel
D
ow
Horodyszcze
Orzechowa
River
Wysock
Sta
Radzyn
Domaczewo
Lubieszów
Dobrowica
Parczew
Wlodawa
Ratne
Kamien Koszyrskij
Ton
Ostrow
Bug
Wyzwa
Wlodzimierzec
Sarny
lawy
Lubartow
Kowel
Czartorysk
Horodec
Pripet
Horyn
Chem
Sokul
Kolki
blin
River
Turzysk
Ben
fow
Krasnostaw
Wlodzimierz Wolyn
Luck
Krasnik
Alexandr
nierz
Janow
Hrubieszów
Lokacze
Klewan
Tucz
Zamość
Komarow
Sokal
Swinjuchy
Rowne
Laszczów
Bilgoraj
Józefów
Tomaszów
Dubno
Ostrog
Belz
Radziechow
Werba
Tarnogród
Rawa ruska
Radziwiłów
Sudylk
zajsk
Kamionka Str. Brody
Krzemieniec
ancut
Przeworsk
Zółkiew
Jampol
Jaroslaw
Busk
Wysogrodek
Jaworów
Dynow
Lwow
Stoczow
Załozce
Zbaraż
Przemysl
(Lemberg)
Swirz

A

FUNCTIONALISM IN POLISH ARCHITECTURE

WOJCIECH LEŚNIKOWSKI

From the West comes the architecture which has gone astray . . . which suits the taste of snobs and parvenus. There, ties linking the present with the culture of the past ages have been severed. From [the] East it was at first the same, as an imitation. Now a shift to 2,000–2,500 years back. To the architecture of Greece and Rome. Polish architecture oscillates between these magnetic poles.

—Romuald Miller,
"The Struggle for Program"

The appearance and development of various architectural and artistic magazines, intellectual and professional programs, and ideological groups was delayed by the general difficulties encountered during the initial, extremely difficult formative years that Poland endured as an independent state. Until the appearance of the architecture magazine *Architektura i Budownictwo* (Architecture and Construction), first published in Warsaw in 1925, the only professional publication in Poland had been *Architekt* (Architect), published in Kraków since 1900. In 1914, due to the war, the magazine stopped appearing, to reappear in 1922 with Władysław Egielski, architect, teacher, and restorer of historical buildings, as editor. The magazine was then published irregularly, ceasing altogether in 1932. Its initial task was to inform the public about the progress made in architecture and technology, about quality design, and about the nature of current theoretical debates. One of the magazine's principal programmatic tasks was the propagation of new building technologies. Among them was reinforced concrete, which (according to the editor), was sculptural and flexible and thus required a fundamental change in architectural aesthetics. The other important issue that *Architekt* emphasized strongly was the need to develop a sophisticated industrial architecture in Poland. Industrial architecture did not have to be ugly and disorderly but should become an essential conceptual stimulus for the development of innovative approaches to architecture in general. Public housing, particularly that of the working class, was another important subject of interest to this magazine. It supported rational views and attitudes in architecture, clearly demonstrated in 1922 when *Architekt* attacked Bruno Taut's expressionistic, romantic ideas associated with his proposals for glass architecture. The magazine considered them wasteful, romantic, and unrealistic.

The first modernist, avant-garde activities in Poland also occurred in Kraków, where various artists with modernist interests grouped themselves around the literary magazine *Zwrotnica* (Switch), which appeared in 1922. In Warsaw, a second avant-garde, modernist magazine entitled *Blok* (Block), published by Mieczysław Szczuka, was launched in 1924. *Blok* was the first true artistic, avant-garde publication in Poland. It addressed a variety of advanced modern issues ranging from literature to painting, from sculpture to architecture. It reported on many European avant-garde developments by translating important theoretical articles that appeared in the foreign press. Szczuka particularly appreciated the writings of Theo van Doesburg in his *De Stijl* magazine. Correspondingly, *Blok* recommended to its readers foreign magazines devoted to modern arts such as *Disk* and *Stavba* (Building), published by Czech modernists Jaromír Krejcar and Karol Teige; *Der Sturm* (The Storm), edited by Herwarth Walden; and *Farbe und Forms* (Color and Forms), edited by van Dietrich, both published in Germany; *Manometre* (Manometer) published by E. Malespine in France; and *Ma* (Today), published by Hungarian Lajos Kassák in Austria.

The artists and intellectuals grouped around *Blok* belonged to the left-wing intelligentsia, which associated creative advancement in the arts and architecture with democratization and openness in the Polish sociopolitical system. The first issue of *Blok* announced its editorial program, emphasizing the need to fight against individualism in the arts in favor of collective values. It stressed objectivity as the fundamental tenet of modern creativity and underlined that systematic, collective, and rational efforts and processes mattered more in the scientific and industrial twentieth century than ever before. The program announced that *Blok* was to become the magazine of constructivists, functionalists, cubists, and suprematists, and its main

7.1. Mieczysław Szczuka. Monument to Freedom. 1922.

mission was to propagate the all-important role of construction in modern architecture. Function and structure were considered more essential as architectural principles than were stylistic formulas. This was particularly critical in view of the poor hygienic conditions prevailing in Poland and the new functional demands advanced by the modern era. With spiritual ardor comparable to that of Russian constructivism, Dutch and German functionalism, and Le Corbusier's machinist radicalism, *Blok* directed attention away from historicism, eclecticism, and formalism and toward machine production and industrial products such as cars, airplanes, trains, and ocean liners.

In view of the general vacuum of modernist ideas and the lack of experience in modern art and architecture in Poland, *Blok* looked for contacts, inspiration, and opportunities abroad in its efforts to propagandize new art and architecture. Szczuka's interests at first encompassed sculpture and painting, and later, architecture. He and other members of the Blok association,

7.2. *Teresa Żarnower, Mieczysław Szczuka, Piotr Kamiński, Antoni Karczewski. Proposal for a super-block residential development. 1927.*

such as sculptors Teresa Żarnower and Katarzyna Kobro, exhibited their artwork in Berlin and Moscow. They were all interested in spatial and structural systems that would yield endless manipulative possibilities carried out on the basis of a rational and standardized approach to design. Szczuka created a constructivist composition called *Monument to Freedom* (1922) (fig. 7.1), substantially influenced by Vladimir Tatlin's formal experiments. Several other compositions and architectonic projects by Szczuka, Żarnower, and Kobro, also influenced by Kasimir Malevich, Theo van Doesburg, Piet Mondrian, and Ludwig Mies van der Rohe, were

published in *Blok*. Two avant-garde painters belonged to Blok: Henryk Stażewski, who was interested in cubism and later in constructivism, and Władysław Strzemiński, who began his artistic studies after the October Revolution in Russia. Strzemiński cooperated until 1922 with the Russian avant-garde and particularly with Malevich. After his return to Poland in 1922, Strzemiński became one of the most active members of Blok and later of the Praesens association. He was the author of numerous theoretical treatises, among which the most important concerned the theory of unism and theory of perception. In 1924 *Blok* announced the slogan of "utilitarian beauty" as an essential value and purpose of modern art and architecture.

Szczuka and Żarnower, as well as others, were also interested in the issues surrounding modern town planning. In 1927, in association with Piotr Kamiński and Antoni Karczewski, the two published proposals concerning new approaches to planning housing subdivisions. In typical functionalist style, they suggested taking the super-block approach to the planning of housing blocks whose edges were left open, and the sites were to be planned as vast gardens surrounding various housing structures (fig. 7.2).

Organizing national exhibits of modern art was also important for the members of Blok. In March 1924 the first avant-garde exhibition was held in Warsaw, in the automobile salon called Laurin and Klement, to emphasize the organic connections between modern art and industrial machines. The role of

Blok as a propagandist of modern art and architecture was particularly important given that at this time the influence of Beaux-Arts ideas and of conservative research into the national character of Polish art and architecture was very strong. It was also important because of the approach taken by the official magazine of the Polish Association of Architects (SAP), *Architectura i Budownictwo,* from the beginning. This magazine began to appear in Warsaw in 1925 with Romuald Miller acting as its editor; the architects connected with the association were not inclined to assume extreme theoretical positions.

Miller's own personality and professional background well define the group's character and ideology. Miller was educated at the Institute of Civil Engineers in St. Petersburg and was a militant socialist. After his return to Poland he became the city engineer in Łódź. From 1918 on he headed the building department of the Polish Railroads. In this capacity he designed several railroad terminals, some in the style of Polish country manor houses; a good example is his terminal in Gdynia. At the same time Miller designed the innovative State Factory of Telephones and Telegraphs in Warsaw, a concrete skeletal system with glass enclosures. He also designed the functionalist children's hospital in Warsaw. Such occasional modernism did not prevent him from practicing the art deco style. He was, therefore, a man of many convictions and abilities. The Polish Association of Architects counted as members such experienced architects as Maksymilian Goldberg, Jan Stefanowicz, Stani-sław Siennicki, Bohdan Pniewski, Lech Niemojewski, Roman Piotrowski, and Jerzy Puterman.

The catalogue of the first exhibition held under the association's patronage stated that SAP was not an artistic group with a single avant-garde program but an inclusive organization with a wide variety of opinions. The dual purpose of magazines such as *Architektura i Budownictwo* and of organizations such as SAP was to elevate Polish architecture to the high international level and to struggle against conservatism and provincialism in Poland. These trends, associated with excessive cultivation of the past and with interest invested creating the "national style," often produced eclectic pastiches of random historical elements. The first editorial that appeared in 1925 in *Architektura i Budownictwo* was signed by Karol Jankowski. In a spirit similar to the proclamations of the Praesens group, he stated that the accelerated development of technology called for functionally and rationally designed buildings and for aesthetic adjustments to the demands and logic of technology. Decoration and craft must give way to technologically derived conceptualization. The modern architect should be defined as an artistic constructor. Designing in the modern spirit required taking a bold leap forward. Inventive and fresh ideas should be primarily associated with new building materials and new methods of construction. Such statements mirrored the convictions of international architecture, and Polish architecture should adopt the same approach.

The *Architektura i Budownictwo* group included also visionaries and theorists such as Lech Niemojewski, who eventually became professor of history and theory at the Warsaw School of Architecture and created many visionary drawings (fig. 7.3) and propositions dealing with industrial cities and cities generated by the functionalist approach. Some of his drawings, such as *Square in a Commercial District* (1925), are strongly reminiscent of the ideas of German planner Ludwig Hilberseimer (fig. 7.4). However, because ultimately *Architektura i Budownictwo* opted for a middle-of-the-road approach to theoretical issues, it became the most important source of broadly conceived information. It provided Polish architects with adequate knowledge of international and national architectural and professional developments.

But some architects and artists judged the compromising intellectual and professional attitude shown by this magazine inadequate and unclear. As a result, Praesens, a new association and its representative magazine, came into being in Warsaw. It consisted of young architects and artists, frustrated with the slow pace of reform, who were looking for more radical answers and solutions in order to bring more rapid changes. Some architects and artists in this group were associated with the Warsaw School of Architecture, and some were former members of the Blok association. In 1926 the Praesens group started publishing its own magazine of the same title; publication had a major impact on the subsequent development of Polish modernism.

The principal role in the development of this organization and its magazine was played by Szymon Syrkus, who in 1925 returned to Poland from Paris and joined Blok immediately. He was highly educated and an internationalist at heart. He studied architecture in Vienna, Graz, Moscow, and Warsaw and art at the Academy of Fine Arts in Kraków. He spent two years, 1922 to 1924, in Berlin, where he familiarized himself with Bauhaus ideas, and in Paris, where he discovered cubism, Le Corbusier, and purism. In Holland, Syrkus met Mondrian and the members of the De Stijl group. His foreign experience put him in a perfect position to assume a leading role in the Polish avant-garde movement. In 1926, he helped to organize the first International Exhibition of Modern Architecture in Warsaw, which became an enormous event within the Polish architectural milieu.

Syrkus used *Blok* and *Praesens* to inform the readers about essential foreign developments. He was immensely impressed by the American building industry, which built houses based on prefabrication and developed serial production of kitchens and bathrooms and their equipment. In his articles, Syrkus pointed out that American workers' effort was limited to the montage of prefabricated components. He connected the problem of mass housing with the concept of industrialization, for which there was an enormous need in Poland. Architecture, in his opinion, should imitate various branches of industry, such as the automobile industry. Architecture must become a machine. Therefore, Syrkus saw studies

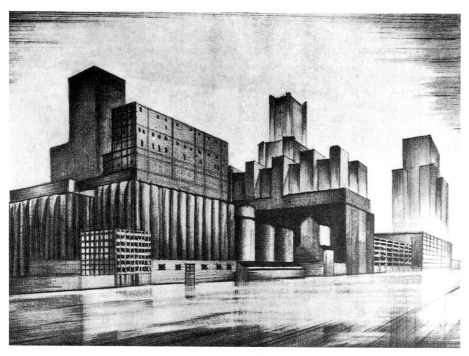

7.3. *Lech Niemojewski*. Grainaries and grain elevators. *1925.*

7.4. Lech Niemojewski. Square in a Commercial District. *1925.*

in abstraction as modern tools of design. He believed that flexibility, openness, and transparency were essential for the modern lifestyle. Similar to the German functionalists, he advocated the establishment of basic minimal standards for housing that would reflect essential behavioral and psychological concerns. Syrkus surrounded himself within the Praesens organization with such future prominent functionalists as Bohdan Lachert, Józef Szanajca, Stanisław and Barbara Brukalski, and painters Andrzej Pronaszko and Henryk Stażewski.

Syrkus defined the magazine's program in its first editorial: architecture had to adapt to industrial production. The machine was to be an inspiration and a key to solving modern social and design problems. Projects by Le Corbusier, Walter Gropius, Gerrit Rietveld, Auguste Perret, Mart Stam, J. J. P. Oud, Alvar Aalto, and Moisei Ginzburg were published in the first two issues. Syrkus had the opportunity in Paris to acquaint himself with Le Corbusier's work, particularly with the content of his seminal *Towards a New Architecture.* He considered Le Corbusier a genius and made the point clear in his magazine. Syrkus also respected Gropius and applauded German architectural achievements with equal enthusiasm. Curiously, Le Corbusier was never invited to speak or exhibit his work in Warsaw, although he traveled through Poland three times on the way to Moscow, where he was building the Centrosoyous. It was, after all, on a train from Poland to Moscow that Le Corbusier wrote his famous reply to Karel Teige's criticism of his proposed Mundaneum in Geneva. Gropius lectured in Czechoslovakia and Hungary and traveled to Russia but also never spoke in Poland.

As a direct result of innovative ideas and projects that members of Praesens submitted to the 1927 international competition for the Palace of the League of Nations in Geneva, the Swiss historian Siegfried Giedion asked Syrkus and Józef Szanajca to join the Congrès Internationaux d'Architecture Moderne (CIAM), which was involved in the international propaganda of modern architecture. CIAM eventually divided its membership into two major groups; Poland participated in the Eastern European group along with Czechoslovakia, Hungary, Yugoslavia, and Greece. As a result of Syrkus's energetic efforts, Polish delegates participated in a few early crucial CIAM meetings, and several Polish projects were exhibited and discussed there. In Frankfurt, Germany, three Polish projects were shown: housing for the Warsaw Cooperative (WSM) by Barbara and Stanisław Brukalski; housing for the Gdynia Cooperative (GSM) by Romuald Gutt, Karol Jankowski, Andrzej Paprocki, and Jan Zakowski; and the Workers Housing Colony at Polesie Konstantynowskie by Jerzy Berlinger, Jan Łukasik, Miruta Słonska, and Wacław Szereszewski. During the CIAM in Brussels, two Polish projects were introduced: a second housing project for the WSM by Barbara and Stanisław Brukalski and housing in the Rakowiec district in Warsaw by Szymon and Helena Syrkus.

The fourth CIAM, which was to take place in Moscow, was not

held there because of the change in political attitude regarding modernism in the Soviet Union. It was held instead aboard the ocean liner *Patris II,* which was cruising between Athens and Marseilles. During this famous "romantic congress," which was entirely dominated by the personality of Le Corbusier, the problems of great European cities, including Warsaw, were discussed. The Polish delegation consisted of the Praesens members Barbara and Stanisław Brukalski, Roman Piotrowski, and Helena and Szymon Syrkus. In 1934, at the CIRPAC conference in London, Jan Chmielewski and Syrkus presented their recent study "Warsaw—The Functional City," which dealt with the development of Warsaw in the context of the entire region. According to Syrkus, Le Corbusier was very impressed by this study, pointing out the unprecedented scope and scale of this undertaking. The members of the Praesens movement also actively participated in national and international exhibitions, such as the 1927 and 1928 exhibitions of Polish architecture in Warsaw and "The Machine Age" exhibition in New York. The catalogue of this last exhibition included Polish projects as well as Syrkus's article "Architecture Opens the Volume."

Another center of intellectual dissent existed at the School of Architecture at the Warsaw Polytechnic. There, Prof. Roman Piotrowski introduced students to Le Corbusier's *Towards a New Architecture.* This revolutionized teaching and students' activities in this school. One of the strongest supporters of teaching and designing modern architecture in this institution was Prof. Tadeusz Tołowiński, who pioneered the idea of the functional city in Poland. Tołowiński was educated at the Karlsruhe Polytechnic in Germany. There he acquired a first-hand knowledge of Western advancements in city planning, particularly in Germany, which he transplanted to Poland. He created the chair of city planning at the School of Architecture in Warsaw. As a professor there he contributed to the development of a few major urban projects in Poland. He is referred to as the father of modern city planning in Poland.

By 1925, the program of architectural studies in Warsaw began to evolve in the direction of modernism without losing the emphasis on traditional studies such as history and art. The changes primarily concerned the design studios and teaching of science and technology. Inspired partially by the scientific programs instituted by Hannes Meyer at the Bauhaus, the science of construction and mathematics prevailed over artistic subjects in Warsaw. Stanisław Hempel, a professor of structures at the school, was a distinguished Polish structural engineer and a member of Praesens. He studied abroad in Graz, Austria, which brought him closer to advanced European engineering. His innovative constructions include the steel Fertilizer Pavilion in Poznań, the Central Institute of Physical Education in Warsaw, aircraft hangars in Warsaw, and two well-known radio aerial masts. One, at the 1937 Paris International Exposition and the other, a radio tower in Raszyn near Warsaw, introduced

students to new methods of solving new design challenges. In 1938 Hempel created a building laboratory at the Warsaw Polytechnic and taught sophisticated courses in descriptive geometry and engineering.

Prof. Stanisław Bryła, another structural engineer, studied skyscraper and steel construction in the United States. He was responsible for several remarkable innovative structures, such as the first welded plate girder bridge over the Słupia River near Łowicz, completed in 1928. Other projects were the two first Polish skyscrapers, one in Katowice, completed in 1931, and another in Warsaw, the Prudential Insurance Company building completed in 1932. He also built two tubular domes, one on the Savings Bank in Warsaw (1931), another on the Jagiellon Library in Kraków (1937–39). An experimental building section was created at the School of Architecture that included the testing of materials, foundations, various types of concrete, ceramics, steel constructions, heating and ventilation systems, wooden constructions, and sanitary installations. Furthermore, there were studies of the use of light in buildings, heating systems, the use of color in architecture, resistance to seismic conditions, long-span constructions, and military fortifications. As a result of these educational and professional innovations, the Warsaw School of Architecture generated a unique blend of traditional concerns that stressed historical and artistic subjects and forward-looking, dynamic applications of the latest information on city planning, architecture, and engineering. The

school became, by the end of the 1930s, one of the most renowned departments of architecture in Europe.

At the same time, another important school of architecture existed in Poland. At the Lwów Polytechnic a number of progressive professors introduced students to new ways of thinking about architecture and city planning. Prof. Władysław Derdacki, who valued utilitarian aspects of architecture, helped to instill functionalist ideas in the students' minds. Prof. Witold Minkiewicz stood for strongly modernized versions of classical architecture. Prof. Ignacy Drexler taught city planning and could be described, along with Tołowiński in Warsaw, as the most important Polish planner of the period. Many gifted Polish modernists such as Maksymilian Goldberg and Lech Niemojewski, and a rising star of Polish modernism, Zbigniew Wardzała, studied and graduated from there as did acclaimed Silesian architects Tadeusz Michejda, Karol Schayer, Tadeusz Kozłowski, Eustachy Chmielewski, and Tadeusz Lobos.

In Kraków between 1923 and 1927 another department of architecture existed, this one attached to the Academy of Fine Arts. Among its professors was the renowned Adolf Szyszko-Bohusz, a graduate of the Academy of Fine Arts in St. Petersburg and of Lwów Polytechnic. He was the architect of many excellent monumental and neoclassical buildings such as the Savings Bank in Kraków, the Mining Academy of Kraków, and the summer residence of the Polish president in Wisła, an interesting

combination of modernism and regionalism. Szyszko-Bohusz was also famous as a restorer of major historical buildings in Poland. This architect's talent, knowledge, and range of design ideas were truly astounding. In addition to the buildings he designed in the neoclassical and regional styles, he also on occasion produced excellent modernist works. His two functionalist villas in the Cichy Kącik housing development in Kraków (an exclusive garden suburb planned by Wacław Nowakowski in the mid-1930s as a Bauhaus-influenced development of uniformly high design) and his post office in Częstochowa prove this beyond doubt. Szyszko-Bohusz became professor of monumental architecture in Warsaw after the Kraków architecture department closed. Among other faculty at the Academy of Fine Arts was Józef Gałęzowski, educated in Münich and Dresden. He was the most accomplished modernist in Kraków, the designer of numerous projects, and the dean of the school. Another teacher, Franciszek Krzywda-Polkowski, created many futurist drawings and propositions. This short-lived school represented, on the whole, a more conservative, fine-arts-oriented approach, unlike the schools in Warsaw and Lwów. The closing of Kraków's department of architecture was associated with the economic crisis of the late 1920s, which produced a general slump in building construction.

The second educational institution in Kraków was the Industrial-Artistic Trade School, which represented a high level of professionalism. Here the faculty included Franciszek Mączyński, designer of many religious buildings; Stanisław Ekielski, designer of many apartment buildings in Kraków; and Stanisław Odrzywolski, renowned restorer of historical buildings, among them the Wawel Cathedral in Kraków.

The fourth architecture department in Poland, in the city of Wilno, shared the same fate as the department in Kraków. The Wilno department was attached to the department of fine arts; both were created in 1919. Among its better-known professors were Ludwik Sokołowski and Juliusz Kłos. The department closed in 1929, also due to the economic difficulties of the time. If Kraków's architecture and teaching were influenced by Viennese sources, which included Secessionism, expressionism, and the monumentalism of the "Red Vienna" architecture, the architecture and teaching in Wilno had more to do with neoclassicism and the search for a Polish style of architecture. The buildings of Juliusz Kłos, Stefan Narębski, and Antoni Wiwulski represent good examples of such tendencies. In sum, the school and the architecture of Wilno were the most conservative and provincial in Poland.

Other significant contributions to the advancement of modern architecture in Poland came from the more than one hundred architectural competitions held during the twenty years of Polish independence. These competitions concerned new town plans, new urban subdivisions, regulatory plans for existing cities, the planning and replanning of urban plazas, the planning of important new streets,

and transportation links. Other competitions concerned the design of important buildings such as museums, churches, government offices, sports complexes, and housing of various forms and standards. For instance, the team of Bohdan Lachert and Józef Szanajca entered numerous competitions, winning a few. Among them was the 1926 competition for the School of Political Science in Warsaw, for which they were awarded second prize. Their solution featured an elegant, horizontal, dynamic glass building demonstrating the team's remarkable creative talent. Both architects also participated in the "Economic House" competition organized in 1926 by the city of Lwów, where they won several prizes for their proposals. The 1929 competition for the Warsaw Central Railroad Terminal was one of the most important competitions in prewar Poland. The prize-winning design by architect Czesław Pawłowski was built between 1929 and 1939 but unfortunately destroyed by German bombings. A vast complex of precast concrete volumes and spaces centered on a large arrival plaza, it was one of the biggest and finest new terminals in Europe. Among other competitions demonstrating the gradual progress that modern architecture was making in Poland was the 1934 competition for the Savings Bank headquarters in Poznań, for which the team of Zbigniew Puget and Juliusz Żorawski proposed an elegant glass tower. In 1934 a competition for the redesign of Saski Plaza in Warsaw was organized. The team of Maksymilian Goldberg and Hipolit Rutkowski entered with a modernist scheme that included

a high rise. Goldberg, one of the original functionalists in Poland, had distinguished himself a few years earlier with a modernist proposal for a hotel in Warsaw and with a 1929 competition entry for the Ministry of Posts and Telegraphs, also in Warsaw.

Gradually, beginning with the 1927 international competition for the Palace of the League of Nations in Geneva, modernist entries prevailed. The Geneva competition showed how architecture and politics were sometimes interconnected in Poland. Five Polish teams entered, including the teams of Lachert and Szanajca, and Henryk Oderfeld and Szymon Syrkus. All of the entries were sponsored by the Ministry of Foreign Affairs, which was anxious to promote architecture as an important art representing reborn Poland. In 1931 Grzegorz Sygalin participated with Bertold Lubetkin and Henryk Blum in the competition for the Palace of the Soviets in Moscow. Their project received honors and was purchased. Lubetkin, who subsequently became one of the most respected modernists in Western Europe, studied architecture in 1923 in Warsaw before moving to Paris.

The technological revolution that challenged Europe in the 1920s had a tremendous impact on the evolution of modern architecture, even though technology penetrated architecture rather slowly because of the general lack of laboratories and workshops that could speed up the integration of modern engineering and architecture. The production of household equipment, particularly of electric kitchen appliances, refrigerators,

heaters, and cooling fans in the United States and Western Europe was steadily rising. But Poland, because of her technological retardation, lagged far behind. For this reason aggressive development of science and engineering was seen as imperative in Poland. Brick remained the basic building material for Polish housing until the late 1930s. Criticism was often directed at the Polish avant-garde, pointing out that its architecture "pretended" to be built on the basis of advanced technology while in reality it camouflaged the technological conservatism behind its forms. The same criticism had been leveled before at the Russian constructivists and Western architects such as Gerrit Rietveld for his 1924 Schröder House in Utrecht.

But the 1930s saw a considerable development of new technologies and new materials in Poland. In housing, concrete skeletons appeared and were used in luxury housing to increase interior spaciousness and flexibility. Wide-span prestressed concrete frames were used in industrial, office, sports, and commercial structures. Steel skeletons appeared not only in high-rise buildings but also as experimental structures used to build individual houses, sanatoriums, and schools. The massive potential of concrete was applied to such constructions as the harbor in the new Baltic port of Gdynia and in the water barrage in Porąbka, in the Beskidy Mountains. Most constructions used fireproof, flat concrete roofs. The new residential buildings were equipped with central heating and centrally supplied hot water. Most of the new buildings had trash-burning facilities. The elevations of new buildings were treated with ceramics, stucco, granite, marble, and large amounts of glass. Stainless steel, aluminum, bronze, and glass were introduced in the interiors, particularly in office buildings, giving them a spacious, shining, polished, and transparent quality. The art of sophisticated detailing and interior design was steadily on the rise. The growth of public interest in the design of elegant modern furniture paralleled the development of ambitious architecture. The evolution of furniture design toward modernist concepts was swift and decisive. An excellent example of the mastery achieved in this domain was the steel and aluminum furniture designed in 1930s under the influence of Bauhaus ideas by Praesens member Andrzej Pronaszko for the presidential villa in Wisła built in the 1930s by Adolf Szyszko-Bohusz. Functionalist furniture similar to that designed for this building was used in many sanatoriums, hospitals, hotels, offices, and houses.

In 1934 the literary journal *Wiadomości Literackie* (Literary News) conducted an opinion poll among leading intellectuals on the acceptance of modern architecture. It concluded that the response was generally positive. Still, at this time modern architecture was the subject of often negative, conservative public reaction in many European nations that formerly had been considered architectural leaders, including Germany and the Soviet Union. In these countries modern architecture was to a large extent eradicated. Surprisingly, the growing nationalism in Polish domestic

politics did not much disturb the development of modernism. In fact, some of the most sophisticated Polish modernist works appeared at the end of the 1930s, when modernism elsewhere was in decline or had ceased to exist altogether. Proof of this can be found in a number of awards that Polish modernists received for their designs abroad and at home. Jan Bogusławski won the Grand Prix at the "Art and Technology" International Exposition in Paris in 1937 and first and second prizes at the 1939 World's Fair in New York. Stanisław Brukalski with Bogdan Pniewski won the Gold Medal for the design of the Polish Pavilion for the exposition in Paris in 1937, where Bohdan Lachert was awarded the Grand Prix for his Economic Pavilion. Lucian Korngold, who after the war became one of the most important South American architects, won the honorary diploma for his designs at the Fifth Triennale in Milan, Italy.

One of the more interesting aspects of Polish modernism and architectural education was the fairly large number of women architects who participated in the design of more challenging projects. This was a rather unique, progressive phenomenon compared with other countries, where architecture was practically an all-male discipline. Poland's progressive social agenda, which involved building public housing, nurseries, hospitals, and sanatoriums, must have been an important factor. We have already mentioned Teresa Żarnower, who with Władysław Szczuka edited *Blok* magazine and there published her imaginative spatial and architectonic modernist compositions.

Other women who practiced abstract painting and sculpture were Zofia Stryjeńska, who collaborated with her husband, Karol Stryjeński, and with Józef Czajkowski on the design of the Polish Pavilion at the 1925 Paris exposition. Another was Margit Sielska, who created many abstract compositions used in modernist interiors. We have already mentioned Barbara Brukalska and Helena Syrkus, who with their husbands belonged to the elite of Polish functionalist designers. Other distinguished women practitioners were Jadwiga Dobrzyńska, who with her husband, Zygmunt Łoboda, participated in the 1927 competition for the League of Nations in Geneva. She was also the co-designer of the famous children's tuberculosis sanatorium in Istebna and of many other competition entries and built projects. Anatolia Hryniewiecka-Piotrowska designed the modernist 1929 Pavilion of Women's Work in Poznań. Miruta Słowinska participated in the design of workers' housing in Polesie Konstantynowskie and in the development of a regulatory plan for the city of Poznań. Maria Wroczyńska studied the architecture of affordable housing, and Janina Rumel won the competition for the city of Paluch in the district of Warszawa Okecie. It is not surprising that after the Second World War the Polish architectural profession counted a very large number of women practitioners and teachers— a situation that continues today.

DESIGNING WITH HEALTH IN MIND

The poor state of public health in Poland forced the authorities to undertake the construction of

many health-related buildings. Tuberculosis, one of the most lethal diseases of the time, required specialized treatment centers, mainly sanatoriums, which had to be located in climatically appropriate regions of the country. The 1930s witnessed a large number of such buildings erected at or near several famous recreational areas including Krynica, Zakopane, Żegiestów, Wisła, and Bystra, located in the southern, mountainous part of the country, and Otwock and Ciechocinek, located in central Poland, near Warsaw. Some of the sanatoriums represented the best of Polish functionalism. An example is the 1936 Wiktor Sanatorium in Żegiestów, built by the Małopolska oil company for its employees and devoted to the cure of digestive disorders (figs. 7.5, 7.7). It was designed by Prof. Jan Bagieński and Zbigniew Wardzała of Lwów. It is located in a deep, picturesque valley of the Dunajec River, near the renowned Krynica spa, and belongs to a smaller spa called Żegiestów, which was planned and built in 1930s. Wiktor's architecture reflects a clean and rational functionalist style. The L-shaped plan features an asymmetrical volume dominated by a corner tower within which principal vertical circulation, game rooms, and a viewing terrace are located. The main wing, containing the patients' rooms, is treated in a decisive, compositionally horizontal manner. Its boldly cantilevered round balconies are reminiscent of Erich Mendelsohn's architecture. The shorter, perpendicular wing, which contains dining and kitchen facilities, was conceived as a crisp, pronounced cylinder, lending the sanatorium a strikingly dynamic character. The free-flowing composition and pleasant appearance of this building demonstrate the facility with which modern architecture could fit into the natural environment if handled with formal sophistication by a talented architect. This was only the second building conceived by the young and brilliant Wardzała, who was its principal designer. In the same spa is an interesting modernist hotel called Warszawianka. Its architecture undoubtedly derives from De Stijl three-dimensional handling of spaces and volumes. The third impressive building in Żegiestów is the spa center, designed in a stripped-down classical style by Adolf Szyszko-Bohusz.

The Krynica spa, located in the beautiful Sądecki Beskid mountain chain, features several interesting buildings erected before World War II. Among them is the Central Bath House that was designed by Wiktor Minkiewicz of Lwów in his typical, radically modernized classical style (fig. 7.8). Its long and plain piers forming frontal arcades recall the neorationalist designs of fascist Italy, which must have served as a model for this building, with its excellent and expensive modernist detailing. Among the modern hotels of this spa is the elegant Patria Hotel designed in 1932–34 by leading Warsaw architect Bohdan Pniewski (fig. 7.6). As in many of his other buildings, Pniewski here combined neoclassical and functionalist references in one tightly integrated and visually strong expression. This elegant project demonstrates to what extent modern architecture and the natural

7.6. Bohdan Pniewski. Patria Hotel. Krynica, 1932–34.

7.5. Jan Bagieński and Zbigniew Wardzała.
Mezzanine plan, Wiktor Sanatorium.
Żegiestów, 1936.

7.7. Jan Bagieński and Zbigniew Wardzała. Wiktor Sanatorium. Żegiestów, 1936.

landscape could complement each other. Pniewski, probably the most successful Polish architect of the 1930s, combined strong, personal aesthetic sensitivity and culture with continuous practical training and international experience acquired during his numerous foreign travels. Before he began his studies at the Warsaw School of Architecture, he studied in the building department at the Wawelberg's and Rotwand's Technical School in Warsaw.

In the southern region of the Karpaty Mountains exists another vacation and health resort called Rabka, located near the highway linking Kraków with the mountain

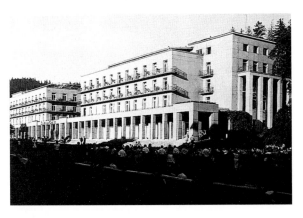

7.8. Wiktor Minkiewicz. Central Bath House. Krynica, 1932.

sports center of Zakopane. Here, several balneological and tuberculosis healing establishments for children and adults were built before 1939. The large Pstrowski sanatorium, conceived by Silesian architect Stanisław Gruszka and built in 1946, represents a late product of functionalism that survived into the early communist era and features a complex combination of several wings of different geometric configurations. Its rear elevation has

particularly interesting formal characteristics: well-executed dynamic curves, horizontal bands of windows, and a large amount of glazing. Its architect, active in the region of Upper Silesia, is also known for his 1938 modernist, asymmetrical Social Security Office in Katowice. Other healing establishments and numerous houses for doctors and housing for medical personnel were also erected in Rabka. Their consistent, superior styling gives the entire settlement a pronounced modernity comparable to Krynica.

Near Wisła, the modern spa town built in the Beskidy Mountains as the recreational health center for the population of heavily industrialized Silesia, a large children's tuberculosis sanatorium was built in 1936 by the team of Jadwiga Dobrzyńska and Zygmunt Łoboda, two of the most talented designers of the Polish modernist avant-garde (figs. 7.10, 7.11). This handsome complex was planned around a series of stepped buildings and terraces, integrating into the steeply sloping, picturesque, wooded site (fig. 7.9). The crisp, simple, functionalist geometry, rational aesthetics, and attention to detail can still be admired today. This complex has survived in good shape even though its principal wing, which once featured a visually stimulating, open, patients' deck, was enclosed in glass after the war.

Two other health-oriented buildings in Wisła deserve mention. The new spa center built in 1937 by

the architect Roman Piéńkowski accommodates administrative, commercial, and cultural functions (fig. 7.12). The architecture demonstrates a rather curious but successful combination of De Stijl compositional influences and neoclassical, neorationalist references visible particularly on the building's arcades. The second is the Idylla Pensione, which emphasizes typically modern volumetric and planning asymmetry. It was designed by architect Tadeusz Michejda, who studied in Lwów and became one of the most productive architects in Silesia. He designed many schools, churches, office buildings, and industrial buildings. He was also known for his experiments with steel skeletons, which he applied to individual houses. The tuberculosis sanatorium in the village of Bystra near Bielsko-Biała in the Beskidy Mountains was designed in 1936 by Wacław Nowakowski, architect of the Cichy Kącik housing development in Kraków (figs. 7.13, 7.14). This long, tall, and thin main building, finished in 1949, is static and symmetrical. Nevertheless, its curving terraces, which define the opposite ends of the building and are protected by curving glass curtain walls, strongly suggest the canonical images of dynamic functionalism. The building is positioned in the midst of a sloping, picturesque, heavily wooded park, along with other pavilions and service buildings.

Also in the Beskidy Mountains, overlooking the town of Maków Podhalański, is the large railroad workers' tuberculosis sanatorium designed in the 1930s by Bohdan Pniewski. It is sited on a steep slope

in the midst of dense woods, facing the rich panorama of surrounding hills and valleys. Respecting topographical difficulties, Pniewski designed the building as a long, thin,

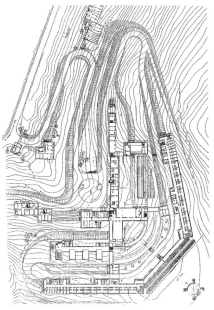

7.9. Jadwiga Dobrzyńska and Zygmunt Łoboda. Site plan, children's tuberculosis sanatorium. Wisła, Beskidy Mountains, 1936.

irregular volume containing the patient rooms and medical, dining, and administrative facilities. This building connects via covered pedestrian bridges to a secondary pavilion located on the upper part of the slope, giving the complex a bold, somewhat futuristic appearance. Its abstract, plain, and simply but comprehensively articulated volumes are enriched by geometrically distinct balconies and terraces. The architecture of this interesting ensemble resembles that of other Polish functionalist sanatoriums, although it is atypical of this architect famous for skillfully blending modernism and classicism.

The tuberculosis sanatorium

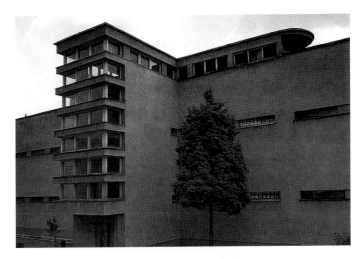

7.10. Jadwiga Dobrzyńska and Zygmunt Łoboda. Children's tuberculosis sanatorium. Wisła, Beskidy Mountains, 1936.

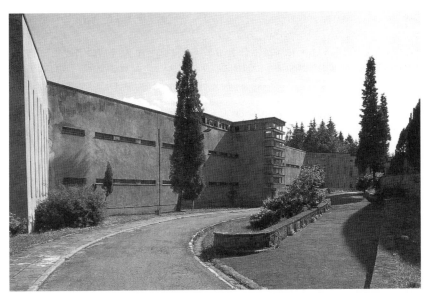

7.11. Jadwiga Dobrzyńska and Zygmunt Łoboda. Children's tuberculosis sanatorium. Wisła, Beskidy Mountains, 1936.

for the military in Otwock near Warsaw was designed in 1935 by leading Polish modernist Edgar Norwerth (fig. 7.15). Norwerth was educated and worked abroad. He studied at the Institute of Civil Engineers in St. Petersburg and at the Institute of Communication Engineers in Moscow. He taught in 1917 in St. Petersburg and Moscow and designed several industrial buildings in Russia, including a power station near Moscow. After his return to Poland, he lectured at the Warsaw Technical University between 1926 and 1930. He contributed considerably to the public success of Polish functionalism. Norwerth planned the sanatorium in Otwock as a long horizontal building whose curving terraces and platforms suggest ocean liners. Here too the abstraction of his architecture blends with the natural setting. The building's terraces are no longer used for tuberculosis cures but stand for an epoch of expressive, hygienic, and humanist architecture.

In 1931 Helena and Szymon Syrkus built an experimental rest home in Konstancin, a Warsaw suburb (fig. 7.16). They employed a prefabricated steel skeleton to which they added external glass partitions separating individual balconies. This gave the building a characteristic lightness, transparency, and aesthetic elegance. The team of Bogdan Lachert and Józef Szanajca designed a small tuberculosis sanatorium in Gostynin, near the indus-

trial city of Łódź. It also had a skeletal construction and elegantly expressed modernist shades mounted on a gently curving front facade. In 1929 in the southern border town of Cieszyn, architect Karol Tchórzewski built a tuberculosis sanatorium whose clean, symmetrical volume is reminiscent of more conservative German modernist works, such as those of Fred Otto's 1930 hospital in the town of Chemnitz in Saxony.

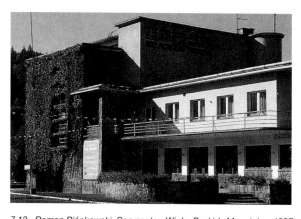

7.12. Roman Piénkowski. Spa center. Wisła, Beskidy Mountains, 1937.

SPORTS FACILITIES

The construction of sports facilities was directly related to the construction of health facilities. By the 1930s competitive and recreational sports in Poland had become a matter of national health and prestige; therefore, they benefited from considerable government support. Among the sports facilities erected, two deserve particular attention. The first is the Central Institute of Physical Education in Warsaw's Bielany district designed in 1928 by Edgar Norwerth and sponsored by the armed forces (fig. 7.17). This vast project, one of the biggest of its

kind in Europe, occupied eighty hectares. It consisted of several facilities such as exercise and gymnastic halls, a swimming stadium, an open athletic stadium, lecture rooms, laboratories, and residential facilities for professors and students. The project was executed in reinforced concrete and represented a big step in the development of modern architecture and construction in Poland.

In 1938 a great horse racing track in the Służewiec district of Warsaw was designed by a team of architects under the direction of Zygmunt Zyberk-Plater (figs. 7.18, 7.19, 7.20). It was one of the biggest stadiums of this sort in Europe. Its elegant glass and concrete architecture suggests an ocean liner. Its interior consists of a complex ramp system that connects various levels like ship decks. The beautiful and dynamic shapes of the viewing stands reserved for the public feature boldly cantilevered, thin concrete shells. The architecture of this facility convincingly demonstrates that at a time when most of modern European architecture was in retreat, functionalism was flowering in Poland.

The other great sports facility, built in 1929, was Legia Stadium in Warsaw, designed by Aleksander Kodelski and Romuald Raksimowicz (fig. 7.21). The main, open stadium could accommodate fifteen thousand people; also included were an Olympic swimming stadium, and a tennis stadium that could seat up to two thousand spectators. The most striking architectural fragment of this complex is the diving tower of the swimming stadium, designed in a sharp, dynamic, constructivist style. Also in Warsaw, architects Eugeniusz and Zygmunt Piotrowski in 1933 built the pavilion of the police rowing club on the Vistula River, a good example of modern, skeletal architecture (fig. 7.22).

In 1930–32 in the health spa town of Ciechocinek, north of Warsaw, architect Romuald Gutt and engineer Aleksander Szniolis built a saline swimming pool with a capacity of fifteen hundred bathers (fig. 7.23). An elegant entry canopy is the most characteristic feature of this complex. In the southern town of Bielsko-Biała, the local architect Stanisław Juraszko designed in 1938 an elegant, modernist swimming stadium. It skillfully exploits the sloping terrain to create a sophisticated composition of service buildings, terraces, tribunes, and swimming pools that overlook the picturesque panorama of the Beskidy Mountains. A similar facility was built in 1934 in the recreational town of Wisła by architect Stanisław Tworkowski. In the region of the Tatra Mountains, Aleksander Kodelski built between 1933 and 1936 three cable car stations serving Kasprowy Mountain in a modernist, stripped-down classical style. Architect Józef Jaworski erected a mountain hostel in the Kalatówki Valley, conceived in a style combining modernism with regional features and materials. The restaurant and hotel on top of Gubałówka Mountain in Zakopane and the mountain railroad stations at Parkowa Mountain in Krynica both have similar features. Both illustrate that modernist, abstract geometry need not be at odds with the natural environment. These examples are only the best known of

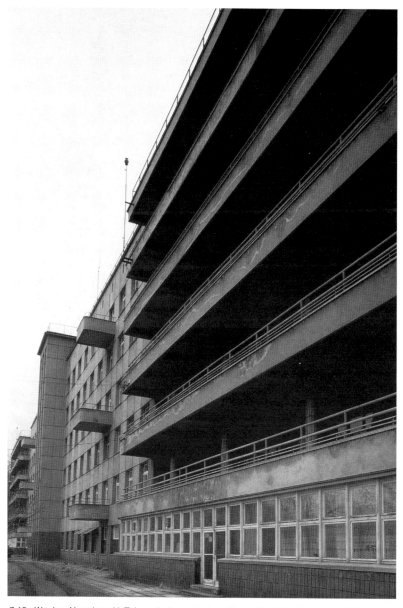

7.13. *Wacław Nowakowski. Tuberculosis sanatorium. Bystra, Beskidy Mountains, 1936.*

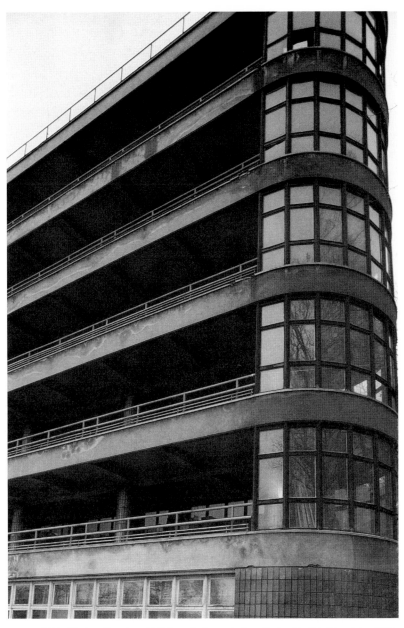

7.14. Wacław Nowakowski. Tuberculosis sanatorium. Bystra, Beskidy Mountains, 1936.

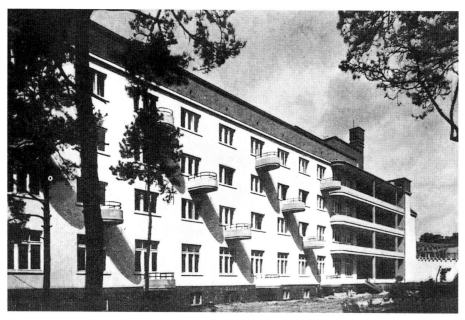

7.15. Edgar Norwerth. Tuberculosis sanatorium for the military. Otwock, 1935.

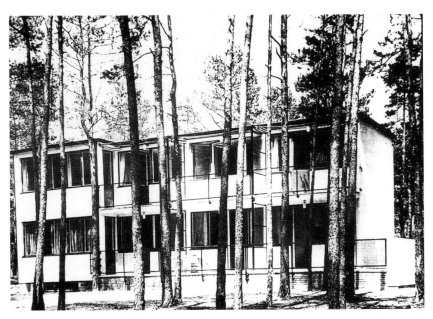

7.16. *Helena and Szymon Syrkus. Rest home. Warsaw-Konstancin, 1931.*

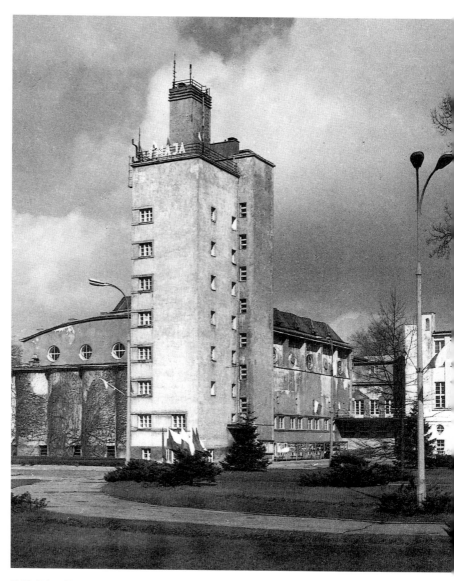

7.17. *Edgar Norwerth. Central Institute of Physical Education. Warsaw-Bielany, 1928.*

the health and sports facilities that every major Polish community sponsored between the two world wars.

PUBLIC HOUSING

Architects' participation in the design of public housing in Poland took on, from the very beginning, a combative, ideological, leftist character. Modern European functionalism was associated with the creation of affordable housing for the masses, formerly often deprived of decent living conditions. The socialist character of modern architecture was best demonstrated in the construction of large housing developments in Germany, Holland, Russia, and consequently in Poland. The functionalist concept of city planning and housing subdivisions moved away from the nineteenth-century emphasis on bourgeois individualism and the liberal laissez-faire approach toward the suppression of individualism. It inclined toward the mass production of housing, educational, and health facilities that had to be quickly provided at low cost.

In approaching the planning of new housing, the Polish functionalists took German planning experiences from Frankfurt, Berlin, and Magdeburg as their starting point. Already in the late 1920s the first Polish functionalist planning proposals, related to the large-scale planning of public housing, started appearing. Among them was the 1927 project for the housing development in the Żoliborz District of Warsaw, designed by Jan Jankowski and Wacław Weker, and Romuald Gutt and Jan Jankowski's 1928 competition entry for the Nowe Rokicie housing development near Łódź. Both projects use the German finger planning system and Bauhaus ideas such as parallel rows of identically oriented, prefabricated housing slabs. Identical in character were Jan Łukasik and Miruta Słońska's 1928 competition project for Polesie Konstantynowskie, Wacław Szerszewski and Jerzy Berliner's 1928 entry to the same competition, and Stanisław Filipkowski and Jan Graeffe's 1931 proposal for a large suburban community called Winiary, in the city of Poznań. In addition, theoretical projects by Szymon Syrkus and by students of the Warsaw School of Architecture, who were exploring Le Corbusier's concept of super-*Unités,* contributed to the implementation of new ideas in urban planning in Poland.

The scale of investment and construction of public housing in Poland, given the country's limited financial resources and modest technological base, could not compare to the awesome accomplishments of Weimar Germany. In the beginning of Polish independence, the scale of housing subdivisions was limited to groups of individual and twin houses built in a traditional manner. Only at the end of the 1920s was the construction of public housing carried out at a larger scale, taking into the account the experience of Holland and Germany.

In spite of the Polish agrarian reform of 1924, which limited the size of farms to three hundred acres, the rural population continued to flock to towns looking for work. Hundreds of thousands of flats were needed. The government

supported various employees' co-operatives while new constructions were exempted from taxation for the first fifteen years. Many cooperatives that consisted of employees of large private firms or of the state bureaucracy built settlements in the form of large housing blocks. The Social Insurance Institutions had considerable funds, which they invested in housing. In 1934 the National Economy Bank, the State Forest, the Labor Fund, and the Social Insurance Institutions founded the Society for Workers' Housing. Several cities offered free building sites while the Society for Housing Reform offered practical advice. Correspondingly, the Military Fund built houses for army personnel. Important private corporations built their own housing for workers.

By 1938, whole settlements and even new towns were erected around new factories in the so-called Central Industrial Region, the most ambitious effort of the Republic of Poland. Most of the affordable apartments had four rooms: a living room, a dining room, and two bedrooms. The research on affordable housing inspired by German standards of minimum habitable space centered from the very beginning on optimal reduction of space, elimination of corridors, and standardization of kitchens (which involved the Polish counterpart of Grette Lichotzki's "Frankfurt laboratory kitchen"), bathrooms, built-in wardrobes, and furniture.

The question of furnishing small apartments deeply preoccupied Polish architects, who made several proposals in this realm. In 1930 the Society for Housing Reform organized an exhibition in Warsaw demonstrating various design solutions and propositions for affordable housing. Among other organizations interested in the problems of public housing, the Glass Homes Society was created in Warsaw in 1927. It was inspired by Bruno Taut's early visions of glass architecture and was partially responsible for the creation of the modern residential district of Żoliborz in Warsaw. The same society undertook a vigorous public information campaign to familiarize the public in Poland with the goals and achievements of functionalist architecture. The Society for the Construction of Workers' Dwellings actively researched the lowest possible norms for worker housing. In the interest of radical savings, some of their norms stipulated as little as forty-six square meters for a single-family house and thirty-six square meters for collective dwellings. They suggested the use of collective baths and laundry facilities and the elimination of apartment corridors by using rooms for circulation. A good example of such minimum standard housing was the workers' colony built in 1936 in Tomaszów Mazowiecki, a small town not far from Warsaw. The society in 1936 built a handsome development called Paged in the town of Gdynia. The housing consisted of two-story, parallel residential slabs.

One of the most accomplished examples of affordable housing was the exhibition housing development of 1935 in the Koło district of Warsaw. It consisted of a series of individual houses and multi-family housing designed by the team of Roman Piotrowski, Zdzisław Szulc, Kazimierz Lichtenstein,

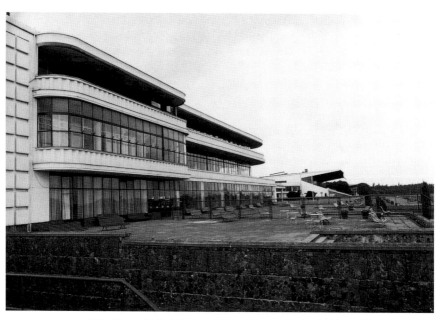

7.18. Zygmunt Zyberk-Plater and team. Horse racing track. Warsaw-Służewiec, 1938.

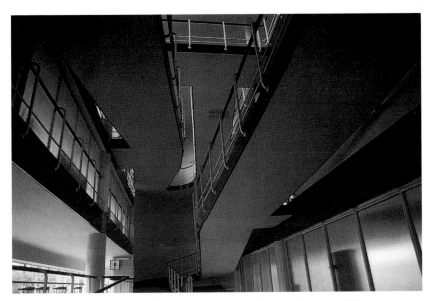

7.19. Zygmunt Zyberk-Plater and team. Horse racing track. Warsaw-Służewiec, 1938.

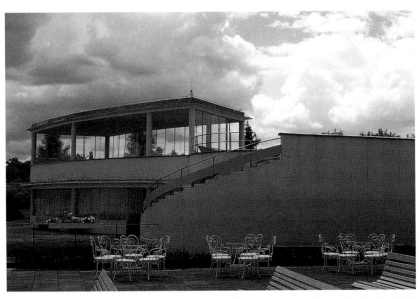

7.20. Zygmunt Zyberk-Plater and team. Horse racing track. Warsaw-Służewiec, 1938.

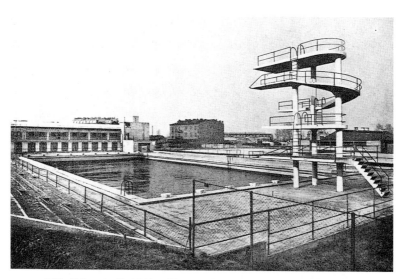

7.21. Aleksander Kodelski and Romuald Raksimowicz. Legia Stadium. Warsaw, 1929.

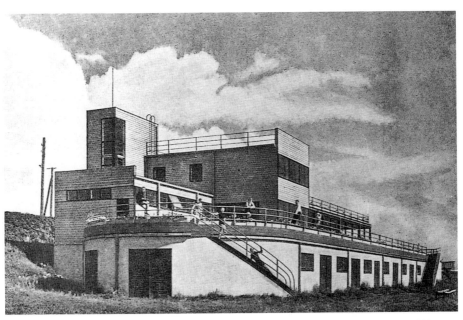

7.22. *Eugeniusz and Zygmunt Piotrowski. Pavilion of the police rowing club. Vistula River, Warsaw, 1933.*

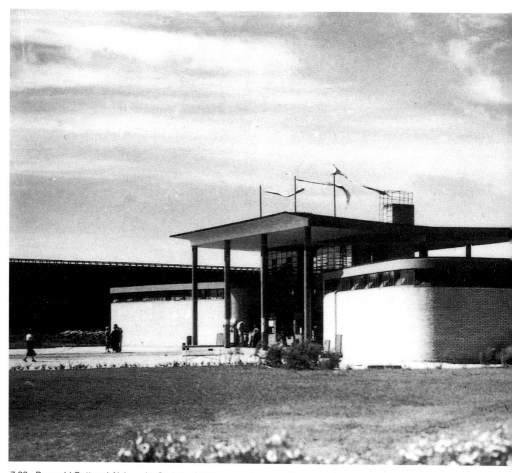

7.23. Romuald Gutt and Aleksander Szniolis. Saline swimming pool. Ciechocinek, 1930–32.

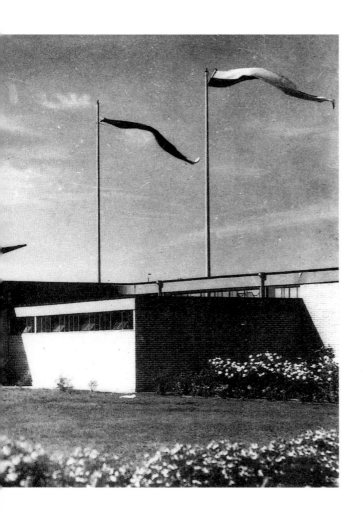

and Aleksander Brzozowski. Affordable workers' housing was also built on a large scale in the region of Silesia in towns such as Bielsko-Biała, Katowice, Janów, Siemianowice, Ruda, Rybnik, and Cieszyn. There architect Tadeusz Michejda proposed an innovative industrialized system of steel-framed, inexpensive, single-family houses. Between 1927 and 1929 architect Jan Bieńkowski built two workers' housing colonies in Piekary-Szarlej and Makoszowy, modeled on Ernst May's housing designs in Frankfurt.

Polish architects and planners working on public housing profited from German experiments in industrial and planning standardization, as well as from German achievements in prefabricated mass housing. German housing design and building methods were under constant observation and study by Polish architects and engineers who had travelled to Germany. German building technology was introduced to Poland under various patents. The Polish review *Architektura i Budownictwo* repeatedly referred to German technological knowledge. In addition, Polish affordable, multistory housing benefited from the theories of Warsaw architect Szymon Syrkus.

In 1931 Syrkus and his wife Helena built a small housing settlement in the district of Rakowiec in southern Warsaw. It became one of the most influential functionalist projects in Poland of the time. Four- and three-story residential buildings were placed in a linear fashion to ensure solar exposure for all units. The buildings feature internal corridors similar in spirit to a street. Efficient functional arrangements service sixteen apartments on each floor. Because the apartments are small and modestly furnished, Syrkus provided an additional communal house containing laundry and social facilities, in the spirit of Russian constructivism. In 1930 this project was presented at the Brussels CIAM meeting. The same architects built, in 1936, a colony of town houses in a suburb of Łódź, Poland's second-largest city, and a row of residential units in the Warsaw district of Saska Kępa, which feature functionalist roof terraces, plain elevations, and ribbon windows.

After 1925 many interesting new housing developments were built in Warsaw and other parts of Poland. The Warsaw Housing Cooperative (WSM), attracted several young avant-garde architects. They saw an opportunity to participate in a progressive, socially engaged architecture. Among them was the team of Barbara and Stanisław Brukalski, who built a series of so-called housing colonies for the WSM modeled on the housing of J. J. P. Oud in Holland. The fourth, built between 1929 and 1931, was particularly innovative (fig. 7.24). Here the Brukalskis adapted the system of external gallery circulation that Hannes Meyer introduced in his 1926 residential slabs in Törten-Dessau. This system allowed four to five apartments to be accessed from one gallery serviced by a detached stair tower. This layout also provided excellent cross-ventilation for all apartments. The apartments were provided with laboratory-type kitchens conceived in the spirit of the standardized Frankfurt kitchen. All apartments had

central heating and hot water. The same architects in 1930–34 built another, larger WSM housing development, VII (fig. 7.25). It featured long, gently curving slabs, once more in the spirit of German public housing of the Weimar period. Both were built in Warsaw's Żoliborz district.

Among the housing projects of the late 1920s is a truly avant-garde one: three town houses, located in the elegant Warsaw suburb of Saska Kępa, the work of the leading Polish modernist team of Bohdan Lachert and Józef Szanajca (figs. 7.26, 7.27). This 1928–29 building has a steel skeleton that contributes to its interior openness, a roof terrace to which access is provided via external stairs, and a functionalist, plain facade with long ribbon windows. Its interiors feature two-story cubist spaces that produce interesting three-dimensional effects. One of the apartments belonged to Lachert, who furnished it with highly attractive modernist furniture of his own design. This project attracted a great deal of professional attention and quickly became the subject of many student visits. It turned out to be one of the most celebrated projects of Polish functionalism.

In 1929 Lachert and Szanajca in collaboration with Roman Piotrowski and Jan Reda also designed a series of handsome twin houses in the new Warsaw district of Żoliborz (fig. 7.28) for the Warsaw Savings Cooperative. The buildings were arranged in a band and were connected by one-story walls that provided a sense of visual volumetric continuity; the two-story apartments had roof terraces. In close proximity to this project, the same architects designed in 1934 two groups of two-story row houses on Promyka Street and Dziennikarska Street that had small front gardens and underground garages. The Warsaw district of Żoliborz became the site of much new functionalist housing built in the 1930s. Here again, between 1928 and 1930, Kazimierz Tołłoczko designed a long, plain, curving housing block at the so-called Journalist Estate (fig. 7.29). Bohdan Pniewski, in 1931, created a row of staggered townhouses for the civil public employees.

Affordable housing was also erected for government employees in 1934 on Obozowa Street in Warsaw by Piotr Kwiek (fig. 7.30), and Juliusz Żorawski designed officers' housing in Rembertów near Warsaw in the same year. Surprisingly, most such functionalist housing survived the war, mainly due to its location outside city centers, which made it less vulnerable to aerial bombing. For instance, the Żoliborz district almost entirely escaped the 1939 and 1944 destruction of Warsaw.

LUXURY APARTMENT BUILDINGS

Similar to the research and costruction of affordable housing, a large number of multistory, middle- and high-income apartment buildings were erected in Warsaw and other major Polish cities. Despite the terrible destruction that the Second World War brought to major Polish urban centers, many such structures survived. Their construction was facilitated by new government tax policies that helped to finance such investments. These apartment buildings have spacious, well-equipped

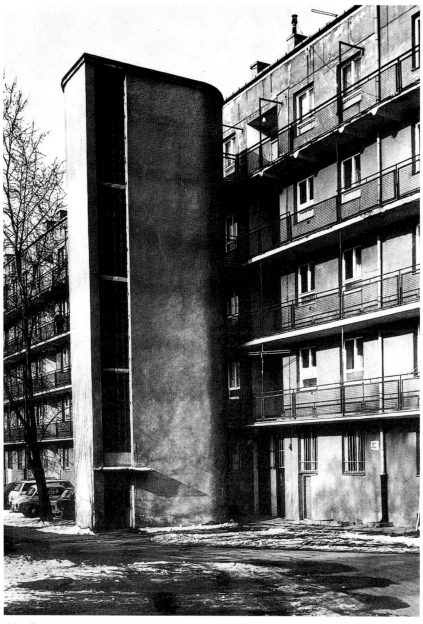

7.24. *Barbara and Stanisław Brukalski. Warsaw Housing Cooperative housing colony IV.*
Warsaw-Żoliborz, 1929–31.

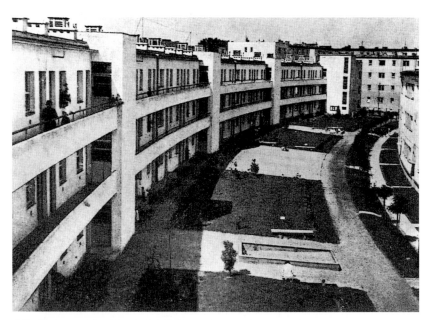

7.25. *Barbara and Stanisław Brukalski. Warsaw Housing Cooperative housing colony VII. Warsaw-Żoliborz, 1930–34.*

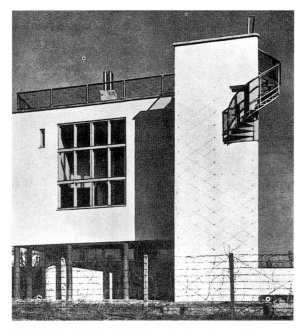

7.26. *Bohdan Lachert and Józef Szanajca. Town houses. Warsaw-Saska Kępa, 1928–29.*

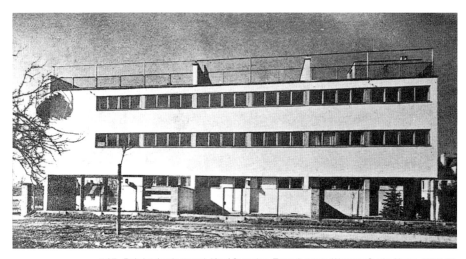

7.27. *Bohdan Lachert and Józef Szanajca. Town houses. Warsaw-Saska Kępa, 1928–29.*

units, concrete or steel skeletons that facilitated flexible planning of interior spaces, roof terraces, balconies, and loggias. Their facades have a large amount of glazing, and the buildings are provided with elevators, since many of them are five stories high. They were designed to avoid the traditional courtyard block configurations and are raised on pilotis. Their facades feature ribbon windows, curving corners, and round, porthole openings—all characteristic of European functionalist architecture.

The greatest concentration of modernist apartment buildings is in Warsaw, Katowice, Bielsko-Biała, Gdynia, and Kraków. Warsaw architect Juliusz Żorawski, inspired by Le Corbusier's architecture, in 1937 designed a long, five-story apartment building on Mickiewicza Avenue in the district of Żoliborz (fig. 7.31). It stood on pilotis and had a characteristic "turbulent," sculptured dynamic roof. The large amount of glass used on its elevations earned this building the title The Glass House, referring to the idea of "glass hygienic houses" launched by Polish writer Stefan Żeromski in the early years of the twentieth century. In the same year Żorawski also built a six-story apartment building on Przyjaciól Avenue (fig. 7.32). It also has pilotis, a thin, heavily glazed facade, and a setback that forms a terrace on the top floor. The third Żorawski building of the same period, erected on Puławska Street, is similar to the Mickiewicza building. All three feature commercial facilities on their ground floors.

Żorawski's work is a rather unique representation of Le Cor-busier's ideas in Poland; the latter, although profoundly admired, found few direct, conceptual imitations in that country. (The above-mentioned town houses in the Saska Kępa district by Lachert and Szanajca represent another exception.) Other residential buildings by Szymon and Helena Syrkus on Jaworzyńska Street in Warsaw of 1937 (fig. 7.33), by Wacław Weker on Spacerowa Street of 1931 and Wiejska Street of 1935, and by Ludwik Paradistal on Sewerynów Street of 1938 belong conceptually and aesthetically to the same type of architecture, as do Lachert and Szanajca's two modernist apartment buildings on Berezyńska and Radziwiłowska streets. In the new harbor town of Gdynia, among several modernist buildings, the apartment building of 1935 by Roman Piotrowski features naval-type architecture expressed with strongly curved corners (fig. 7.34). It is a characteristic example of this international type of architecture outside Warsaw.

In the Silesian capital of Katowice, the center of industry with a professional middle class, several modernist apartment buildings were erected. Among them is the first Polish twelve-story, steel-skeleton-framed residential tower, built in 1931 on Zielna Street by Tadeusz Kozłowski and structural engineer Stanisław Bryła of Warsaw, who had acquired American experience in tall buildings (fig. 7.35). The use of steel, a major product of the region, was seen as especially advantageous. Silesia was considered at the time a "Polish America," and building skyscrapers excited many architects and clients there. In fact, in the same year a smaller

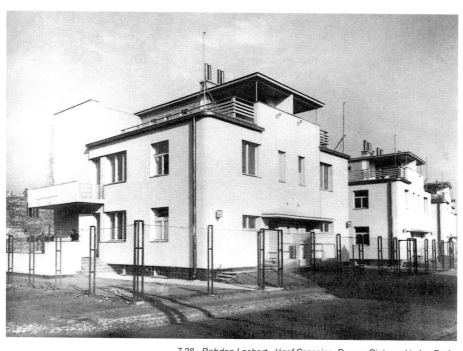

7.28. *Bohdan Lachert, Józef Szanajca, Roman Piotrowski, Jan Reda.*
Twin houses for the Warsaw Savings Cooperative.
Warsaw-Żoliborz, 1929.

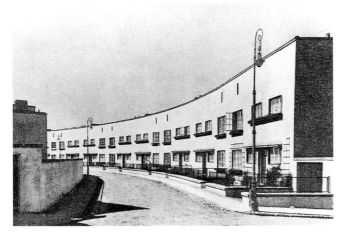

7.29. Kazimierz Tołłoczko. Housing block at the Journalist Estate.
Warsaw-Żoliborz, 1928–30.

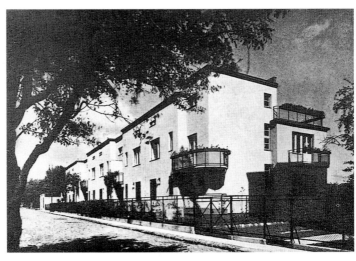

7.30. Piotr Kwiek. Government employees' affordable housing.
Obozowa Street, Warsaw, 1934.

steel-framed building designed by architect Eustachy Chmielewski was erected on Wojewódzka Street in Katowice, establishing a new trend in architectural technology. At the same time, a number of other luxurious and elegant residential buildings were erected. They are unique in Polish functionalism because of the glass-enclosed winter gardens that appeared on the front and courtyard elevations, giving them an exciting, dynamic appearance. The winter gardens were partially motivated by the lack of substantial greenery in conjested, industrial cities such as Katowice. Otherwise, the architecture is rigorously modern: geometrically crisp and smooth, volumetrically asymmetrical, emphasizing openness and transparent corners and employing dynamic horizontal bands of windows and balconies. Among the architects of such buildings was Karol Schayer, one of the best Polish functionalists, known also for his innovative school in Piekary Ślaskie and for the 1934 Museum of Silesia, at the time of construction one of the most modern buildings in Poland, planned around a steel frame and equipped with elevators, escalators, and mechanical ventilation. Unfortunately, shortly after its completion it was systematically razed by the Nazis. Schayer's residential building on PCK (Polish Red Cross) Street is an excellent example of his talent (fig. 7.36).

Among other structures in this district are Henryk Schmidtke's 1937 building on Rymera Street (fig. 7.37) and the 1938 excellent corner building on Sklodowska Curie Street by an unknown architect (fig. 7.38). This building is particularly interesting because of the strongly articulated, enclosed winter gardens forming its curving corner. Tadeusz Michejda, another leading Polish modernist, designed an eight-story apartment building

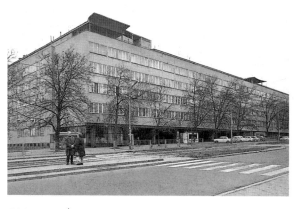

7.31. *Juliusz Żorawski. Apartment building on Mickiewicza Avenue. Warsaw-Żoliborz, 1937.*

on Słowackiego Street in 1931 in which he elegantly expressed the principles of functionalist horizontality and the dynamic treatment of curving, glass-enclosed winter gardens and balconies (fig. 7.39).

In another Silesian town, Bielsko-Biała, a place of considerable wealth generated by the local wool and metal industries, several elegant high-standard apartment buildings were erected in 1930s. Alfred Wiedermann, an architect from the border town of Cieszyn, here designed a few excellent residential, multistory buildings that easily rival those of Warsaw and Katowice in sophistication. Wiedermann possessed a great ability to compose volumes in a modern and

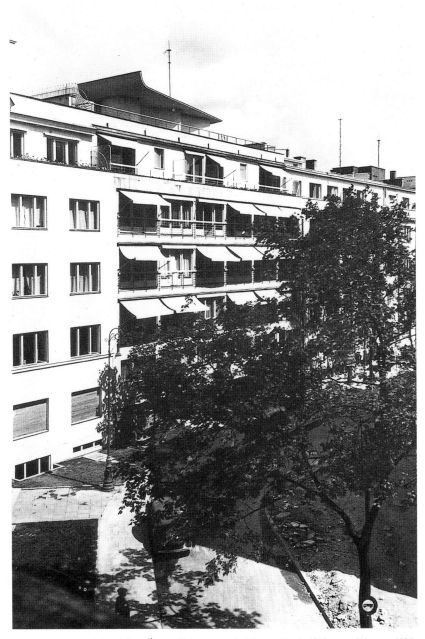

7.32. Juliusz Żorawski. Apartment building on Przyjaciól Avenue. Warsaw, 1937.

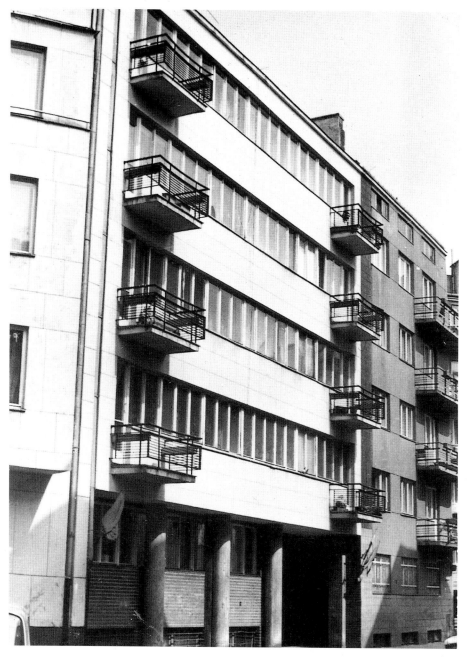

7.33. *Helena and Szymon Syrkus. Apartment building on Jaworzyńska Street. Warsaw, 1937.*

dynamic manner and to use surface fenestration to achieve visually exciting effects. Two of his buildings were built in the area of the former Sułkowski Castle gardens, on today's Bohaterów Warszawy Street, the site of considerable construction in the 1930s. One is a long, curving apartment building set along the Białka River; another is a symmetrical infill building on Bohaterów Warszawy Street carried out in a style somewhat resembling the Viennese housing developments of the 1920s. The local firm of Roman Jüttner and Frantz Bolek was responsible for many other designs in this town, among them the asymmetrical "aerodynamic" building of 1935 forming a corner on Bohaterów Warszawy Street, and the elegant, symmetrical, strongly horizontal, and transparent building of 1934 also in the same street (fig. 7.40). A few buildings down, architect Józef Kozioł in 1935 built a skillfully composed corner structure with external access galleries on its rear elevation (fig. 7.41). In Kraków, among the buildings deeply influenced by Viennese expressionism, are occasional examples of good functionalism applied to residential architecture. Among these are the town houses and villas in the exclusive Cichy Kącik garden suburb.

PRIVATE HOUSES

The end of the international economic crisis of 1929, which had severely affected Poland, brought an accelerated recovery and the development of a Polish economy that in turn produced considerable individual wealth. The beginning of the 1930s witnessed large numbers of luxurious and more modest houses built in the Warsaw district of Saska Kępa and in the Warsaw suburbs, such as Skolimów, Otwock, Konstancin, and Królewska Góra. Hundreds of modern houses were built in the Silesian towns of Katowice and Bielsko-Biała, and along the Baltic coast. These included the residential and vacation suburb of Gdynia, called Kamienna Góra, and the Hel Peninsula. The mountain region, where leisure centers such as Krynica and Wisła were located, offered excellent building sites. Modern houses were built in Wilno, particularly in the Antokol district, in Lwów, and in Lublin. Many young Polish architects saw an ideal opportunity to implement the latest ideals of functionalism in designing private houses.

Generally, two design orientations existed in the architecture of private houses: a mixture of classical and modernist influences, and pure Bauhaus-oriented functionalism. The neoclassical tradition has been always very strong in Poland, particularly in Warsaw and its surroundings. Bohdan Pniewski, architect of numerous and highly successful projects, demonstrated an excellent ability to blend neoclassicism and modernism in one system. His three houses in Warsaw deserve mention in this respect. In the sumptuous Zalewski Villa, neoclassical piers combine with modernist terraces and ramps (fig. 7.42); in the equally large, two-family house on Klonowa Street of 1935, the modernist, horizontal, ribbon windows and flat roofs combine with strong vertical rhythms (fig. 7.43). Finally, the more modest

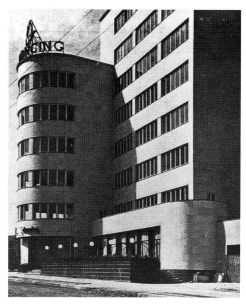

7.34. Roman Piotrowski. Apartment building. Gdynia, 1935.

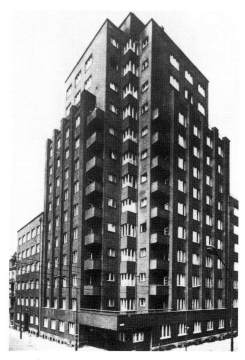

7.35. Tadeusz Kozłowski and Stanisław Bryła. Apartment building on Zielna Street. Katowice, 1931.

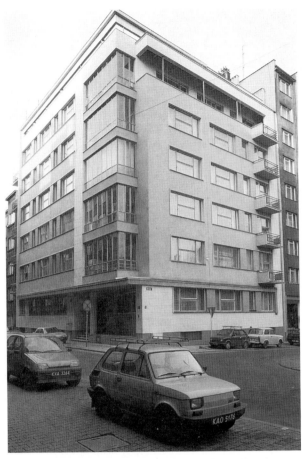

7.36. *Karol Schayer. Apartment building on PCK Street. Katowice, 1936.*

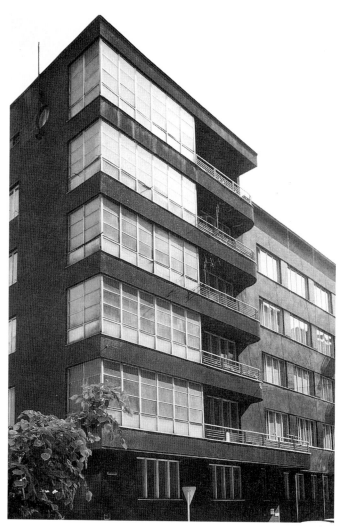

7.37. *Henryk Schmidtke. Apartment building on Rymera Street. Katowice, 1937.*

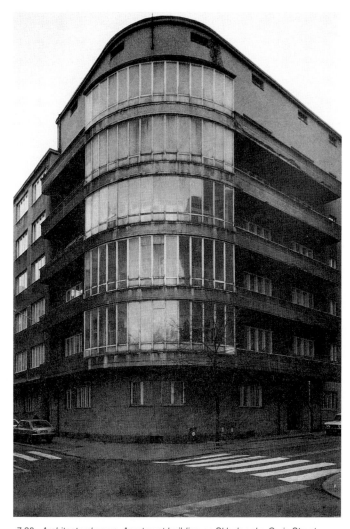

7.38. Architect unknown. Apartment building on Sklodowska-Curie Street. Katowice, 1938.

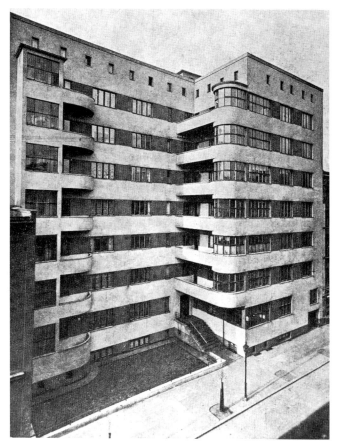

7.39. *Tadeusz Michejda. Apartment building on Słowackiego Street. Katowice, 1931.*

house on Rzymska Street of 1931 reveals his characteristic mixture of classicism and functionalism. This hybrid style was typical of architects who decided to abandon the eclecticism of the Polish Manor Style favored by many conservative and provincial clients in favor of a progressive but not overtly avant-garde approach to design.

Other designers more radical than Pniewski deliberately sought pronounced functionalist expressions, and their many new houses reflect decisive Bauhaus influences. The team of Lucian Korngold and Henryk Blum was responsible for an excellent 1935 house in the Warsaw suburb of Saska Kępa, on Francuska Street (fig. 7.44). The designers here combined the simplicity of smooth cubic massing with the sculptural treatment of external stairs that connect the ground floor to the terrace on the upper floor. Asymmetrical windows follow the functionalist ideal of frank expression of the interior on the exterior of the building. In the same year Korngold, in collaboration with Blum, designed another house on Chocimska Street in Warsaw (fig. 7.45). This house also featured a simple, asymmetrical volume enriched by a wing supported by pilotis. The upper floor of this wing is an open terrace, in a spirit matching that of the 1929 Evžen Linhart house in Prague. In 1935, again in association with Blum, Korngold designed a house in the Skolimów suburb that stylistically strongly resembles Bauhaus compositions (fig. 7.46). It is a simple volume perforated by a row of functionalist ribbon windows. The whole is extended by a curving upper floor with a corresponding terrace directly below. Jadwiga Dobrzyńska and Zygmunt Łoboda built in 1932 a functionalist house also in the Saska Kępa district of Warsaw, featuring cubic massing and a typical flat roof terrace protected by a tubular railing (fig. 7.47). Helena and Szymon Syrkus built a house on Walecznych Street in 1936 of similar character. It is cubic and extremely simple, yet because its eastern elevation is curved, the building projects an overall strong, sculptural character. One year later the same team designed a twin house in Sosnówka. Its two ends are suspended on piers to generate protected terraces below.

Among the Warsaw houses that demonstrate influences other than the Bauhaus are Barbara and Stanisław Brukalski's own house, built in 1927 on Niegolewskiego Street in Żoliborz and modeled on Gerrit Rietveld's 1924 Schröder House in Utrecht (fig. 7.48); the nearby house by Włodzimierz Winkler of 1935 (fig. 7.49); and, designed by Bogdan Lachert and Józef Szanajca, the Szyller House of 1928 in Saska Kępa (fig. 7.50). All refer to De Stijl spatial and graphic compositions.

In other regions of Poland, the architecture of individual houses in Silesia shows a consistently strong Bauhaus influence. In the town of Bielsko-Biała dozens of luxurious modern houses were built during the 1930s. Among them are Otton Lesiecki's own house of 1929 on Niedzielskiego Street and a design by Jüttner and Bolek of 1934 on Wyspiańskiego Street. Both are excellent examples of this style. In Katowice, Tadeusz Michejda in 1930

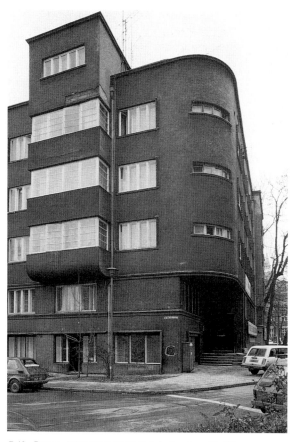

7.40. *Roman Jüttner and Frantz Bolek. Apartment building on Bohaterów Warszawy Street. Bielsko-Biała, 1935.*

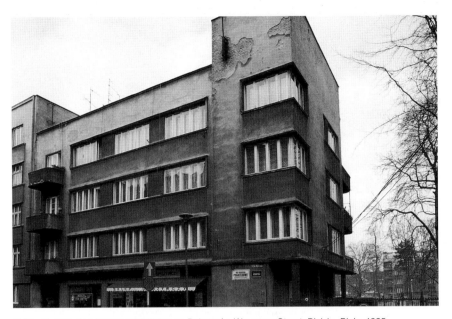

7.41. Józef Kozioł. Apartment building on Bohaterów Warszawy Street. Bielsko-Biała, 1935.

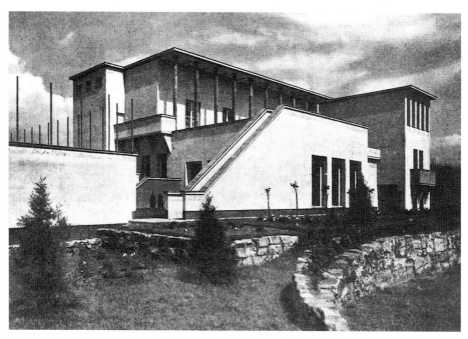

7.42. *Bohdan Pniewski. Zalewski Villa. Warsaw, 1939.*

built a handsome house carried out in a mature Bauhaus style for Dr. Kazimierczak on Bratków Street, in which he applied the steel frame as principal structural system (fig. 7.51). The same architect designed an equally modern house called Tomiczek House in 1931 in Ustroń, a small town in the Beskidy Mountains. Also in Katowice, two other functionalist houses of good formal

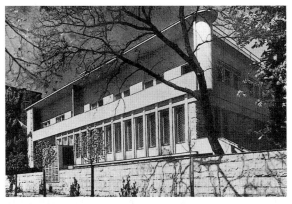

7.43. *Bohdan Pniewski. Two-family house on Klonowa Street. Warsaw, 1935.*

quality were erected: the 1936 villa by architect Glaesel and the 1937 villa by Lucjan Sikorski, whose interesting curving garden elevation points to the influence of Adolf Loos's domestic architecture. Many similar houses were built in the Beskidy Mountain region, particularly in modern spas such as Wisła and Rabka. In Gdynia, in the area of Kamienna Góra, many modern recreational and residential houses were built, among them a 1936 house for Countess Łosiowa designed by Zbigniew Kupiec and Tadeusz Kossak and evoking Mies van der Rohe's Tugendhat House in Brno. Finally, in the Kraków suburb of Cichy Kącik, among the few excellent functionalist houses

erected during the 1930s, are two large houses of 1936 by Adolf Szyszko-Bohusz, designed in a well-articulated and comprehensive Bauhaus style (fig. 7.52).

EXHIBITION PAVILIONS

Among the variety of public buildings that includes government agencies, banks, museums, schools, and university buildings, exhibition pavilions gave the Polish avant-garde an opportunity to express its early creative ideals and aspirations. In 1929 the city of Poznań organized a national exhibition to demonstrate to the public the progress made in various sectors of the industry, culture, and life of independent Poland. The exhibition involved the construction of several pavilions, which allowed a few select young architects to demonstrate their design skills and advertise themselves as modern architects. Although modern designs were in the minority in Poznań, this exhibition proved the turning point in the history of Polish modern architecture. After ten years of sporadic and isolated attempts, modernism here emerged as an established movement in Poland. The impact on Polish architecture of the designs presented in Poznań was similar to that of the 1927 Stuttgart-Weissenhof exhibition and the 1929 Breslau exhibitions on German architecture and of the 1928 Brno and 1932 Prague exhibitions on Czech modernism.

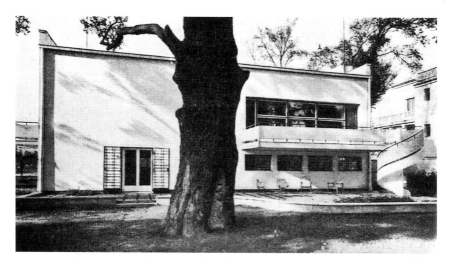

7.44. Lucian Korngold and Henryk Blum. Single-family house on Francuska Street. Warsaw-Saska Kępa, 1935.

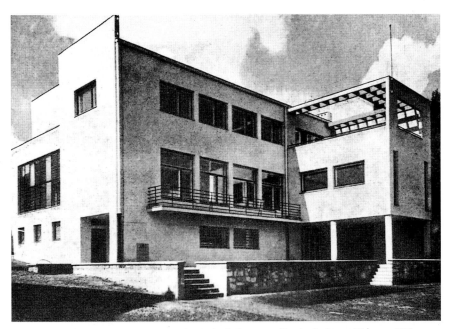

7.45. *Lucian Korngold and Henryk Blum. Single-family house on Chocimska Street. Warsaw, 1935.*

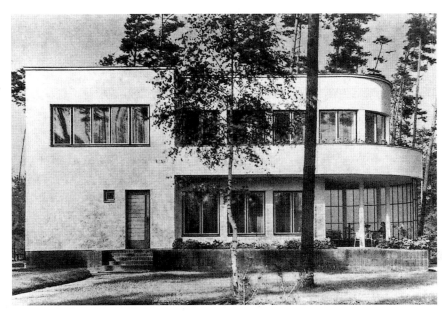

7.46. *Lucian Korngold and Henryk Blum. Single-family house. Warsaw-Skolimów, 1935.*

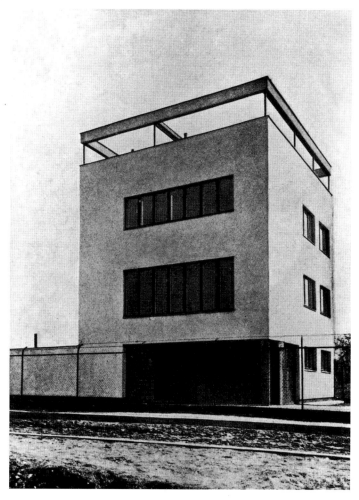

7.47. Jadwiga Dobrzyńska and Zygmunt Łoboda. Single-family house on Estonska Street. Warsaw-Saska Kępa, 1932.

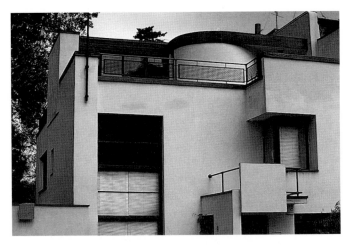

7.48. Barbara and Stanisław Brukalski. House of the architects. Niegolewskiego Street, Warsaw-Żoliborz, 1927.

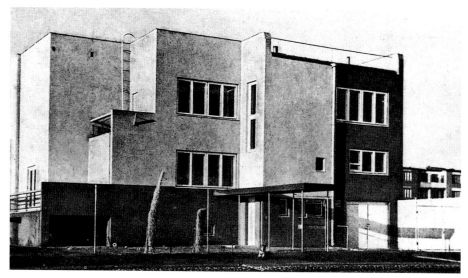

7.49. Włodzimierz Winkler. Single-family house on Niegolewskiego Street. Warsaw-Żoliborz, 1935.

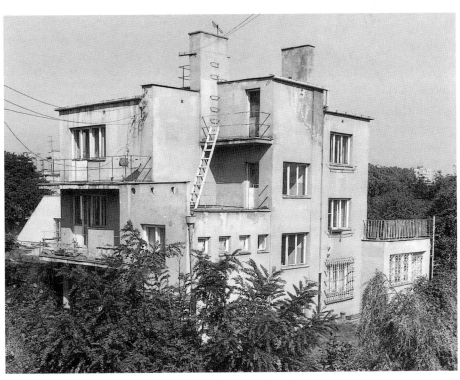

7.50. *Bogdan Lachert and Józef Szanajca. Szyller House. Warsaw-Saska Kępa, 1928.*

Four pavilions built in Poznań helped to revolutionize Polish architecture: the Centro-Cement Pavilion designed by Bohdan Lachert and Józef Szanajca (fig. 7.53), the Women's Works Pavilion by Anatolia Hryniewiecka-Piotrowska (fig. 7.54), the Fertilizer Pavilion by Szymon Syrkus (fig. 7.55), and the Hertze Fashion Pavilion by Bogdan Pniewski, for which he received a gold medal (fig. 7.56). The Centro-Cement Pavilion showed the influence of industrial silo architecture so dear to functionalist architects. Its architecture communicated the visual power of naked, cylindrical volumes. The Women's Works Pavilion celebrated the simplicity and smoothness of walls, roof terraces, and visual circulation placed outside its volume in the interest of dynamic imagery. The Fertilizer Pavilion was reminiscent of Malevich's architectonic compositions and was built in metal and glass as an experiment that leading Polish structural engineer Stanisław Hempel helped to conceive. It employed lavish nocturnal lighting effects that gave the pavilion an extremely transparent, airy appearance. The Hertze Fashion Pavilion featured an elegantly composed, striking combination of volumes that included an external, glass enclosed fashion display space. The pavilion itself was also constructed in metal and glass. All such pavilions underlined industrial detailing, which quickly influenced Polish architecture in general. Among other exhibition pavilions of the

time, Władysław Szwarncenberg-Czerny's pavilion in Katowice of 1932 is a good example of sophisticated steel and glass architecture that owes more to classical influences than to constructivism, as was the case with the Poznań pavilions.

The Polish National Pavilion at the 1937 "Art and Technology" International Exposition in Paris represents a more mixed combi-

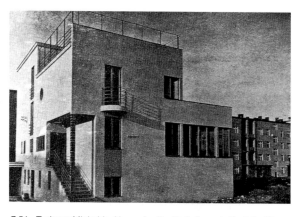

7.51. Tadeusz Michejda. House for Dr. Kazimierczak. Bratków Street, Katowice, 1930.

nation of architectural ideas ranging from Bohdan Lachert and Józef Szanajca's rigorously functionalist architecture to a more monumental and traditional main pavilion conceived by Bohdan Pniewski and Stanisław Brukalski (figs. 7.57, 7.58).

PUBLIC AND INDUSTRIAL BUILDINGS

Besides exhibition pavilions, the functionalist influence on public building designs began in 1927 with Jan Stefanowicz's covered market in Końskie. One of the first purely skeletal constructions in Poland, it combined formal De Stijl influences with a flexibile and open

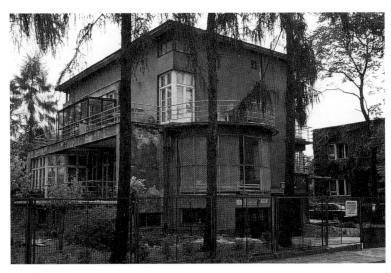

7.52. *Adolf Szyszko-Bohusz. Single-family house. Kraków-Cichy Kącik, 1936.*

structure. Stefanowicz, a pioneer of modern Polish architecture, became in 1926 the first president of the Polish Association of Architects. In 1926 Maksymilian Goldberg and Hipolit Rutkowski designed the House of the Polish Press in Warsaw. This seminal work featured many glass and lightweight partitions in its interior, creating the effect of spaciousness and luminosity and providing the work spaces with appropriate flexibility. The great modern railroad terminal of Warsaw, begun in 1929 by architect Czesław Przybylski, was erected as a concrete-frame building that included enormous glass walls and stainless steel, aluminum, and bronze detailing. Tragically, this great piece of architecture was destroyed by German bombings shortly after completion in 1939. In 1934 Jerzy Puterman built the imposing Central Telecommunications Office in Warsaw. It was planned around a skeletal-frame system to meet the flexibility demanded by the program. The complicated massing was expressed as an interplay of horizontal layering of windows and vertical circulational shafts.

Although most important public buildings such as courthouses, government ministries and agencies, banks, museums, and libraries were designed in the then-popular Italian, French, and German monumental, modernized classical style, several such buildings adopted modernist techniques. A good example is Tadeusz Michejda's 1930 town hall in Janów, Silesia, near Katowice (fig. 7.59). The composition recalls the work of Willem Dudok in Holland, particularly his town hall in Hilver-

sum. Edgar Norwerth's 1931 train station in Będzin, another Silesian town, reflects similar inspiration. The airport in Bielsko-Biała designed by Witold Kłebkowski in 1934 falls within the same category. One year later its architect designed a sophisticated, minimalist, austere, six-story office building clad in smooth stone in Katowice, one of the most interesting functionalist buildings in Poland. In 1932, Tadeusz Kozłowski designed the Institute of Food Control in Katowice (fig. 7.60). This long, low building was articulated at one end by a semicircular glass-enclosed stair tower. Its distinctive streamlined appearance recalls Erich Mendelsohn's commercial architecture. In the same spirit of dynamic curving and asymmetrical volumes, ribbon windows, and roof terraces, Bohdan Damięcki and Tadeusz Sieczkowski designed the 1937 Sailors House of Gdynia (fig. 7.61). Also in Katowice, architects Leon Dietz d'Arma and Jan Zarzycki designed in the 1930s a garrison church in the area of New Town, which consisted of a plain rectangular volume and a detached, tall campanile.

In 1936 Paweł Juraszko, a talented local architect, designed the elegant headquarters of the Savings Bank in Bielsko-Biała consisting of an entirely glazed public pavilion and a neoclassical office wing. This building, which overlooks the town's main square, has sophisticated modernist interior detailing and furnishings. Also in Silesia, in the town of Sosnowiec, the team of Jerzy Gelabart, Grzegorz Sigalin, and Witold Woyniewicz built the modern offices of the

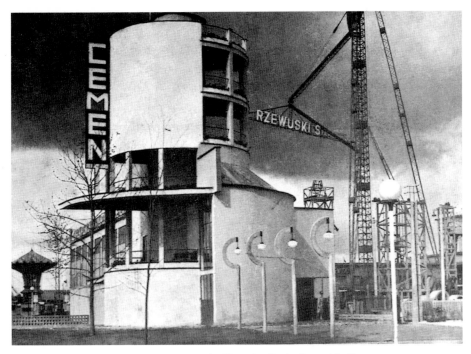

7.53. Bohdan Lachert and Józef Szanajca. Centro-Cement Pavilion.
National exhibition, Poznań, 1929.

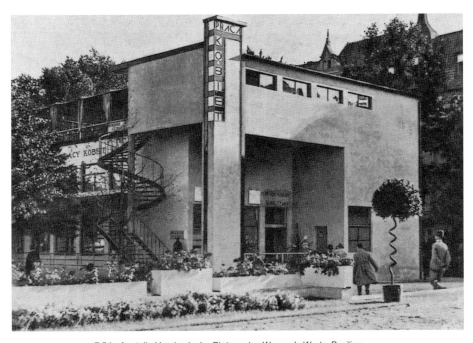

7.54. Anatolia Hryniewiecka-Piotrowska. Women's Works Pavilion.
National exhibition, Poznań, 1929.

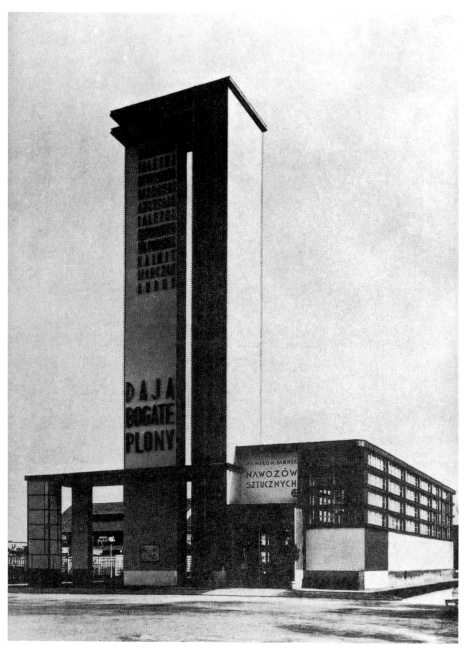

7.55. *Szymon Syrkus. Fertilizer Pavilion. National exhibition, Poznań, 1929.*

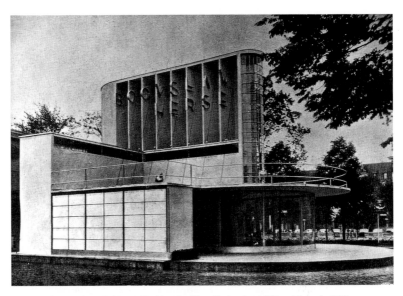

7.56. Bogdan Pniewski. Hertze Fashion Pavilion. National exhibition, Poznań, 1929.

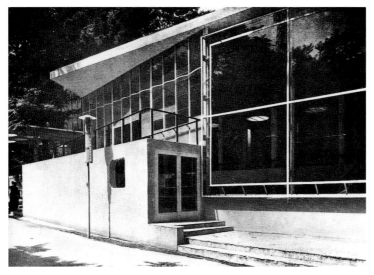

7.57. Bohdan Lachert and Józef Szanajca. Polish National Pavilion. "Art and Technology" International Exposition, Paris, 1937.

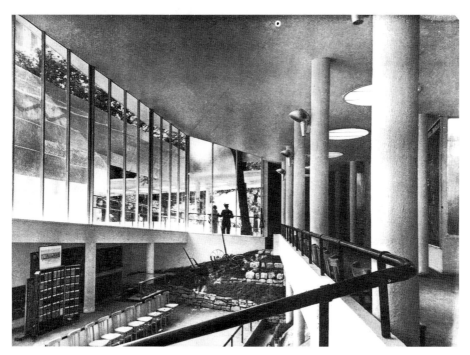

7.58. Bohdan Lachert and Józef Szanajca. Polish National Pavilion. "Art and Technology" International Exposition, Paris, 1937.

Social Security Institution, which, despite its location on a small urban block, conveys a sense of spatial openness. Although simple and economical, it is stylistically dynamic and interesting. In 1937 in the spa town of Ciechocinek, Romuald Gutt and Jan Jankowski built a small but compositionally sophisticated asymmetrical post office (fig. 7.62). It is a good example of the government-sponsored new buildings erected in small Polish communities. In Wilno one of the rare Polish buildings inspired by Le Corbusier was built in 1937 by Stanisław Murczynski and Jerzy Sołtan, the Social Security Headquarters. Sołtan, who after the war worked for Le Corbusier and eventually replaced José Sert as chairman of the Harvard University Graduate School of Design, demonstrated his early interest in the ideas of this French master. In Lwów, among a few rare modernist buildings, the headquarters of the City Electric Works by Tadeusz Wróbel, dating from 1935, and the 1935 Soldiers Home by Andrzej Frydecki and Stefan Porębowicz are examples of superior functionalist architecture.

Tall buildings also interested Polish investors and architects, who were stimulated by images and accomplishments of American architecture. Franciszek Krzywda-Polkowski, an architect from Kraków, visited the United States and produced a series of fantastic and visionary drawings based on this experience. Architects Lech Niemojewski and Stanisław Noakowski were both interested in the images of modern cities and their skyscrapers. They too produced striking fantasies on these subjects, even though their professional work often contradicted this initial modernist enthusiasm. In 1933 Niemojewski became professor of architectural history at the Warsaw School of Architecture. He eventually published many theoretical writings, including *Dwie Szkoly Polskiej Nowoczesnej Architektury* (Two Schools of Modern Polish Architecture) (1934) and *Konstruktywizm w Architekturze* (Constructivism in Architecture) (1932). He was a prize-winner in many competitions, as well as designer of the modernist interiors for the Polish ocean liner *S. S. Stefan Batory.* Noakowski was more interested in Polish regionalism and vernacular architecture and left a legacy of many famous sketches and paintings on such subjects. The leading Polish structural engineer, Stanisław Bryła, visited the United States and studied American steel structures and highrise building methods. The theme of tall buildings was also explored in a number of competitions such as that for the Savings Bank in Poznań of 1934, won by the team of Stanisław Zakrzewski and Czesław Wolf. Among tall buildings designed but not erected due to the eruption of hostilities in 1939 were the 1937 Ministry of Communications building in Warsaw, the Credit Bank of Warsaw of 1935, and the 1938 project for the Polish radio company, by Roman Swierczyński. The Prudential Building, the seventeen-story headquarters of the American insurance company, was built in Warsaw in 1931 in an American-inspired, stripped-down neoclassical style. Architect Marcin Weinfeld designed it, assisted by Stanisław

7.59. Tadeusz Michejda. Janów Town Hall. Janów (Silesia), 1930.

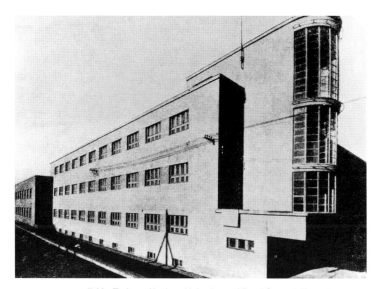

7.60. *Tadeusz Kozłowski. Institute of Food Control. Katowice, 1932.*

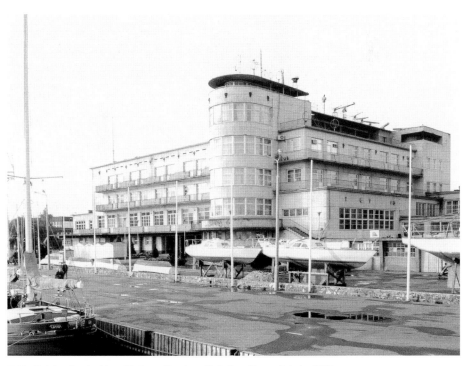

7.61. Bohdan Damięcki and Tadeusz Sieczkowski. Sailors House. Gdynia, 1936.

Bryła, who was responsible for the advanced steel-skeletal construction. It was the tallest building in Poland at the time and one of the tallest in Europe.

Given the urgent need to provide educational facilities immediately after achieving independence, the Polish authorities made huge efforts to build schools of all types, day-care centers, and other educational facilities. Although most were built with severely restricted budgets and lacked sophisticated modern equipment, several projects achieved more advanced standards of design and equipment. In doing so they went against the still-prevailing tradition of courtyard schools based on monastic models. Innovative Polish planners adopted and implemented the new functionally and psychologically dictated ideas based on an open, extroverted pavilion type with good ventilation and proper exposure to natural light. They began to treat schools more as laboratories for learning than as mere assemblages of classrooms and spaces. Many school designers treated their task as experimental, open to investigation. They attempted to find the best possible answers to new, unorthodox programmatic and behavioral challenges.

By 1925, school design started moving in the direction of new, advanced models. The winning project by architects Józef Gałęzowski and Adam Widermann in the competition for the teachers' center in the small Silesian town of Pszczyna

near Bielsko-Biała featured, for the first time, a nonaxial plan. About the same time Jan Stefanowicz in Siemiatycze designed one of the first Polish schools with strongly articulated (according to its functional, internal disposition) volumetrics. This paved the way for future Polish functionalist, open-school configurations. The state high school in Piekary Ślaskie of

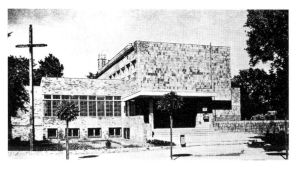

7.62. Romuald Gutt and Jan Jankowski. Post office. Ciechocinek, 1937.

1932, designed by Karol Schayer, first achieved this innovative approach (fig. 7.63). Based on a strongly articulated pavilion configuration, the scheme assures that each classroom has natural cross-ventilation, and provides considerable spatial freedom, allowing more imaginative and flexible arrangements of desks and other furniture. This was the most experimental school design in Poland, and it influenced the construction of other schools in Silesia. In Bielsko-Biała, in 1936, architect Kazimierz Sołtykowski designed one of Poland's first functionalist schools, giving it a characteristically aerodynamic shape and articulating its round windows in a style derived from naval architecture. In 1932 in Warsaw, Tadeusz Nowakowski built a

high school named after Juliusz Słowacki, a famous Polish romantic poet. This also featured a free plan and free volumetric massing, which contributed to its modern appearance. Among other schools in this city that showed more experimental and thoughtful attitudes toward design was the 1936 school in the Koło District by architects Mieczysław Łocikowski and Maria Wroczyńska. Among the day-care centers that started appearing all over Poland at the end of the 1920s, Tadeusz Lobos's day-care school in Katowice was particularly impressive. Its symmetrical, strongly horizontal volume was topped by a glass pavilion that gave access to the roof terrace. It had extensive terraces for outdoor play and extendable canvas shades to protect the children from rain and snow. The access gate to this school is an excellent example of an asymmetrical modernist composition. Although today it stands in an appalling state of disrepair, it belongs to the best works of Polish functionalism.

Retirement homes and housing for the homeless were also given increased attention by the public authorities in response to the rapidly aging population and growing homeless problem in expanding Polish cities. Several such facilities were built in major urban centers. Władysław Czarnecki's retirement home in Poznań of 1934 is one example; Lucjan Sikorski and Władysław Czerny's homeless shelter of 1930 in Katowice is another. Various new hospitals, clinics, and doctors' organizations were also established throughout Poland. For instance, in 1928 Romuald Gutt built the Warsaw School for Nurses, which, although located on a tight corner site, is fairly spacious and flexible thanks to its skeletal construction. Romuald Miller's hospital for children in Warsaw of 1932 and Stanisław Odyniec-Dobrowolski's Doctors' Association building of 1935, also in this city, represent the highest level of design of these building types in Poland.

Finally, commercial and industrial architecture began producing more fine buildings and structures. After 1930, Polish industry started expanding again with increased speed. New industrial centers, such as Stalowa Wola in the center of the country and the new port of Gdynia, were built. The Society for Industrial Buildings Construction erected a series of concrete, prefabricated industrial facilities. Many exhibited significant structural innovation, such as the system applied to the 1926 factory for rayon in Tomaszów Mazowiecki. The Society of Steel Producers was also keenly interested in sponsoring steel skeletons in various types of buildings, including cheap, mass-produced housing. Architects such as Szymon Syrkus and Tadeusz Michejda were particularly interested in such advanced technology. As a result of this progress and these innovations, several advanced buildings were erected in the second half of the 1930s. In Gdynia, the handsome covered city market of 1938, designed by Jerzy Muller and Stefan Raychman, was built with the help of parabolic steel arches standing on an underground storage and delivery room (fig. 7.64). The new grain elevator in Gdynia's harbor, the 1937 work of Bolesław Szmidt and Marian Paszkowski,

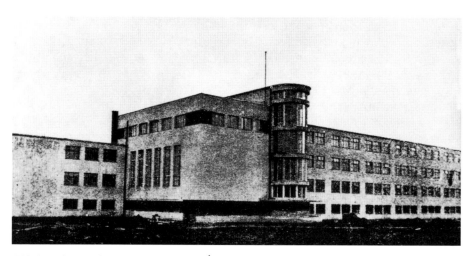

7.63. *Karol Schayer. State high school. Piekary Ślaskie, 1932.*

had a powerful functionalist silhouette appropriate to its function. Engineer Stanisław Hempel erected several bold structures including the aircraft hangars at the Okecie Airport in Warsaw. Similarly, several new bridges, waterworks, and dams were constructed. Small examples of such engineering structures are Jan Bieńkowski's waterworks and water laboratory in Maczki, Silesia, of 1930. Among large works is the beautifully designed water barrage in Porąbka, near Bielsko-Biała, designed as a concrete dam that includes a hydroelectric power plant. It is beautifully integrated into the natural scenery of the Beskidy Mountains (figs. 7.65, 7.66).

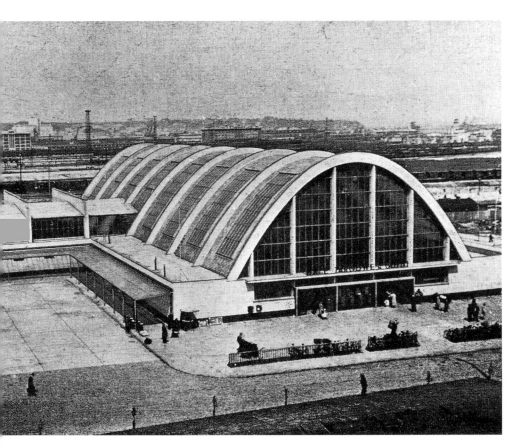

7.64. *Jerzy Muller and Stefan Raychman. Covered market. Gdynia, 1938.*

7.65. Architect unknown. Water barrage. Porąbka (Bielsko-Biała), Beskidy Mountains, 1938.

7.66. *Architect unknown. Water barrage. Porąbka (Bielsko-Biała),
Beskidy Mountains, 1938.*

Gmunden Wiener-Neustadt Moson

St. Wolfgang Gloggnitz Sopron (Ödenburg) Györ

zburg Hallein Ischl St. Gallen Maria Zell Csorna Kis-Bér

Werfen Hallstatt Sopron (Ödenburg)

Zell Bischofs-hofen Selzthal Admont Eisenerz Kapuvar

St. Johann Leoben Mürzzuschlag Papa Stuhl

Hof Bad Gastein Knittelfeld Bruck Pinkafeld Hartberg River

Mauterndorf Murau Köflach Hartberg Szombathely Veszprem

Gmünd Friesach Voitsberg Graz Fürstenfeld Vasvár Sumeg

Vellach Spittal Straszburg St. Leonhard Feldbach Körmend Tapolcza Tamas

Feldkirchen St. Veit St. Andrä Leibnitz Zala-Egerszeg Keszthely Baláton Lake

Villach Klagenfurt Maribor Balaton Berény

Ptuj Nagy-Kanizsa Dombo

Tolmino Kranj Celye Varazhdin Dráva Szob Kaposvár

Udine Lyublyana (Laibach) Krshk Krapina Csurgó Szigetvár Pécs

Gorizia Idria Zabok Sv. Ivan Zelina Bares Sik

G. of Trieste Trieste Kochevye Jaska Zagreb (Agram) Bielovar River

ulf of Venice Delnice Karlovac Sisak Grubisnopolle Virovitica

SERB Mrkopalj Cemernica Garesnica Slatina Daruvar Nashitse

Fiume Vojnic Topusko Pakrac Pozhe

Ogulin Sluin Vranograc Nova Gradishka Br

KRK Senye Plaski Kostalnitsa Stara Gradishka Sáva Der

CHERSO Goli Otocac Cazino Novi Predor

VRERA Pavic Krupa Banyaluka Bos Gradishka Doboj

UNIE Rab Krasno Binach Stari Majdan Kotor-Varos Teshani

LUSSIN Kozenica Sanskimost Magla

Pag (Pago) Gospich Petrovac Varkar Vakut Yaitse

SILBA Karlobag Kluch Travnik

PREMUDA MALY OLIB Grachat Mokranoge Der

IST MOLAT VIR Dol Vakut Foinica Viso

DUGI (Lunga) Novigrad Glamoc Mokranoge

ZUT Benkovac Knia Zen

KORNAT Shibenik Livno Prozor Zupaniac Ke

Ancona ZIRIE Split (Spalato) Infoski Mo

DRVENIK BRACH (Brazza) Markarska

SULET Lesina Starigrad

SVETAC IVAR (Lesina)

VIS (Lissa) Scedro Metkovic

CORCHULA (Curzola) PELJESac Lj

CAZZA MLIED (Meleda) SIPAN

LAGOSTA (It.) Dubrovnik (Ragusa)

PELAGOSA Boka

G A R Y

SLOVENE KINGDOM

SLAVIA

DANUBE

DAPEST (Budapest)
Budafok
senbürg

Gyarmat
Eger
Gyöngyös
Mezőkövesd Hajdúnánás
Füzes-Abony
Hajdu-Böszörmény
Tisza-Füred
Hajdu-Szoboszlo
Debreczen
Nyírbátor
Nagy-Károly
Oradea Mare (Nagyvárad)
Cluj (Kolozsvár)

Esztergom
ata-Tevaras
Ujpest
Bicske
Vácz
Hatvan
Gödöllő
Jász Berény
Monor
Kunhegyes
Karczag
Kis-Ujszállás

Soroksár
Török-
Szent-Miklos
Szolnok
Devavanya
Gyoma
Bekes
Bekes-Csaba
Bejus
Paraci

Czegled
Nagy-Kiris
Mezotur
Kecskemet
Fülöpszallas
Felegyhaza
Szarvas
Szentes
Csongrad
Oroshaza

Duna-Földvar
Paks
Tolna
Kalocsa
Majsa
Hodmezo
Vasarhely
Arad

Szegszard
Halas
Szeged
Makó
Maros
Baja

Mohács
Subotitsa
Mokrin
Temisoara (Temesvár)
River

Sombor
Senta
Topolja
Velika Kikinda

Apatin
Kula
Vrbas

yek
Dalj
Vukovar
Novi Sad
Veliki Beckerek
Vel Gradiste

Vinkovci
Shamats
Palanka
Petro Varadin
Zichyfalva
Vrsac

Bps.
Shamats
Mitrovitsa
Ruma
Pancevo

odrić
River
Zemun
BEOGRAD (BELGRADE)

Gradacac
Bjelina
Sabac
Kurinovo
Obrenovac
Semendria
Pozharevats
Kucevo
Dolni Milanovac

Gračanica
Tuzla
Loznica
Ubo
Palanka
Zabari
Majdanpek
Negotin

Zvornik
Krupanj
Lizarevac
Svilajnat

Vlasenica
Srebrenica
Gornji Milanovac
Kraguyevats
Jagodina
Zalechar
Vidin

Olovo
Uzice
Cacak
Cuprija
Bolievac

Rogatica
Vishegrad
Kraljevo
Varvarin
Paracin
Soko Banja

Trnovo
Gorazda
Dalboj
Trstnik
Krushevats
Alexinac
Knlazhevats

Focha
Lim
Nova Varos
Prijepolje
Ivanjica
Raska
Nish

Plevlje
Sjenica
Novi Pazar
Prokuplje
Kursumlia
Pirot
Soko Banja
Tsaribrod (Caribrod)

Goransko
Savnik
Bijelopolje
Mitrovica
Leskovats
Vlasotince
Tren

Bilek
Niksic
Kolasin
Pristina
Vranya
Saruilica
Beililgrad
SOFIA

Andrijevica
Danilovgrad
Spuz
Pec
Plav
Djakovica
Trnovac
Kumanovo

Kotor (Cattaro)
Varos
Prizren

Drina River
Moraca
Morava
Tisza
Koros
River

8

HOLOCAUST
AND AFTERMATH

WOJCIECH LESNIKOWSKI

> Even the fiercest enemy and the heaviest bombs cannot destroy designs engraved in human minds, which will help to put the scattered stones and bricks together again, in a better pattern than before.
>
> —Roman Sołtyński
> *Glimpses of Polish Architecture*

The war and subsequent holocaust that Nazi Germany wrought upon Europe resulted in enormous human and material casualties, particularly in Central and Eastern Europe. Many modern architects from Czechoslovakia, Hungary, and Poland either perished or suffered enormous hardships during the Second World War and after the communist takeover. Two contributors to this book, János Bonta and John Macsai, are German labor camp survivors. A brief account of the fate of various members of the Czechoslovakian, Hungarian, and Polish functionalist avant-garde follows.

On March 15, 1939 Czechoslovakia ceased to exist. Under enormous German pressure, Czech president Emil Hácha agreed to turn what was left of his republic after the infamous Munich Conference, the territories of Bohemia and Moravia, into a German protectorate, which meant in practice their incorporation into the Third Reich. With this event, the development of Czech functionalism came to an abrupt end. Czechoslovakia became independent again in May 1945, after it was liberated by the Soviet and American armies. Until 1948, the year in which the communists took power, Czechoslovakia remained politically democratic, allowing functionalism to resurface and to produce interesting projects. Among these was Bedřich Rozenhal's Children's University Hospital in Brno, whose design was influenced by Le Corbusier's work and presented at the 1947 Congrès Internationaux d'Architecture Moderne (CIAM) in Bridgewater, England. The apartment buildings in Litvinov by Evžen Linhart and in Zlín by Jiří Voženílek are good examples of this phase of functionalism. But these projects were the last gestures of the Czech movement that was responsible for perhaps the highest architectural achievements in modern architecture in Europe. The communist ideology, goals, and demands put an end to this extraordinary era.

The fate of the former functionalists varied widely under the new political conditions, depending on personal integrity, professional attitudes, and business opportunities. Bohuslav Fuchs, the acclaimed functionalist from Brno, became shortly after the war the honorary vice president of the International Federation of Housing and Town Planning in the Hague in Holland. Later he slipped into relative obscurity to die in 1972 in Brno. Karel Teige, who refused to convert his original communist beliefs to the new Stalinist ideology, was intellectually condemned, silenced, and isolated after being accused of being Trotsky's follower. He died in 1951 in Prague after a period of difficult living. Lubomír Šlapeta, who once collaborated on the Werkbund housing developments in Breslau and on the Siemenstadt development in Berlin, received similar treatment. After a period of teaching and practice in Olomouc, he departed for Germany to work in Hans Scharoun's Berlin office. He died in 1983 in Olomouc. Josef Gočár, another renowned Czech functionalist, died in 1945 in Prague. Arnošt Wiesner, an important member of the Czech modernist movement from Brno, emigrated to London in 1939 to teach at the School of Architecture at Oxford University and later in Liverpool. He also practiced architecture out of his Liverpool office. Another famous prewar functionalist, Jaromír Krejcar, reestablished his office in Prague and taught in Brno until 1948; he left the country after the communist takeover. Krejcar had been a member of the militant Left Front movement in the 1920s and 1930s and spent several months working in Moscow with the Russian constructivists. It was therefore highly ironic that such a devoted and militant leftist had to emigrate over disagreements with Stalinist authorities. From 1948 until his death in 1949 he lectured at the Architectural Association school in London. Pavel Janák, planner of the famous Baba development in Prague, died in 1956 in that city.

Jiří Kroha, the functionalist architect from Brno, a highly talented and radical communist, represents the most poignant case of spontaneous and enthusiastic conversion from one leftist concept of architecture to another. During the war he was imprisoned by the Nazis in the Dachau and Buchenwald concentration camps. He returned to Czechoslovakia to become chancellor of the Brno Technical University in 1948. From then on he was actively involved in his practice and even won second prize in the famous 1949 competition for the gigantic Stalin memorial in Prague. He died in 1974 after undergoing another conversion, this time back to his original functionalist interests, particularly Russian constructivism, about which he wrote a book. Oldřich Starý, another renowned Czech functionalist, converted quickly and wrote and lectured on the virtues of the Stalinist approach to architecture. Jaroslav Frágner, the functionalist who participated in the first Bauhaus international architecture exhibition in 1923, like Kroha had an important career in communist-dominated Czechoslovakia. He was chairman of the

Czechoslovak Association of Architects, chancellor of the Academy of Fine Arts in Prague, professor of architecture at the Polytechnic of Prague, and architect of the Prague Castle. He died in 1967 in Prague. Finally, Vladimír Karfik, who worked for Hollabird & Root in Chicago and for Frank Lloyd Wright and served as architect of Baťa's industrial empire, became professor of architecture at the Slovak Technical University in Bratislava. He died in 1985.

Given the dramatic events that surrounded Hungarian history between and after the world wars, the fate of the Hungarian functionalist avant-garde was, not surprisingly, turbulent and often dramatic. Hungary, embittered by the treatment she received at the hands of victorious allies after the First World War, was looking for ways to recover her lost territories. The easiest way to achieve this was to join the Italian-German military association, which she did in 1938, receiving as a reward portions of Slovakia, Transylvania, and Carpathian Ukraine. In 1941 Hungary went into the war against the Soviet Union on the side of Germany and eventually suffered severe damages in the 1944 German and 1945 Soviet invasions. The Hungarian Jewish minority, which often represented the intellectual and financial force behind functionalist architecture, was almost totally annihilated by the Nazis. Although Hungary became a democratic republic after the Soviets liberated the country from the Nazis, in 1949, under Soviet pressure, the communists took power and turned Hungary into another communist state. Before this event, immediately following the end of the hostilities, some excellent functionalist architecture was built. For instance, in Budapest, Lajos Gádoros, Imre Perényi, Gábor Preisich, and György Szrogh built the modern Builders Union Headquarters, one of the last major statements of functionalist architecture. By 1951 modern architecture and the activities of architects connected with it came to an end. In that same year József Révai attacked functionalism as the communist state launched its first and exemplary building operation: construction of the model city of Stalinváros. Ironically, the chief architect of this Stalinist project was Tibor Weiner, a former Bauhaus pupil who went with Hannes Meyer to Russia to build communist industrial cities. Modernist Imre Perényi, coauthor of the functionalist Builders Union Headquarters, became the chief ideologue of socialist realism in Hungary. This sudden conversion of modernists to Stalinist architecture probably reflected both simple professional opportunism and, since many modernists were politically leftist, natural ideological solidarity with the communist regime. Another avant-garde designer of excellent prewar functionalist buildings, Gyula Rimanóczy, converted to socialist realism in 1951, practicing in this style until 1958. Virgil Birbauer, another member of the prewar functionalist elite, was an undersecretary for housing in the communist government between 1947 and 1949.

Among the few who opposed the historicizing socialist realism

was Máté Major, a modernist who closely followed CIAM principles and was a staunch Marxist before the war. He was appointed professor of architecture at the Polytechnical University of Budapest in 1946. He died in 1986. József Fischer, an outstanding designer of functionalist houses, survived the war to become, in 1945, president of the Budapest Public Works. Later, after the communist takeover, he worked in various government agencies as a minor architect but essentially refused to practice the new form of architecture. He even became secretary of construction in the short-lived reformist government of Imre Nagy. Béla Hofstätter, gifted designer of functionalist apartment buildings and theaters, was killed by the Nazis during the war. Marcel Breuer, internationally the most successful Hungarian functionalist, returned in 1933 from Switzerland to Budapest and began a collaboration with Farkas Molnár and József Fischer. In 1935, after being denied membership in the Hungarian Guild of Architects because his Bauhaus diploma was not recognized by this body, Breuer emigrated to England and later to the United States in 1937. There he taught for ten years at the Harvard University Graduate School of Design and until 1941 was Walter Gropius's partner. Molnár, another Bauhaus member, started writing during the war for right-wing newspapers and shifted his design approach so far that he designed a neo-Gothic Catholic church in Budapest. Molnár died during the Russian siege of Budapest in 1945. Alfréd Forbát, Walter Gropius's collaborator in Berlin, returned to Hungary in 1933 and settled in Pécs, where he built several houses. Unable to find a favorable professional climate in his native country, he moved to Sweden in 1938. There he worked until 1942 in the city planning offices of Lund and Stockholm. He spent the 1960s and 1970s teaching architecture in Stockholm and in Münich, where he died in 1972.

The steady progress achieved in the development of Polish functionalism was interrupted by the deluge of Nazi bombings begun on September 1, 1939. The cover page of the last issue of *Architektura i Budownictwo* (Architecture and Construction) of June 1939, which featured a falling bomb, referred symbolically and directly to the future carnage. The entire country was engulfed in flames and mass destruction. Ironically and tragically, Warsaw's brilliant major, Stanisław Starzyński, who was responsible for giving Warsaw its modern planning and architecture, directed a heroic fight to defend his city against the Nazis and in so doing witnessed his years of work being destroyed. He was eventually murdered in a Nazi concentration camp in 1945. When the guns finally fell silent, Poland's population, industry, infrastructure, and culture were shattered. Out of the 36 million inhabitants of the prewar period, only 24 million remained. The large and vibrant Jewish minority vanished. Poland's German minority was forcibly resettled. As a result of the Yalta agreement Ukrainians, White Russians, and Lithuanians who were formerly citizens of Poland found themselves within the

Soviet Union's new boundaries. The city of Warsaw was completely destroyed. The enormous task of rebuilding this time fell on the communists, who firmly took charge of Poland in 1947 and who performed this task with considerable skill and commitment.

Such dramatic political change had far-reaching ideological implications for Polish functionalist architecture, which had been rejected vehemently in the Soviet Union by 1933. But Polish functionalism did not die an immediate death; it lingered for a while. Its ideas and principles were still discussed during the war, during which clandestine architectural and town planning workshops in Warsaw conducted studies of the reconstruction of Warsaw and its further growth. Several projects conceived in the functionalist manner are due to the efforts of architects grouped around this workshop, among them a 1943 project for the Warsaw Housing Cooperative (WSM) for the district of Koło and two 1942 projects for the district of Rakowiec. These projects clearly show the continued influence of functionalist, large-block, and open-edged planning principles. Szymon and Helena Syrkus, after their return from Nazi concentration camps, in 1947 designed and built an interesting housing development called Koło II in Warsaw, based on the same criteria. In 1949 Bohdan Lachert built a functionalist residential district called Muranów in Warsaw for which he designed four-story apartment slabs serviced by external circulation galleries. The last manifestation of Polish functionalism was the 1949–51 Central Department Store in Warsaw, designed by architects Zbigniew Ihnatowicz and Jerzy Romański. This transparent, elegant, all-glass building was the last link in Poland to the great tradition of modernist commercial buildings begun by Erich Mendelsohn in Germany. With this building Polish functionalism, after thirty years of development and growth, came to an end. It was replaced by the Stalinist monumental and eclectic socialist realism, which began with the construction of the Josef Stalin Palace of Culture skyscraper in Warsaw in 1948.

The fate of the generation of architects responsible for the accomplishments of Polish modernism varied considerably. Stanisław Brukalski was interned from 1939 to 1944 in a German prisoner-of-war camp and conducted illegal courses in architecture there. After the war he and his wife Barbara actively participated in the reconstruction of Warsaw by designing buildings in the communist-inspired, socialist realist style. Their theater and cultural center in the district of Żoliborz is a good example of their new approach to design. They also became professors at the School of Architecture in Warsaw. Romuald Gutt, a prolific architect of the modernist period, survived the war and became a professor at the school. Bohdan Lachert, one of the principal Polish functionalists, survived the war to resume his architectural activities under the communists. He was on the team that designed the Cemetery of the Russian Soldiers in Warsaw and

other buildings in the socialist realist style. He was a professor at the School of Architecture in Warsaw. Bohdan Pniewski, so successful professionally before 1939, became again successful during the communist era. During the war, he illegally taught architecture in Warsaw. He was also involved in the reconstruction of Warsaw after 1945. He rebuilt the Warsaw Grand Opera and Theater and the Parliament building. He was also a professor at the School of Architecture in Warsaw. Former Lubetkin collaborator Grzegorz Sigalin survived the war in the Soviet Union and eventually became the chief architect of Warsaw. He was responsible for many socialist realist buildings in the city. Szymon Syrkus, the most famous theorist and practitioner of functionalism in Poland, was deported to Auschwitz in 1942. He survived to continue his practice and to become, in 1949, a professor of architecture at the School of Architecture in Warsaw. For a few short years he continued designing functionalist architecture in Warsaw. He later devoted himself to the theory of architecture and, ironically, to the glorification of socialist realism. His wife, Helena, arrested by the Germans and deported to Breslau, also survived to become a professor at the Warsaw Polytechnic. Tadeusz Tołowinski, the father of Polish modern planning, survived to become professor of urban planning at the Kraków Polytechnic after 1945. Juliusz Żorawski, one of the most talented Polish functionalists, also survived the war. During the war he participated in clandestine teaching; later he

became professor at the School of Architecture in Kraków, in charge of the department of industrial architecture.

On the other hand, Stefan Bryła, a brilliant Polish engineer, was murdered by the Nazis in 1943. Jadwiga Dobrzyńska, one of the three most important women architects of the interwar period, died early in the war, in 1940. Her husband, gifted modernist Zygmunt Łoboda, died in 1945 in the Nazi concentration camp of Flossenburg. Maksymilian Goldberg, one of the early stars of Polish functionalism, refused the help of friends who wished to hide him from the Nazis, out of concern for their safety. He entered the Warsaw Ghetto, where he disappeared without a trace. Katarzyna Kobro, the intense and productive modern artist, saw her entire work destroyed during the war. Although she survived, she refused to produce any art under such dramatically changed ideological conditions. Bohdan Lachert's friend and long-term partner Józef Szanajca, the most brilliant talent of Polish modernism, died a soldier's death on one of the battlefields of 1939. Lucian Korngold, a brilliant functionalist designer, escaped the Holocaust and moved to Brazil, where he became one of the leading architects of South America. Tadeusz Michejda, a devoted architect and public activist in Silesia, survived the war as a sick and broken man and never resumed his practice. He died in 1955. Romuald Miller died in the last days of the war. Lech Niemojewski survived to devote himself to scientific interests, as he refused to practice in the

new ideological climate. Edgar Norwerth, in a similar spirit, did not resume his practice after the end of hostilities; he died in 1950. Karol Schayer, the gifted designer of modernist schools, was forced to flee his native Silesia and died abroad during the war. Teresa Żarnower, who after the 1927 death of Mieczysław Szczuka, with whom she was deeply connected, interrupted her work in 1927 to emigrate to the United States in 1937. She committed suicide in New York in 1950. Finally, Zbigniew Wardzała, the rising young star of Polish functionalism, committed suicide after the war, unable to cope with the loss of his beloved city of Lwów and the dramatic sociopolitical change in Poland.

Thus, as we confront the current *fin de siècle* with insecurity and scepticism and prepare to enter the twenty-first century, the accomplishments and tragedies of the Central European modernists may perhaps be contemplated as a fitting example of genuine human and creative progress. This is particularly evident when viewed from the perspective of our present precarious moral and professional condition, one characterized by everyday-American pragmatism, survival-oriented business deals and platitudes, and short-lived conceptual follies. In comparison, the generation of the Central European modernists appears to have been driven by a broad, genuine, and profound belief in the necessity of radical, lasting social and creative change in the name of progress. It was this progress that was to produce improved living conditions for everyone, and for which many of these modernists were ready to sacrifice their careers and even their lives. Their functionalist and constructivist work paved the way for the stupendous technological and ultimately poetic achievements that have been realized recently by the current progressive elite of architectural designers from Great Britain, France, Japan, and many other countries.

János Bonta

(b. Miscolc, Hungary, 1921) studied architecture at the Innerarchitectural Design Department of the Academy of Arts and Crafts in Budapest from 1939 to 1942. From 1949 to 1970 he was Chair for the Design of Public Buildings at the Polytechnical University of Budapest. In 1974 he was appointed professor and director of the Institute of History and Theory of Architecture, a position he held until 1986. Dr. Bonta has practiced architecture at the Office of Public Buildings in Budapest and has won several competitions, both as an individual and as a team member. Dr. Bonta is the author of several books: *Architecture and Industrialization* (1963), *The Contemporary Architectural Environment* (1967), *Ludwig Mies van der Rohe* (1978) *Skidmore, Owings & Merrill* (1982), *Theory of Architecture* (1981 and 1982), and *Modern Architecture—Post Modern Architecture* (1990). His articles and essays have been published in English, French, and German, and he has lectured in the United States, Germany, Austria, and Belgium.

Olgierd Czerner

(b. Swietochlowice, Poland, 1929) graduated from the School of Architecture of the Polytechnic Institute of Wrocław in 1951 and earned the degree of Doctor of Technical Studies in 1960. He has taught at the Polytechnic Institute of Wrocław since 1969 and was appointed professor of the history of architecture there in 1977. Between 1955 and 1965 he held the position of conservator of Wrocław's historical monuments; currently he is involved in the restoration of Polish historical monuments in the former Polish territories in Ukraine. Mr. Czerner founded the Museum of Modern Architecture in Wrocław and has been its director since 1965. In addition, between 1990 and 1993 he was vice-president of the International Committee for the Preservation of Historic Monuments. He is the author of numerous books and monographs on the history of architecture and the conservation of historical monuments. These include a monograph on the Polish architectural avant-garde presented at the Centre Pompidou in Paris in 1981, and books on the architecture of Wrocław and Lwów. Mr. Czerner has lectured widely in the United States, Germany, France, and Italy.

Wojciech G. Leśnikowski

(b. Lublin, Poland, 1938) graduated from the School of Architecture of the Polytechnic Institute of Kraków in 1961 and practiced architecture in Poland until 1964, the year he moved to Paris to practice and teach. Since 1968 he has lived in the United States, where he has taught at Yale University, Cornell University, the University of Pennsylvania, Pratt Institute, the University of Wisconsin, The Art Institute of Chicago, and the University of Illinois at Chicago, where he is an adjunct professor of

architecture. Currently he is the Don Hatch Distinguished Professor of Architecture at the University of Kansas, in Lawrence. In the United States Prof. Leśnikowski has practiced architecture in New York and Chicago, and he has won prizes in several international competitions. He is the author or co-author of four books, *Rationalism and Romanticism in Architecture* (1982), *The New French Architecture* (Rizzoli International Publications, 1990), *Architecture Studio* (1991), and *Many Faces of German Architecture* (1994), and his theoretical articles have appeared in many international publications. Prof. Leśnikowski has received grants and awards from the Graham Foundation of Chicago, the National Endowment for the Humanities, the German Academy of Sciences, and the Fulbright Commission; he is also the recipient of the Chevalier des Arts et Letters medal awarded by the French Republic.

John Macsai

(b. Budapest, 1926) received his architectural training at the Polytechnical University of Budapest and his architecture degree from Miami University in Oxford, Ohio. He worked as an architectural designer at Skidmore, Owings & Merrill in Chicago and at Raymond Loewy Associates, and in 1975 he formed his own firm, John Macsai and Associates, in Chicago. Currently he is a partner at the Chicago office of O'Donnell, Wicklund, Pigozzi and Peterson and a professor at the School of Architecture at the University of Illinois at Chicago. Prof. Macsai has designed a wide variety of buildings, including hospitals, community centers, schools, office and apartment buildings, factories, and hotels, many of which have received distinguished awards and been published in national architecture magazines. He is the author of the textbook *High Rise Apartment Buildings—A Design Primer* (1972), and the book *Housing* (1976, rev. 1982), as well as numerous articles on design, zoning, and planning published in professional journals.

Vladimír Šlapeta

(b. Czechoslovakia, 1947) received his doctorate in architecture and urban planning at the Czech Technical University in Prague, where he is currently professor of architectural history and theory. Since 1991, he has also been Dean of the Faculty of Architecture. Prof. Šlapeta is widely considered one of the foremost authorities on Czechoslovak modern architecture and has published and lectured on this subject throughout the United States and Europe. His publications include the book *Czech Functionalism* (Architectural Association, 1986) and articles on modern architecture in international magazines. Prof. Šlapeta has lectured extensively and has taught in Vienna, Innsbruck, London, and Berlin.

SELECT BIBLIOGRAPHY

CZECHOSLOVAKIA

Vondrová, Alena et al., eds. *Architektura Cesky Funkcionalismus 1920–1940* (Czech Functionalist Architecture 1920–1940). Prague: Umělecko Průmyslové Muzeum; and Brno: Moravská Galerie, 1978.

Burkhardt, François. *Cubismo Cecoslovacco*. Milan: Electa, 1982.

Dostál, Oldřich. *Moderní architektura v Československu* (Modern Architecture of Czechoslovakia). Prague: Czeskoslovenkych Vytvarnych Umelcu, 1967.

For New Architecture. Exhibition catalogue. Prague: Museum of Decorative Arts, 1940.

Fuchs, Bohuslav; Jaroslav Oplt; and Zdeněk Rossmann, eds. *Building and Housing Exhibition Catalogue, Brno, September 8th to 24th, 1933*. Brno: N.p., 1933.

Pavel Janak 1882–1956. Prague: Kunstgewerbemuseum, 1984.

Kamil Roskot 1986–1945: Architectural Work. Exhibition catalogue. Olomouc: Gallery of Fine Arts, 1978.

Kittrich, Josef. "Dwellings of Industrial Workers". *Stavba* 11 (1932–33).

Kroha, Jiří. *Sociologický fragment bydlení* (The sociological fragment of dwelling). Brno: N.p., 1973.

Kubinszky, Mihály. *Bohuslav Fuchs*. Budapest: Akadémiai Kiadó; and Berlin: Henschelverlag Kunst und Gesellschaft, 1986.

Kusý, Martin. *Emil Bellus*. Bratislava: Tatran, 1984.

Pechar, Josef. *Programy české moderní architektury* (Czech modern architectural programs). Prague: Odeon, 1981.

Kamil Roskot 1886–1945. Prague: Narodni Technicke Muzeum, 1978.

Šlapeta, Vladimír. *The Brno Functionalists*. Exhibition catalogue. Helsinki: Museum of Finnish Architecture; and Jyväskylä: Alvar Aalto Museum, 1983.

———. "Bata Architecture." *Rassegna*, September 1990.

———. "Czech Architecture Between the Two World Wars and its International Contacts". *Umeni* 5 (1981).

———. *1900–1978: Guide to Modern Architecture*. Prague: Narodni Technicke Muzeum, 1978.

———. *Czech Functionalism 1918–1938*. London: Architectural Association, 1987.

Stavitel, vol. 12, 1931.

Teige, Karel. "Mundaneum." *Stavba* 7 (1928–29).

———. *Nejmenší byt* (The Smallest Flat). Prague: N.p., 1932.

———. "Moderní architektura v Československu" (Modern Architecture in Czechoslovakia). *MSA—Mezinórodní soudobá architektura* 2 (1930).

Zatloukal, Pavel. *Počátky moderní architektury na Moravě a ve Slezsku* (The beginnings of modern architecture in Moravia and Silesia). Olomouc: Gallery of Fine Arts, 1981.

HUNGARY

Borbiró, Virgil. *A magyar épitészet története* (The history of Hungarian architecture). Budapest: Magyar Szemle Társaság, 1937.

Ferkai, András. *Buda épitészete a két világáború között* (The architecture of Buda between the two world wars). Budapest Hungarian Academy of Sciences, 1995.

Gábor, Eszter. *A C.I.A.M. magyar csoportja 1928–1938* (The Hungarian branch of C.I.A.M 1928–1938). Budapest: Akadémiai Kiadó, 1971.

Gassner, Hubertus. *Ungarische Avantgarde*

in der Weimarer Republik (Hungarian Avant-Garde in the Weimar Republic). Kassel, Germany: Jonas Verlag, 1986.

Granasztói, Pál. *Vallomás és búcsú* (Confessions and leave taking). Budapest: Magvető Kiadó, 1961.

Györgyi, Dénes; Dezső Hütl; and Lajos Kozma. *Új magyar épitőművészet* (New Hungarian architectural design). Two vol. Budapest: István Budai, 1935 and 1938.

Jékely, Zsolt, and Alajos Sódor. *Budapest épitészete a XX. században* (The architecture of Budapest in the twentieth century). Budapest: Műszaki Könyvkiadó, 1980.

Kozma, Lajos. *Das neue Haus* (The New House). Zurich: Dr. Girsberger Verlag, 1941.

Kubinszky, Mihály, ed. *Modern épitészeti lexikon* (Lexicon of modern architecture). Budapest: Műszaki Könyvkiadó, 1978.

———. *A harmincas évek épitészete* (The architecture of the thirties). Budapest: Magyar Művészet Sándor Kotha Ed., 1985.

Major, Máté. "A modern épitészet szolgálatában: Farkas Molnár" (In the service of modern architecture: Farkas Molnar), *Jelenkor* 3 (1956).

Major, Máté, and Judit Osskó, eds. *Új épitészet, új társadalom* (New architecture, new society). Budapest: Corvina Kiadó, 1981.

Merényi, Ferenc. *A magyar épitészet (1867–1967)* (Hungarian architecture 1867–1967). Budapest: Műszaki Könyvkiadó, 1969.

———. *1867–1965: Cento Anni di Architettura Ungherese* (1867–1965: One Hundred Years of Hungarian Architecture). Rome: Accademia d'Ungheria in Roma, 1965.

Mezei, Ottó. "Kölcsönhatások: A magyar avantgárd a weimari köztarsaságban" (Interconnections: The Hungarian avant-garde in the Weimar republic). *Magyar*

Épitőművészet, November/December 1986.

Mezei, Ottó. *Molnár Farkas.* Budapest: Akadémiai Kiadó, 1987.

Molnár, Farkas. *Munkák: 1923–1933* (Works: 1923–1933). Introduction by László Moholy-Nagy. Budapest: Magyar Műhely Szövetség, 1933.

Pamer, Nóra. *Magyar épitészet a két világháború között* (Hungarian architecture between the two world wars). Budapest: Műszaki Könyvkiadó, 1986.

Pica, Angeldomenico. *Nuova Architettura nel Mondo* (New World Architecture). Exhibition catalogue, Milan Triennale. Milan: Hoepli, 1937.

Preisich, Gábor, and Ágost Benkhardt. "Budapest épitészete a két világháború között" (The architecture of Budapest between the two world wars), *Épités és Közlekedéstudományi Közlemények 3–4* (1967).

Rados, Jenő. *Magyar épitészet története* (History of Hungarian architecture). Budapest: Műszaki Könyvkiadó, 1961.

Schlemmer, Oskar; László Moholy-Nagy; and Farkas Molnár. *A Bauhaus szinháza* (The theater of the Bauhaus). Budapest: Corvina Kiadó, 1978.

Szendrő, Jenő, et al. *Magyar épitészet 1945–1970* (Hungarian architecture 1945–1970). Budapest: Corvina Kiadó, 1972.

Kontha, Sándor, ed. *Magyar művészet 1890–1919* (Hungarian art 1890–1919). Budapest: Műszaki Könyvkiadó, 1981.

———. *Magyar művészet 1919–1945* (Hungarian art 1919–1945). Budapest: Műszaki Könyvkiadó, 1985.

Tér és Forma. Issues 1928 to 1937. Borbiró Virgil Ed. (Special CIAM volumes: 1932/12, 1934/1, 1953/1, 1936/1, 1937/12).

Pusztai, László, intro. *Magyar épitészet a két*

világháború között (Hungarian architecture between the two world wars). Exhibition catalogue. Budapest: Országos Műemléki Felügyelőség Építészeti Múzeuma, 1981.

POLAND

Brukalski, Barbara and Stanislaw. "Nasza Praca nad Mieszkaniem Robotniczym" (Our Work on the Worker's Flat), *Polskie Towarzystwo Reformy Mieszkaniowej* (Special Journal of the Library of the Polish Housing Reform Society), series 1, no. 8. Warsaw: 1937.

Brukalski, Barbara . "Nowoczesna Architektura" (Common Architecture), *Tęcza* 13 (1931).

Chojecka, Ewa. *Architektura i Urbanistyka Bielska-Białej do 1939 Roku* (Architecture and Urbanism of Bielska-Biała Prior to 1939). Bielska-Biała: Biblioteka Bielska-Białej, 1994.

Czerner, Olgierd, and Hieronim Listowski. *Awangarda Polska. Architektura i Urbanistyka 1918–1939* (The Polish Avant-Garde. Architecture and Urbanism 1918–1939). Warsaw: Interpress; and Paris: Editions du Moniteur, 1981.

Czerner, W., and M. Szelepin. *Konkursy Architektoniczne w Polsce w Latach 1918–1939* (Architectural Competitions in Poland in the years 1918–1939). Wrocław: N.p., 1970.

Faryna-Paszkiewicz, Hanna. *Saska Kępa 1918–1939.* Wrocław: Zakład Narodowy im. Osolińskich, 1949.

Jonkajtys-Luba, G. "50 Lat Architektury Polski Niepodłegłej" (Fifty Years of Architecture in Independent Poland), *Architektura* 11 (1968).

Kobro, K., and W. Strzemiński. *Katalog Wystawy w Zachęcie* (Catalogue of the Zachęta Exhibition). N.p., 1956 and 1957.

Krakowski, Piotr. "Recepcja Bauhausu w Architekturze Polskiej" (The Reception of the Bauhaus in Polish Architecture),

Sztuka XX Wieku (Twentieth Century Art), 1971.

Krassowski, W. "Problemy Architektury Polskiej Między Trzecią Ćwiercią XVIII a druga XX Wieku" (Polish Architecture Between the Third Quarter of the 18th and the Second Quarter of the 20th Century), *Architektura* 11–12 (1978).

Lisowski, Bogdan. "Nowoczesna Architektura w Polsce" (Modern Architecture in Poland), *Interpress,* 1968.

Malessa, S. "Rozwój Planowania Regionalnego w Polsce, 1930–39" (The Development of Regional Planning in Poland, 1930–39) *Biuletyn Towarzystwa Urbanistów Polskich w Zjednoczonym Krolestwie* (Bulletin of the Association of Polish Planners in the United Kingdom). London: December 1944.

Minorski, Jan. *Polska Myśl Innowacyjna w Architekturze 1918–1939* (Polish Innovative Thought in Architecture 1918–39). Warsaw: N.p., 1970.

———. "Postulaty i Koncepcje Urbanistyczne i Architektoniczne w Polsce w Ostatnim Pięcioleciu Przed Drugą Wojną Światową" (Town-Planning and Architectural Concepts in Poland in the Last Five Years Before the Second World War), *Materiały i Studja* (Materials and Studies) 1965.

———. "Próba Oceny Architektury Polskiej Okresu 1818–1939" (An Evaluation of Polish Architecture in 1918–1939), *Architektura* 12 (1953).

———. "Warunki Społeczno-Gospodarcze i Tendecje Rozwoju Architektonicznej w Polsce w Latach 1926–34" (Socio-economic Conditions and Development Trends in Polish Architectural Thought in 1926–34), *Materiały i Studja* (Materials and Studies), 1963.

Niemojewski, Lech. "Architektura Ruchu" (Architecture of Movement). *Komunikat SARP,* 1937.

———. "Dwie Szkoły Polskiej Architektury Nowoczesnej" (Two Schools of Modern

Polish Architecture). *Przegląd Techniczny* LXXIII (1934).

———. "Na Marginesie Programów Modernistycznych" (On Modernistic Programs). *Architektura i Budownictwo* (Architecture and Construction) 7 (1927).

Norwerth, E. "Architektura Przemysłowa" (Industrial Architecture). *Architektura i Budownictwo* (Architecture and Construction) 7 (1934).

Odorowski, Waldemar. *Architektura Katowic w Latach Międzywojennych 1922–1939* (Architecture of Katowice Between the Two World Wars, 1922–1939). Katowice: Muzeum Śląskie, 1994.

Olszewski, A. *Architektura Warszawy 1919–1939* (Architecture of Warsaw 1919–1939). Warsaw: N.p., 1968.

———. "Z Problematyki Architektury Dwudziestolecia Międzywojennego w Polsce. Z Zagadnień Plastyki Polskiej w Latach 1918–1939" (Problems of Architecture in the Twenty-year Period Between the Wars in Poland. Problems of Polish Art in 1918–1939). *Studia z Historii Sztuki,* vol. 9 (1963).

Pawłowski, K. "Współczesna Myśl Urbanistyczna w Polsce - okresu 1939 r." (Contemporary Town-Planning Thought in Poland to 1939). *Materiały III Krajowego Przeglądu Miejscowych planów Zagospodarowania Przestrzennego* (Materials of the 3rd National Review of Local Spatial Development Plans). Warsaw: N.p., 1964.

Pniewski, B. "Polska Twórczość Architektoniczna w Pierwszej Połowie XX Wieku" (Polish Architecture in the First Half of the 20th Century). *Biuletyn Techniczny Zarządu Biur Projektowych Budownictwa Miejskiego 6* (1955).

Sławińska, J. "O Społecznych i Estetycznych Założeniach Funkcionalizmui Konstruktywizmu" (Social and Aesthetic Principles of Functionalism and Constructivism). *Studia Filozoficzne 5* (1960).

Sołtyński, Roman. *Glimpses of Polish Archi-tecture.* London: Standart Art Book Co., 1942.

Strzemiński, Wacław, and Szymon Syrkus. "Teraźniejszość w Architekturze i Malarstwie" (The Present Day in Architecture and Painting). *Przegląd Artystyczny 4* (1928).

Syrkus, Helen and Szymon. "Architekci Reformatorzy (IV Międzynarodowy Kongres Architektury Nowoczesnej)" (Reform Architects [4th International Congress of Modern Architecture]). *Życie WSM* (Journal of the Warsaw Housing Cooperative) 1937.

———. "Architecture Opens the Volume." *The Machine Age.* Exhibition catalogue. New York: Little Review, 1927.

———. "Dziesięć Lat Pracy Międzynarodowych Kongresów Architektury Nowoczesnej" (Ten Years of Work of the International Congress of Modern Architecture, 1928–1938). *DOM* (House, Settlement, Dwelling) 6–7 (1938).

Tołowinski, Tadeusz. *Urbanistyka* (Urbanism). Two volumes. Warsaw: N.p., 1948.

Wisłocka, Izabela. *Awangardowa Architektura Polska 1918–1939* (Polish Avant-Garde Architecture,1918–1939). Warsaw: N.p., 1968.

———. *Rola Praesensu w Kształtowaniu Nowoczesnej Architektury w Polsce* (The Role of Praesens in Shaping Modern Architecture in Poland). Warsaw: N.p., 1964.

Zachwatowicz, Jan. *Architektura Polska* (Polish Architecture). Warsaw: Arkady, 1967.

Zahorska, S. "Miedzynarodowa Wystawa Architektury w Warszawie" (International Architecture Exhibition in Warsaw). *Architekt 5* (1926).

Załeski, Jan. "Pawilon Polski na Międzynarodowej Wystawie 'Sztuka i Technika' w Paryżu 1937" (The Polish Pavilion at the International "Art and Technology" Exhibition in Paris, 1937). *Architektura i Budownictwo* (Architecture and Construction) 6 (1937).

INDEX